STARBURST

Color Photography in America 1970–1980

Kevin Moore

STARBURST

Color Photography in America 1970 –1980

With Essays by James Crump and Leo Rubinfien

cincinnati art museum

HATJE
CANTZ

CONTENTS

FOREWORD

This exhibition and its accompanying catalogue celebrate the moment when color photography burst onto the art scene. It is difficult to imagine today but when this occurred, the work was not taken seriously. In fact, most critics, when they were confronted with these saturated colors and everyday scenes, deemed the work utterly banal. It did not conform to the standards that had been developed painfully over the preceding five decades in order to admit photography into the hallowed halls of art museums and art histories. Photography had only managed to attain a status not quite equal to that of painting, sculpture, and the other arts by reducing itself to the almost abstract clarity of black and white. This simplicity reflected a taste in art for fundamentals, but also was the outcome of the limited technological capabilities of color photography. Photographers quite simply could not afford to make color images and, when they could, the results were not as disciplined as what their aesthetic and technical training had taught them how to control in black and white. Now, suddenly, as if miraculously, color photography was possible, became accepted, and produced spectacular results.

Just as important as the emergence of color photography as a technique was the arrival into the frame of the particular subject matter with which color photography scaled the bastions of high art. The photographers whose work appears in this exhibition looked neither at the studied poses of the beautiful nor at the anguished expressions of those caught in poverty, but at the bland, the everyday, the normal, that which was around them everywhere. What came of age in the 1970s was as much the artificial environment that technology had created as it was the means by which that landscape was documented by some of the best photographers in the world. At this time films, popular songs, and all the other bits and pieces of a mass culture had already started to trace the emergence of a plastic reality. It was color photography, however, that truly managed to capture the vibrancy of a material reality that most artists had ignored in favor of either high art subjects or their deliberate opposites.

Starburst shows us what the world had become after the 1960s and before the backward-looking era of Ronald Reagan and postmodernism. If these images have the quality of being unstudied, having come about by happenstance, or even being deliberately malformed, those qualities reflect this period of doubt that laid the seeds for the self-conscious and even revelatory art that came after. It also reflects an emerging aesthetic and the critical attitude toward social reality that color photography has championed, and which we welcome into the Cincinnati Art Museum. Today, few of us would refuse to take color photography seriously, nor would we turn away from what has become one of the most productive landscapes for aesthetic perusal, the endless miasma of suburbia and the artificial reality we have made. This exhibition shows us how, in the hands of great artists, Kodachrome and shopping malls became building blocks for transcendent beauty.

I wish to thank Kevin Moore, who conceived of and directed this exhibition, as well as our own curator of photography, James Crump, who worked with Kevin to create this masterful assembly of images. I would also like to thank all of the galleries and the private individuals who so generously lent work from their collections for this exhibition. The Princeton University Art Museum is our partner in this venture. Hatje Cantz of Ostfildern, Germany, has assembled these images into this catalogue. Many here at the Cincinnati Art Museum worked hard to bring this project to fruition. In particular I would like to thank Stephen Jaycox, Jay Pattison, Susan Hudson, and Matt Leininger.

Aaron Betsky

Director
Cincinnati Art Museum

STARBURST: COLOR PHOTOGRAPHY IN AMERICA 1970–1980

KEVIN MOORE

"Let's face it, the photographs of William Eggleston are a mess."—Gene Thornton[1]

"[Eggleston's] pictures look insignificant, dull, even tacky, on the wall."—Janet Malcolm[2]

"As pictures . . . these seem to me perfect."—John Szarkowski[3]

"Perfect? Perfectly banal, perhaps. Perfectly boring, certainly."—Hilton Kramer[4]

It is hard to imagine today that color photography was once controversial. What could be more natural, more ordinary than a color photograph? No one cared, of course, about the color picture in your wallet; it was the color photograph appearing on the wall of a gallery or art museum that caused the stir. Up until the 1970s, exhibitions of color photography were still rare enough. Aside from a few minor shows occurring during the early 1970s—modest, often overlooked exhibitions of color photographs by Robert Heinecken, Stephen Shore, Helen Levitt, and others—art photography, even by the mid-1970s, was predominantly black and white. The lid blew off in 1976 with an exhibition titled *Photographs by William Eggleston,* organized by the Museum of Modern Art in New York (fig. 1). Few people, it seems, "got it," and the catalogue essay by the show's curator, John Szarkowski, only added kerosene to the barbecue grill. In that essay, printed on mint green paper, Szarkowski described Eggleston's pictures as "perfect," to which critic Hilton Kramer responded, famously, "Perfectly banal, perhaps. Perfectly boring, certainly."[5] Eggleston is today recognized as one of the most important photographers of the 1970s. What was it that sparked such confusion and agitation at the time?

Color photography's departure from black and white signaled more than a technological inevitability. Color technologies had in fact improved by the early 1970s and had become more affordable, making it possible for a large number of photographers to explore the potential of art photography in color. Yet the rise of color—and resistance to it—was a cultural phenomenon. Black and white had long been the medium associated with both art photography and serious photojournalism. Indeed, by the 1960s these two photographic tracks had drawn closer together, with museum collections and exhibitions often intentionally blurring boundaries between the two. Documentary photography that was considered art was perforce infused with subjectivity. Photographers as wide ranging as Walker Evans, Henri Cartier-Bresson, Robert Frank, and Diane Arbus were praised for an art-documentary style founded on an attitude of clear-eyed realism, personal engagement, and individual expression. Though styles differed—Evans adopted frontality and a "styleless style"; Cartier-Bresson a lyrical formalism discovered in the instant; Frank a gritty pessimism; and Arbus a psychological classicism—each of these artists bestowed on their subjects a certain dignity, a sense of heroic struggle (with shades of irony, in Arbus's case), through formal structuring in black and white. Frank's proclamation that black and white represented "the alternatives of hope and despair" revealed a telling assumption: monochromatic photography held inherent social purpose. It also signaled an engagement with social life that was deeply romantic. Some photographers working in black and white, such as Lewis Hine and Dorothea Lange, had set out to change society; for others, such as Evans and Frank, observation was enough. In both instances, the photographer revealed an attitude of profound respect for photography's ability to tell a truth, to reveal some aspect of the human condition. Even Garry Winogrand's pictures, which often pushed such conventions to the limits of recognition, maintained through black and white a sense of graphic order

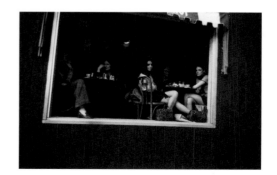

2. Garry Winogrand, *Untitled,* c. 1970. Gelatin silver print, 11 × 14 in.

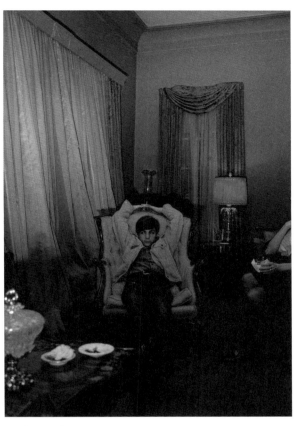

1. William Eggleston, *Sumner, Mississippi*, c. 1969–70. Dye transfer print, 20 × 24 in.

and social purpose (fig. 2). Black and white was historical, a medium associated with modernism: it represented not only a belief in visual truths but an assumption of compulsory engagement with the world. For various reasons, such assumptions began to disintegrate by the 1970s.[6]

Color photography had certain "low" associations with advertising and entertainment, which formed an initial stumbling block for some. But it was color's suggestion of social—and by extension moral—indifference that underlay the fiercest resistance to the medium. With color came a new aesthetic vocabulary of transparency and ambiguity. Some artists, particularly early on, were careful to position their imagery in relation to familiar visual languages in order to make their motives intelligible. Robert Heinecken worked in mixed media and a tradition of collage; Stephen Shore's early work linked-in to Conceptual Art; Helen Levitt tactfully inserted color into her own well-established black-and-white oeuvre of street photography. Others, such as Eve Sonneman, William Christenberry, and Neal Slavin, referenced film, vernacular photography, and commercial portraiture, respectively, situating their efforts in the broader culture. Certain photographers, however, dropped or never bothered with such associations and simply explored color photography. Shore's later work and Eggleston's in particular seemed unconcerned with art traditions, eschewing both the roster of worthy subjects and any overt commentary on the part of the photographer. What's more, both photographers' work flaunted a sense of apathy toward social life, an attitude some found confusing if not infuriating, particularly during the early 1970s when idealist principles of the 1960s were still very much alive. While this approach may be explained in part by color photography's seeming transparency—the sense that the photographic image no longer mediated the visible world—it also represented a common response to the 1970s, a decade of widespread cultural

malaise. As the country struggled to regain its sense of direction following the political activism and social idealism of the 1960s, photographers embarked on a search to discover new subjects, methods, and meanings. Color offered an obvious if indistinct way forward, a path leading beyond the void left by the 1960s and the era of the "concerned photographer" (as defined by Cornell Capa in 1968) toward some new as yet to be defined sense of purpose.[7] 1970s color photography may thus be characterized as a chaotic and disparate search, a heterogeneous effort encompassing diverse bodies of work by artists as dissimilar as Mitch Epstein, Jan Groover, Les Krims, and others toward the rediscovery of something ennobling and purposeful in modern American life.

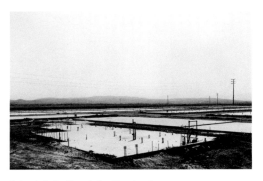

3. Lewis Baltz, *Foundation Construction, Many Warehouses, 2892 Kelvin, Irvine,* 1974. Gelatin silver print, 6 × 9 in.

By the late 1970s, there was a "rush to color," culminating in Sally Eauclaire's cumbersome summation titled *The New Color Photography,* exhibited at the International Center of Photography, New York, in 1981.[8] That project accounted for some fifty New Colorists, many of them "76ers," photographers who had appeared following Eggleston's *succès de scandale* of 1976, and many of whom fell into relative obscurity soon after. Writing in 1985, photographer Lewis Baltz identified color photography, along with the *New Topographics* exhibition of 1975 (in which he exhibited; fig. 3), as the two photographic trends of the 1970s. Baltz recognized the work of Eggleston and Shore, who also exhibited at MoMA in 1976, as representative of a committed effort to understand color but he went on to damn other bodies of color work as "Soft Contemporary, user-friendly pap."[9] Interestingly, although by 1985 color photographs had become the standard for art photography, both in photography proper and the larger realm of contemporary art, the designation "color" was generally dropped from exhibition and publication titles. Color had assimilated to the point that the distinction no longer had to be made. But the significance of color's emergence, particularly in relation to large-scale color work of subsequent decades—work by Jeff Wall (fig. 4), Thomas Struth, Rineke Dijkstra (see p. 46), and others—remained, and still remains, unexamined.

The New Color Photography was no more nor less a movement than New Topographics or, its younger half-sibling, the Pictures Generation.[10] Like those groups, New Color was defined by a constellation of exhibitions, personal associations, critical commentary, and a shared interest in a complex set of ideas, all flourishing with great intensity during a fairly short period of time. Color photography of the 1970s happened in a starburst. As any astronomer can tell you, a starburst is an intensely destructive and creative environment, caused by a collision or close encounter between two or more galaxies, resulting in the formation of stars. New Color was, on the surface at least, a promiscuous photographic enterprise, a flirtation with numerous practices and ideas occurring simultaneously in other art movements and the popular culture. This period of media impurity was a conscious step outside the bounds of traditional art photography, modernist photography in particular, which had maintained a standard of media separation since the beginning of the twentieth century. During the late 1960s such ideas had reached their zenith, with Szarkowski promoting the concept of "pure photographic seeing" in numerous definitive exhibitions and catalogues.[11] Yet New Color embodied a radically defensive impulse as well. For all the photographers' apparent interest in post-conceptual modes such as Pop, Minimalism, and Land Art, as well as mass media imagery and vernacular photographic forms, New Color hewed to a photographic discourse throughout the decade. While photographers freely transgressed the boundaries of modernist strictures, threatening to demolish the old set of standards, they continued to discuss their work in the received vocabulary of photography. By the end of the 1970s, there was a discernible "return to order," a reaffirmation of photography's status as a distinct medium with its own aesthetic criteria. These criteria were very much the same as those of the previous decade, only now they incorporated color and a range of cultural associations that came with it.

4. Jeff Wall, *Diagonal Composition,* 1993. Transparency in lightbox, 15¾ × 18⅛ in.

If this collision of galaxies was located anywhere it was New York City, where most of the color exhibitions and publications were formulated and where photographers mingled with artists and ideas from other solar systems. Besides Eggleston and Shore, the group included Joel Meyerowitz, Helen Levitt, Harry Callahan, Neal Slavin, Les Krims, Mitch Epstein, Jan Groover, Eve Sonneman, John Pfahl, Joel Sternfeld, Leo Rubinfien, and many others.[12] Members of the West Coast contingent, represented by Robert Heinecken, John Divola, Barbara Kasten, Richard Misrach, and others, were exhibited in New York throughout the decade, bringing a more integrated art-school approach to the dialogue.[13] An upstart group of New York photography galleries exhibited these artists, most prominently Light Gallery, which opened on Madison Avenue in 1971, with Tennyson Schad as backer and Harold Jones as its first director; Witkin Gallery, which had opened on East Sixtieth Street in 1969; and Robert Freidus Gallery, which opened in 1977.[14] Numerous mainstream contemporary galleries also incorporated photography during the seventies, mixing New Color photographers with artists who just worked in photography: Castelli Graphics, Sonnabend, John Weber, Marlborough, and Robert Miller, all in New York.[15] Influential critics included several photography old-timers, such as Gene Thornton, Jacob Deschin, and Max Kozloff, as well as various newcomers, such as A. D. Coleman, Ben Lifson, Andy Grundberg, and Julia Scully, publishing in *Artforum, The Village Voice, SoHo Weekly News, Modern Photography*, and elsewhere. Especially by the end of the 1970s, numerous museums organized important exhibitions of color photography. Besides the Museum of Modern Art in New York; The Metropolitan Museum of Art; the George Eastman House, Rochester; the Museum of Fine Arts, Boston; the San Francisco Museum of Modern Art; The Center of Creative Photography, Tucson; the Corcoran Gallery of Art, Washington, D.C.; and the Princeton Art Museum offered significant color shows.[16]

Attentive readers of 1970s photographic criticism quickly realize that color was not always the central issue; looking back from the mid-1980s, Baltz called color a "pseudo-issue."[17] Though there was much legitimate exploration, both technical and aesthetic, around the challenges posed by color, color often served as a rubric for multifarious experimental practices taken up by photographers that were harder to isolate and would take years to articulate, particularly within the boundaries of traditional photographic discourse. Color became an umbrella of sorts, sheltering a range of photographic behaviors, involving new types of subject matter and new forms of photographic expression. Banal, artificial, pointless, kitsch, commercial, and other milder pejorative terms, such as beautiful, romantic—these were used to describe a range of photographs that were, in fact, some of the most challenging and prescient images of their day. At the time, however, not many viewers—not even most critics—had the vocabulary to say what the pictures were about. Marvin Heiferman, director of Castelli Graphics during the late 1970s, where much New Color work was shown, has said, "People didn't know what they were looking at."[18] And as late as 1982, critic A. D. Coleman could proclaim: "One of the most exciting aspects of contemporary color photography is that everyone concerned with it—inventors, manufacturers, historians, critics, curators, dealers, collectors, audience, and photographers—are all operating in a state of roughly equivalent ignorance."[19]

It is significant that New Color organized itself around a technical point. That the group was identified by a technology—though, in fact, color technologies were myriad and remained troublingly unperfected throughout the decade—reveals a firm commitment, even through all the experimental excesses of the 1970s, to photography and its traditions.[20] Many artists who came to be identified with the group were pulled in or crossed over from other artistic spheres (Robert Heinecken, William Christenberry, Jan Groover, and Barbara Kasten were all painters), while others who considered themselves strictly photographers adopted practices common to other mediums (Les Krims, John Divola, and John Pfahl each imported aspects of performance and conceptual art to the photographic image). Still, discussion

always came back to photography—its precedents, exploration, and potential. New Color was fundamentally a photographic discourse. In that sense, New Color may be seen as a protective historical frame, preserving the history and practice of a medium that had only very recently been accepted as an art form. Despite the frenetic and hallucinatory images many of these photographers produced, not to mention the wealth of images that were confrontationally banal, the color phenomenon as a whole should be seen as a moment of both widespread exploration and self-conscious preservation. New Color, based on a technological distinction, became the point of reference for a historical moment. While the technologies may not have had great historical significance, the dialogue that sprang up around them during the 1970s did.

The cultural underpinnings associated with color photography are perhaps more deeply meaningful than color's impact on art photography. In its schematic trajectory across the 1970s, New Color's development may be seen to mirror the political and cultural patterns that characterized the "un-decade."[21] Starting out in 1970 with a politically engaged, socially conscious attitude, color photography by mid-decade had cooled to a more detached, inward-looking, regional, and, at times, nostalgic set of activities, arriving finally at 1980 as a self-consciously formalized, highly synthesized, institutionalized, and globally-conscious set of practices.[22] The country's mood shifted by similar degrees. The early part of the seventies saw 1960s political and social idealism wither in the face of obvious failure in Vietnam, the embattled Nixon administration, and a halting economy. By 1976 Thomas Wolfe had christened the seventies "The Me Decade" to describe the nation's collective retreat from politics and social activism into self-absorption and the pursuit of personal transformation.[23] Mid-decade also saw a spate of nostalgia films and TV shows, such as *American Graffiti* (1973), *Happy Days* (1974), and *Days of Heaven* (1978), signaling a desire to escape the malaise by returning to simpler times—an escape that would be instituted in a big way, for better or worse, with the election of Ronald Reagan in 1980. A period of cultural stabilization, economic prosperity, and, most importantly, a renewed sense of purpose was on the horizon.

The far-reaching debates over color photography's merits and intentions, centered on the bodies of work by the small critical sampling of artists examined in this book, provide a register of the anxieties transforming American society during the 1970s. In the broad range of subject matter represented here, New Color offers a front-row seat on the seventies, a decade that continues to define our political thought, cultural ethos, and artistic sensibility, while also examining an important lost chapter in the history of art. New Color, like the seventies itself, is a missing link, a connection between the rampant, often heroic, creative agitation of the 1960s and the stabilizing and rationalizing impulses of the 1980s.

"If photography had been invented in color, who would have missed black and white?"—Judy Linn[24]

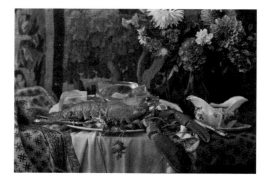

5. Unidentified French photographer, Still life with lobster, c. 1907–10. Autochrome, 5 × 7 in.

Photography's nineteenth-century inventors were surprised that their pictures were not in color and embarked on efforts to perfect the process, believing that the monochromatic image was only a temporary and rudimentary stage in the medium's development. Despite widespread research throughout the century, hand tinting remained the simplest and most reliable way to produce a color photograph and was, at any rate, no less artificial looking than the various laboriously scientific processes developed by Louis Ducos du Hauron and others.[25] In 1907 the first commercial color process became available when the Lumière brothers launched the Autochrome (fig. 5), a starch-based glass transparency that bore a striking resemblance to Pointillist and Post-Impressionist painting. Aesthetes and wealthy amateurs such as Alfred Stieglitz, Jacques Henri Lartigue, and George Bernard Shaw were the Autochrome's main consumers as the cost and fragility of the plates discouraged reproduction or exhibition.

7. Harry Callahan, *Chicago*, c. 1952. Dye transfer print, 8¾ × 13½ in.

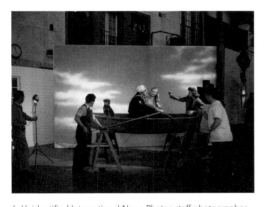

6. Unidentified International News Photos staff photographer, Filming a movie scene, c. 1946. Chromogenic print, 10⅛ × 12¹⁵⁄₁₆ in.

The real breakthroughs occurred during the 1930s with the development of color processes geared toward lucrative commercial markets. Technicolor came out in 1935, bringing novelty and fantasy to movie audiences seeking Depression-era escapism (fig. 6); the effects were nowhere better dramatized than in the exhilarating moment when the narrative leaped from black and white to color in *The Wizard of Oz,* released in 1939.[26] In 1935 Kodak had released the first 35 mm color film, Kodachrome. The film had marked disadvantages: at first it was rather slow (ASA 10), requiring long exposure, and yielded only one-of-a-kind positive transparencies (slides). But it was easy to use and became widely available to photographers of every stripe, including amateurs.[27]

The perfection and distribution of color processes accelerated after World War II. Kodak began marketing a color negative film in 1942, and Ektacolor paper for making color prints was released in 1955, allowing artists for the first time to control production of prints, such as those produced for exhibition. Polaroid upped the ante during the 1960s by introducing its first instant color film, Polacolor, followed by the popular SX-70, which appeared in 1972.[28]

Most art photographers before the 1970s remained skeptical of color processes on both practical and aesthetic grounds. The expense and time commitment associated with printing in color was enough to dissuade most—but this did not discourage the taking of color photographs for more experimental purposes. There was in fact fervid exploration of color among artists, particularly at the Institute of Design in Chicago, where professors such as László Moholy-Nagy, Arthur Siegel, and Harry Callahan (fig. 7) perpetuated the avant-garde spirit of the Bauhaus. For them, advocating experimentation with color materials was but one facet of a continuing investigation into all forms of industrially manufactured materials. The resulting images were generally considered studies and remained unexhibited except within the institution.[29]

There were also corporate schemes for placing color materials in the hands of respected photographers, mainly for the purpose of promoting sales among amateurs. Edward Weston was invited by Kodak in 1946 to photograph Point Lobos with daylight Kodachrome film, which produced 8 × 10–inch positive color transparencies. Weston accepted the invitation and went on to produce more images of his classic subjects, many of which appeared in Kodak advertisements for years after.[30]

Though it was widely repeated in 1976 that Eggleston's MoMA exhibition was the first endorsement of color photography at that institution, color photographs had been appearing at MoMA since the 1940s. Eliot Porter had been shown there in 1943 (fig. 8) and, not long after, color was launched in an ambitious way by Edward Steichen. Steichen, director of the museum's photography programming from 1948 to 1962, brought a populist attitude to his position, organizing large-scale exhibitions of press photography and other forms of commercial work alongside art photography. Steichen had himself explored color both as a painter and photographer, starting around 1900, when he practiced as a Pictorialist and protégé of Alfred Stieglitz. He continued to work between the world wars as a highly successful commercial photographer. While it is clear that Steichen hoped to attract a larger audience by displaying color photography—for its novelty, accessibility, and shock value within the museum setting—he also embraced the notion that color might well be photography's future as an artistic medium.[31]

8. Eliot Porter, *Pool in Brook, New Hampshire*, 1953. Dye transfer print, 10¾ × 8⅜ in.

Steichen's first show at the museum, *In and Out of Focus,* a broad survey of contemporary trends in photography, opened in 1948 and included what one reviewer called "garishly blown up experiments in color photography" by Weston, Ansel Adams, and several others.[32] Two years later, Steichen organized *All Color Photography,* a massive, chaotic show consisting of 342 photographs by 75 photographers, which included a few color works by Callahan and other art photographers mixed in with examples from industrial, governmental, journalistic, and amateur photography.[33] Despite Steichen's progressive and integrationist intentions, the show only emphasized what was commonly believed: color was a commercial and amateur medium not suitable for art. Subsequent shows featuring color, among them *Abstraction in Photography* (1951) and a solo exhibition of color photography by Ernst Haas (1962; fig. 9), fared little better. In both instances, Steichen took a more patrician tack, cleaving color photography from the usual commercial and amateur associations, while also emphasizing color's artiness when conjoined with abstraction. Critics pointed out that the color in these photographs associated the images more closely with painting and declared them simply derivative.[34]

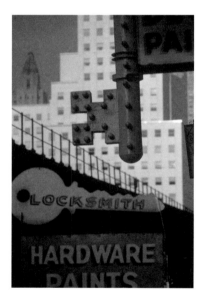

9. Ernst Haas, *Locksmith's Sign*, 1952. Dye transfer print, 20 × 16 in.

In the end, a century of art-photography tradition, which had defined itself largely against commercial and amateur uses and had honed its standards on an aesthetic of black and white, had formed a high wall of resistance to color photography and its attendant associations. For all Steichen's diverse efforts, color photographs—most commonly presented within the museum in expensive state-of-the-art commercial processes such as dye transfer and carbro prints—could only really be understood within a context of industrial design. Steichen's approach seems to have precipitated a reverse effect, creating an even greater chasm between what was considered serious art photography in black and white and examples of industrial design in color. Critics perceived a state of schizophrenia within the photography program, describing a "feeling of indecision" in the mixing of such works.[35] Szarkowski, Steichen's successor, would take a much more cautious approach in his handling of color. Such caution is nowhere more evident than in his hesitation to exhibit Eggleston, whose work Szarkowski had seen and wanted to exhibit in 1967; the pictures did not go up until 1976, a delay suggesting that color's maturation was more a matter of culture than technology.

"I sometimes visualize myself as a bizarre guerilla, investing in a kind of humorous warfare . . . but without consistent rationale."—Robert Heinecken[36]

"I had 36,000 postcards printed, convincing myself that a New York art audience would love to see the city of Amarillo as a Conceptual project."—Stephen Shore[37]

Insurgency and naïveté are two important elements in the seventies color photography story. Robert Heinecken became known during the 1960s as a "West Coast enfant terrible of photography" by challenging the medium's purity and confronting various social taboos in his imagery.[38] In college Heinecken had majored in printmaking but then, in a moment of academic musical chairs, became a professor of photography at UCLA, a position he held for thirty years. Heinecken became known in New York in 1970, when Peter Bunnell, a curator in the Photography Department at MoMA, included him in an exhibition titled *Photography into Sculpture*.[39] In that show, purist notions of photography were challenged through artworks that broke the illusionistic surface of the photograph, calling attention instead to photographs' status as three-dimensional objects. Heinecken's work consisted of a series of black-and-white photographs of nude women that were mounted to small wooden blocks, some of which resembled an adult Rubik's Cube.

Most of Heinecken's work of the 1960s was monochromatic, comprising layered images—some based on his own photographs, some appropriated—of tangled, orgiastic nudes devoid of any obvious political or social content. Starting in the late 1960s, Heinecken shifted his attention to print media, beginning an obsessive, extended, symbolic assault against the blandly colorful and contented façade appearing in the mainstream media—the truth was different. By that time, the Vietnam War had escalated to intolerable proportions, with more than 30,000 American soldiers dead during the Johnson administration alone, prompting regular protests against the administration.[40] Meanwhile, the culture was breaking apart. Essayist Joan Didion reported from L.A. that "The center was not holding":

> It was a country of bankruptcy notices and public-auction announcements and commonplace reports of casual killings and misplaced children and abandoned homes and vandals who misspelled even the four-letter words they scrawled. It was a country in which families routinely disappeared, trailing bad checks and repossession papers. Adolescents drifted from city to torn city, sloughing off both the past and the future as snakes shed their skins, children who were never taught and would never now learn the games that had held the society together. People were missing. Children were missing. Parents were missing. Those left behind filed desultory missing-persons reports, then moved on themselves.

> It was not a country in open revolution. It was not a country under enemy siege. It was the United States of America in the cold late spring of 1967, and the market was steady and the G.N.P. high and a great many articulate people seemed to have a sense of high social purpose and it might have been a spring of brave hopes and national promise, but it was not, and more and more people had the uneasy apprehension that it was not. All that seemed clear was that at some point we had aborted ourselves and butchered the job.[41]

Heinecken sometimes described himself as a "paraphotographer" and, later, a "photographist," suggesting a real commitment to the photographic image but at one or two steps remove.[42] Although he sometimes took pictures, Heinecken's real interest lay in photography's mediation of the world—its role in the mass media as a ubiquitous force, shaping, normalizing, and distorting political and social values.

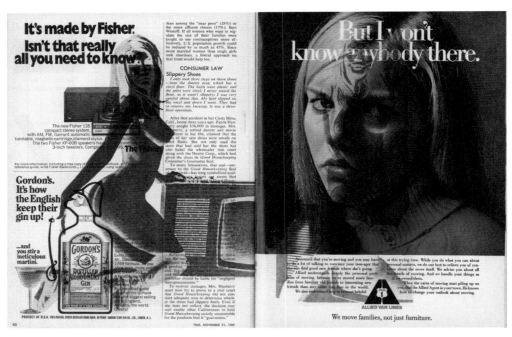

11. Robert Heinecken, *Untitled* ["But I won't know anybody there"], spread from *Time, 1st Group*, 1969.
Offset lithography on magazine

In that sense, his interest in photography was similar to that of Andy Warhol, Robert Rauschenberg, and John Baldessari. If the differences seemed merely fractional (Szarkowski wrote in 1978 that Rauschenberg's prints "absorb photographs" while Heinecken's maintained a "stubborn, gritty precipitate of fact"),[43] the matter was more clearly settled by the artist himself. Despite his involvement with mixed media, appropriated imagery, and the early propagation of postmodern ideas, Heinecken steadfastly identified with photography, exhibiting his work in photography galleries, such as Witkin and Light, throughout his career—this decision in and of itself a form of guerilla warfare, a challenge to the institution of photography from within.[44] Heinecken's influence was profound, particularly during the early 1970s, and his style was much imitated, yet few of his art-photography colleagues seemed to harbor the depths of rage over American culture that fueled his best work.[45]

Heinecken's magazine page interventions have the feeling of a man at war in his own culture, shooting repeatedly at only vaguely identified targets. The fashion pages, which Heinecken overlaid by the thousands with an image of a South Vietnamese soldier clutching two severed Vietcong heads (fig. 10), produce the literal effect of an attractive and wholesome society hemorrhaging with violence. Heinecken chose pages with provocative images and slogans—"Freedom," "The glare-killers are man-killers now," "This is the way Love is in 1970"—leaving the placement of the gruesome image on the page to chance.[46] The blotching and streaking of the crude lithography over the slick color imagery added another layer of violence to the image. In the reconfigured magazines (fig. 11), Heinecken inserted images of pornography for similar effect, and in one recorded instance escalated the work to a guerilla-like action, making off and returning to the newsstand with a bundle of magazines, freshly printed with violent and sexual imagery, for some unsuspecting buyer to discover.[47]

A. D. Coleman identified Heinecken's layered pornographic images as "sardonic satires of a deranged society whose anti-eroticism and sexual hysteria (as reflected in the original source of the imagery) is a perfect metaphor for its sterility and degeneration," yet he went on to note a transcendent beauty and

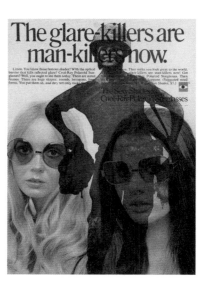

10. Robert Heinecken, *Untitled* ["The glare-killers are man-killers now"], c. 1970. Offset lithography on magazine page

"tangible lyricism" in the finished product.[48] Such lyricism and humor is distinctly evident in *TV/Time Environment,* an installation work from 1970, consisting of a black-and-white positive transparency of a woman's torso attached to the screen of a functioning color television. Here the flickering patterns of the broadcast and the fleeting, chance alignments—sometimes comical, sometimes vulgar—of the two images result in a dynamic exchange between mass culture and sublimated libidinal impulses. The work was intended to be both political and absurd. As it was installed in the Pasadena Museum in 1972, *TV/Time Environment* carried a precise political message (fig. 12). The assembled room, with "funky wallpaper and plastic poinsettias," contained a magazine depicting Vice-President Spiro Agnew on the cover; also present was an Agnew mask. "The idea was that the viewer would put on the mask, read the magazine and watch TV; some sort of triangulation would occur," Heinecken later related. "This, of course, was at the time when Agnew was very critical of the media."[49] (Agnew would resign in a tax scandal in 1973, giving Heinecken a triangulation of sorts.)

In its overt social and political engagement, Heinecken's work was very much of its time and, at least in spirit, not so unlike the "concerned" black-and-white photography of the moment. Aesthetically and attitudinally, of course, the work was entirely different. Bold, provocative, at times offensive, Heinecken's collages and installations were intensely ironic, questioning in dada-like fashion (Heinecken was a great admirer of Duchamp) the sanity of rational society.[50] In this context, the color photograph, taken directly from advertising and entertainment, is convulsed, as Heinecken, through a series of manipulations, invests what was assumed to be apolitical—color photographs of fashion models and mundane television programming—with barbed political content. Heinecken's work is important as it reveals both the political urgency of the early 1970s and color photography's seeming inadequacy to address this urgency, except in some highly elaborated form.

During this same period, Stephen Shore was in New York, hatching a scheme to launch himself as a conceptual photographer. Shore was twenty-four, self-taught, and had spent the last several years loafing around the Factory, photographing Warhol and his coterie.[51] From Warhol, Shore absorbed an attitude of detached irony toward the world as well as an appreciation for consumer culture and the mass-produced. Shore's interest in conceptual art was sparked around this time by an encounter with Ed Ruscha's book *Every Building on the Sunset Strip* (1966); Shore immediately bought all of Ruscha's books, in which the dullest of documentary pictures were deployed in service of a larger serial idea.

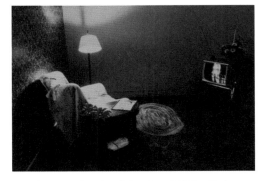

12. Robert Heinecken, Installation view of *TV/Time Environment,* 1970, with artist's description: "Life-size functioning commercial television set; positive transparency superimposed; related magazine"

Shore's proven skill as a photographic formalist, evident in his black-and-white Factory pictures as well as his later classical color photographs of the 1970s, cast his work of around 1970 in a curious light. Following an exhibition at the Metropolitan Museum of Art, in which Shore exhibited black-and-white conceptual photographs à la Douglas Huebler, Shore embarked on a series of willfully inartistic projects, all based around the notion of vernacular photography.[52] First Shore curated an exhibition of found photographs at Holly Solomon's 98 Greene Street Loft. Titled *All the Meat You Can Eat,* the show was made up of snapshots, photo-booth portraits, newspaper photographs, and police mug shots. The show got a review from the *New York Times,* where Gene Thornton described the selection as a "healthy, if possibly somewhat unwelcome, reminder of the part that photography really plays in the world."[53]

Like Heinecken, Shore was tuned to the significance of popular imagery and sought ways to bring this to bear on art photography. Whereas Heinecken intervened in the photograph to control its rhetorical purpose, Shore adopted a more deadpan approach. Rather than appropriating imagery, Shore appropriated genres. In the summer of 1971, Shore made a trip to Amarillo, Texas, to visit friends. With Ruscha in mind, Shore decided to produce a series of postcards depicting ordinary Chamber of Commerce-type

locations around the city. He photographed the sites himself—plain buildings and intersections—in a blunt and unimaginative way, but now in color, as per commercial convention. Having selected ten images, Shore employed a large commercial postcard printer to produce the series, complete with generic captions: "Polk Street," "American National Bank Building," "Double Dip/1323 S. Polk" (fig. 13). When they came back, Shore was amused to discover that the colors had been intensified—grass was very green, skies were very blue. "They are the pros. They know how postcards should look," Shore later commented.[54] Shore had hoped to sell the series, which he titled Amarillo—"Tall in Texas," through Wittenborn bookstore, in New York, but none were sold so he deployed his own guerilla tactics, slipping the cards into postcard racks at tourist sites during subsequent trips across the country.[55]

13. Stephen Shore, *American National Bank Building*, from the series Amarillo—"Tall in Texas," 1971. Postcard

Following a period of experimentation, taking snapshots with a cheap camera in the shape of Mickey Mouse's head called the Mick-o-matic, Shore decided to expand his purview on the vernacular genre by making a road trip in the style of Robert Frank, who had, in the 1950s, inadvertently established this activity as a rite of passage for future generations of photographers. Frank's photo essay, published in 1959 as *The Americans,* was a grainy, existentialist view of America that garnered much negative critical attention in the press as well as cultish admiration, especially among younger photographers.[56] Frank worked in black and white, "the alternatives of hope and despair"; Shore worked in the common palette of the Kodak drugstore print, suitable for the tawdry surfaces—the American surfaces—he would encounter in diners, motels, and gas stations along the way. Yet Shore and Frank shared one thing in common: an understanding that the sum total of their series was a personal portrait as much as it was a public exposé. Here again was that modernist fusion of documentary intent and individual subjectivity, public truth and private expression, which still defined art photography in 1972.

14. Stephen Shore, *Oklahoma City, July 1972,* from the series American Surfaces, 1972. Inkjet print after commercially processed chromogenic print

Shore, it is often noted, turned his camera away from the obvious sites—the monuments, natural features, and odd occurrences—one normally expects to see among batches of tourist photographs, documenting instead his own personal space: beds, toilets, plates of food, service staff. Shore's direct, frontal style, particularly noticeable in his images of architecture, was in conscious emulation of Walker Evans (whose work Frank had also admired), as was a certain ironic regard for his subject matter. This attitude, in Shore's case, was also an expression of Warhol's phrase, "I like boring things."[57] For Shore was not so much neutral toward his surroundings—not detached like Evans and detached as Shore himself would later become—as he was appreciative. Shore described his encounters with driveways and Formica counters: "I was just really amazed by all these things I was encountering—what my motel looked like, and what the food looked like."[58] The resulting series had a quirky affection for the garishly artificial jungle of American life, with even a kitsch sunset appearing here and there over a gas station, enhancing a dry sense of romance (fig. 14). It was often the disparity between the affectations of cheap decor and the earnest efforts to put on a front depicted in Shore's democratic, non-hierarchical photographs that struck a chord. Kozloff described the world depicted in Shore's images as "a much less heroic and monumentalizing culture, whose highbrow tastes and lowbrow motifs coexist very well."[59] The layout for Shore's show at Light Gallery in the fall of 1972 had a similar democratic feel. All 312 of the 3 × 5 inch drugstore prints were glued to the walls in an even grid, three pictures high, running end-to-end, in no particular order. The effect was so underwhelming, "like colored wallpaper," no one seems to have reported on this legendary show and no installation views survive.[60] If Heinecken was of his time, Shore was ahead of his. None of Heinecken's artistry or interest in politics is present in Shore's series, which offers instead a casually unengaged, ambiguous view of American culture. This attitude would become increasingly and controversially identified with color photography of the 1970s.

"Photography dumbed color to down to emotional button pushing—blue for cool, red for warmth. Faced with this, I felt, as Winogrand put it, 'at war with the obvious.'"—Mitch Epstein[61]

In a 1969 essay on photography, Walker Evans wrote: "There are four simple words for the matter, which must be whispered: Color photography is vulgar."[62] A Francophile, Evans no doubt intended "vulgar" in the French sense, meaning "popular," as well as "in bad taste." Evans was targeting both commercial and amateur applications of color—advertising, fashion, *National Geographic*–style travel pictures, postcards, and family snapshots—but his pronouncement applied to the aesthetic character of the pictures as well. As in Shore's postcards, the colors appearing in vernacular images were altered, intensified. This was due in part to technical imperfections both in the color processes and in their translation into print, but the effect was often intentional; colors were punched up in order to generate a hyperreal vision of products, clothes, and faraway places that appealed to conditioned consumers. Such images could be flagrantly sentimental, garish, and kitsch. Critic Bruce Downes praised fashion photographers John Rawlings, Irving Penn, and Cecil Beaton for "deliberately exploiting the defects of the color process."[63]

By the early 1970s, and in the right hands, such technical problems were diminished to the extent that the accuracy of the color in photographs could no longer be seen as the issue blocking color's potential for artistic expression. Indeed, that accuracy, which increasingly lent photographs a greater sense of naturalism and transparency, became a new issue altogether, in that photographs no longer seemed to mediate the world in a pronounced and obvious way. Just as black and white had transformed the visible world into a monochromatic field of darks and lights, signaling an image of documentary and/or artistic intent, exaggerated colors had produced a similar transformation, distilling a "colorized," make-believe version of reality much like the one Hollywood, TV, and ad agencies had been disseminating for some time.[64]

The more naturalistic the color in photographs became—the more the divide closed between the color the eye saw and the color the film yielded—the more the experience of looking at a photograph became like looking through a very clean picture window. In short, there was nothing to see but the subject itself; the presence of the photographer had become harder to detect and the meaning of the photograph harder to discern. Defending Stephen Shore's later, large-format work, which some saw as "empty" or "banal," John Szarkowski explained, "There is nothing, or very little, in Stephen's pictures that reminds you of the artifice, of the method of making the picture. There is no grain in the film to establish the surface of the picture, no visible lighting. . . . Type C prints [chromogenic prints] are so *immaterial*." Szarkowski concluded, "A Shore picture is very classical in spirit, very quiet, very poised Not boring, not empty—but suspended."[65]

The immateriality of the color photograph, along with its association with commercial and vernacular forms, posed certain challenges for artistically minded photographers but also opened up new avenues for rethinking photography. How might the "new realism" proposed by color photography suggest new ways of relating to contemporary life? While some saw color, especially at first, as just another layer to be integrated into the formal structure of the photograph, others saw in it a democratic attitude, an aesthetic of the ordinary and the everyday. In the most skilled hands, color photography became useful in two distinct ways: as both a means of describing the immediacy of mundane experience and, in its resemblance to the fantasy world projected by the mass media, a way of acknowledging the creeping influence of mass culture on individual perception and the nature of representation itself. Color pho-

tography became both a means of ennobling the ordinary and recognizing the disparities between media-generated fantasies and everyday life during the 1970s.

Evans's photographs, in their detached irony and lack of evident style, became a major influence on 1970s color photography, and the second part of his statement on color is more prescient than the first: "When the point of a picture subject is precisely its vulgarity . . . then only color film can be used validly."[66] Now here was an idea to grab onto. Evans may have had in mind Garry Winogrand, whose mannered, often comica work Evans was known to dislike.[67] Winogrand had appeared recently, in 1967, with Diane Arbus and Lee Friedlander in Szarkowski's important exhibition *New Documents*, which attempted to define a new personal documentary style.[68] In that show, Winogrand's color photography made a rare and brief appearance (fig. 15).[69] While the show also included Winogrand's black-and-white photographs, which were shown as standard prints, his color pictures were exhibited by slide projection, at that time a common, economical (and certainly non-committal) method for the display of color works.[70] Winogrand's seemingly reckless, snapshot-like "documents" of American public life—captured on streets, in airports, at tourist sites, political rallies, stockyards, and amusement parks—appeared to present an undiscerning, casually unmediated view of American consumer culture. The Kodachrome slide film Winogrand used to make these pictures was no different than that used by common amateurs. What most critics did not quite discern was a self-reflexive attitude; for Winogrand, an industrially manufactured color film mimicked to perfection the industrially manufactured colors of clothes, automobiles, and paint colors the film recorded. As in Shore's early work, Winogrand's color photographs had self-consciously adopted the vulgar aesthetic of their subjects.[71] And in color, the pervasive ambiguity in Winogrand's work—embodied in his often-repeated statement, "There is nothing as mysterious as a fact clearly described"—was more exposed.[72]

Despite the low visibility of Winogrand's color work, the photographer may be seen as a significant figure in relation to New Color. Winogrand's style was readily and controversially associated with vernacular photography, in particular the haphazard snapshot style of unskilled amateurs; in art circles this became known as the "snapshot aesthetic."[73] Winogrand also approached color as just another descriptive element, which differed radically from the use of color by commercial photographers and other art photographers, who often sensationalized color (critic Max Kozloff called Ernst Haas a "Paganini of Kodachrome").[74] In Winogrand's hands, this brought the image even closer to the limits of a recognizable art photograph, further eroding and trivializing any evidence of style or content. Winogrand skated so close to the edge of photographic intelligibility, his attitude toward the medium and its traditions could at times seem nihilistic. Commenting on one photographer's work, Winogrand paid the compliment: "That's just beautiful. That's really a picture of nothing."[75] Such comments earned Winogrand a reputation as a sort of formalist on the brink when in fact the attitude demonstrates a hunger for unembellished realism and an attendant ambiguity, not unlike Shore's. Yet Shore very consciously situated the color photograph within the framework of a conceptual art strategy, identifying color art photography with vernacular modes and, by extension, ordinary experience—he made color comprehensible by relating it to non-artistic color forms that were already understood. Winogrand, by contrast, saw color as an extension of black and white, as another technical and aesthetic challenge to be "pushed through." (Interestingly, Shore would gravitate toward this same perspective soon after.) Color aesthetics were something to be absorbed into modern photographic tradition, not the basis of a revolution.

15. Garry Winogrand, *Lake Tahoe*, 1964. Chromogenic print, 11 × 17 in.

Perhaps most importantly, Winogrand was a charismatic teacher, and his classroom at Cooper Union became a laboratory of sorts for students interested in color. Although Winogrand was apparently reticent about sharing his own color work, he often brought in color photographers to speak as guest

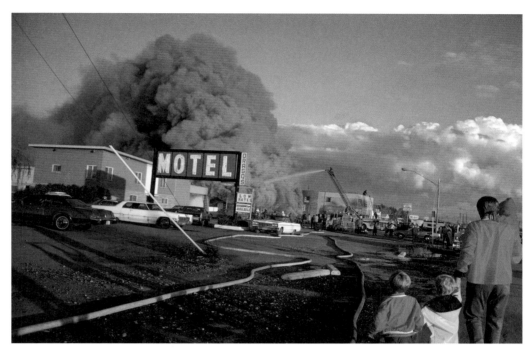

16. Mitch Epstein, *Tonawanda, New York*, 1974. Dye transfer print, 16 × 20 in.

17. Helen Levitt, *New York*, 1980. Dye transfer print, 12 × 18 in.

lecturers; William Eggleston visited Winogrand's class several years before his work became known at MoMA.[76] Mitch Epstein, who was Winogrand's student during the early 1970s, recalls, "Winogrand taught me to think of color as an integral element of a picture. We rarely discussed color in separate terms."[77] Epstein's early work in particular bears a strong resemblance to his teacher's, in the tilting horizon lines and attention to odd and ambiguous events (fig. 16). His later work of the seventies shows development away from Winogrand's so-called snapshot style toward a grander, more stable picture, one bordering on theater, in which the narrative potential of happened-upon scenes is heightened through strong lighting and elevated perspective (see plate 51). Such techniques lent a tableau quality to the pictures, veering at times toward the cinematic, and indeed Epstein acknowledges influences ranging from Edward Hopper to Michelangelo Antonioni.[78]

One of the earliest bodies of color street photography to be exhibited in a prominent way was by Helen Levitt, another artist who shared Winogrand's view of color as an element to be integrated into monochrome traditions. Levitt had established a career as a social documentary photographer in black and white with a series of sensitive views of street life taken in poor neighborhoods of Manhattan during the 1940s.[79] She began photographing in color in 1959 but lost that work to a burglar a decade later. Starting again in 1971, Levitt made a series of Kodachrome slides, forty of which were shown as a continuous slide projection at MoMA in 1974. In the press release for the exhibition, curator John Szarkowski described Levitt's work as the simple reporting of "routine acts . . . full of grace, drama, humor, pathos and surprise," and he went on to compliment Levitt's restrained use of color, noting that it was "neither decorative nor . . . purely formal."[80] Levitt's color was indeed highly effective as an additional descriptive tool, allowing her to reveal the contrast between the dark tenement buildings and the lively patterned clothing of the neighborhood's inhabitants—who appeared as dragonflies "caught between bundles of black plastic trash," one critic aptly noted.[81] Here the expressive potential of color fused perfectly with the photographer's content, for Levitt had long been transfixed by the disparity

between grim environments and the human life seen to thrive there, revealed especially in the play of children. Although the slide projection format was chosen for practical and economic reasons (color prints were expensive to produce), the effect seemed to replicate the glancing regard of the artist, catching glimpses of gesture and color at every turn.[82] A filmmaker with a background in editing, Levitt cued two instances of "jump cuts" in her sequencing, which show variants of the same scene involving a woman and girl—one inside and one outside, both lost in thought—in quick succession (see plates 55–56). Levitt continued to photograph in color after 1974, producing some of her best work over the next decade (fig. 17).

Seriality, series, and sequences became increasingly common during the 1970s, filtering in through art practices of the 1960s and film as well. The adoption of these modes in photography signals a shift in attitudes toward the documentary image as a single, stable point of view proffering one summational moment. In other words, there was by the early 1970s a healthy skepticism toward the notion of a whole self and a decisive moment.[83] Series and sequences opened time up, acknowledging meaning as transitory and fleeting.[84] Like Shore, numerous photographers began applying seriality to personal subjects, turning away from the great humanist themes—war, poverty, social injustice—that photography had once treated toward a search for meaning that was more personal, open-ended, and ambiguous. As a potentially transparent medium with personal and sentimental associations, color photography was ideally suited to this type of exploration.

Joel Meyerowitz started a series in the 1960s he would eventually title From the Car (fig. 18). Begun during a driving trip across Europe, the series was a kind of European vacation version of Shore's American Surfaces, yet conceived in transit, as a personal, offhand, casual exercise in vision, carrying with it a sense of wonder over both the act of looking and the world "out there."[85] Continuing the series at home, the artist conceived of his pictures as something between a tourist snap and an artist's sketch. Meyerowitz was a highly accomplished color street photographer in the style of Winogrand by the mid-1970s. In that body of work, Meyerowitz honed a nervous skill of filling every inch of the frame with balanced and dynamic formal elements, all the while consciously attempting to "give up the catch for more description."[86] Meyerowitz's car pictures, by contrast, offer a quick and disorganized assessment of their subjects, replicating nothing but instantaneous regard of a striking, often enigmatic vision. Black-and-white prints from the series were exhibited at MoMA in 1968, in a show titled My European Trip, but Szarkowski, its curator, had seen Meyerowitz's color slides and must have had these in mind when he described the work in the wall text as "a succession of kaleidoscopic glimpses, unconnected and unexplained and unconsummated."[87] The systematic nature of the series presaged Meyerowitz's work of the late 1970s, in which he applied the same structure—but at a fundamentally slower pace—to landscape and portraiture

An easy way to explain the use of the sequence was to characterize it as a classic avant-garde rejection of the previous generation. In this case, Henri Cartier-Bresson was the academy. One young reviewer juxtaposed Cartier-Bresson, whose perfect formal compositions "presupposed a stable self confronting a world in flux," to Eve Sonneman, who presented pairings of indecisive moments that made her into "a participant in the disorder and randomness she records."[88] Sonneman's work garnered a lot of attention during the 1970s within the general art establishment as it seemed the visual equivalent of a humanities-wide interrogation of the mechanics of narrative, which was the intellectual equivalent of the slogan "Question Authority."[89] Sonneman, who had been interested in the sequences of Minor White in college, began making diptychs in black and white during the late 1960s.[90] Those pictures demonstrated a greater interest in social life than her later color work; moreover, the time span between moments was

18. Joel Meyerowitz, *From the Car, New York Thruway*, 1973. Chromogenic print

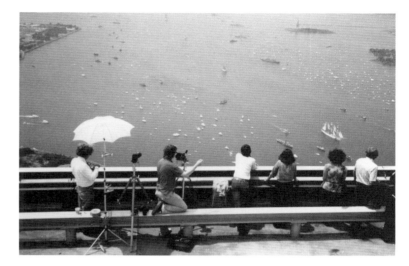

19. Eve Sonneman, *July 4, 1976*, 1976. Two Cibachrome prints, each 8 × 10 in.

much shorter, offering a greater sense of the cinematic jump cut.[91] By the mid-1970s, Sonneman had justifiably moved to color, reasoning that it represented more closely the way the world was actually perceived.[92] One effect of that decision was to align the diptychs more closely with European avant-garde cinema as well as tourist snapshots and postcards. Sonneman's photographs of classic foreign sites, such as the Parthenon, and even pictures of New York, such as those taken atop the World Trade Center (fig. 19), reveal an inherent duality in lived experience. They suggest on the one hand a scripted, packaged experience, informed by conventions of cinema and tourism, and, through the addition of a second image, something much more nuanced, fleeting, and personal.

A more regimented approach to the use of series may be seen in the group portraits of Neal Slavin (fig. 20). Slavin won an NEA grant in 1973 to explore color through a series he dryly titled "Group Portraits of American Organizations." Slavin's project, carried out across the country during Watergate and the beginnings of Nixon's impeachment proceedings, seemed to be asking the question on many people's minds: Who are we, the American people? "I envision a work that communicates the desire to belong in America in the mid-1970s and the conflicts caused by that wish," Slavin wrote. "In short, I want to photograph groups—they are the American icon."[93] A successful commercial photographer, Slavin applied a slick professional color vocabulary to his images. Yet instead of posing his subjects, he asked them to pose themselves, reasoning, "no outsider knows the status and rank of each individual as well as the membership does."[94] Slavin's work received a lot of attention in the art world and popular press as a deadpan stunt, framed as a serious social experiment, that had surprisingly insightful results. Slavin's portraits of what one reviewer called "bizarre and off-putting groups"—Lithuanian scouts, lady wrestlers, mummers, and Star Trek conventioneers—revealed an irrepressible individualism and poignancy in the members' palpable desire to belong.

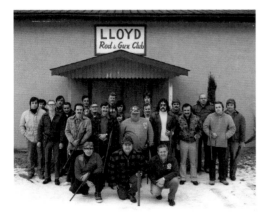

20. Neal Slavin, *Lloyd Rod and Gun Club, Highland, New York*, c. 1976. Chromogenic print

A private exploration of what critics called the "social grotesque" may be seen in mid-decade work by Les Krims.[95] Krims began experimenting with the Polaroid SX-70, a basic picture-making system that captured the attention of many artists ranging from Walker Evans to Lucas Samaras, soon after the technology became available in 1972. A self-developing system producing a unique image instantaneously, the SX-70 seems now the perfect complement to the Sexual Revolution (SeX-1970) and indeed seems to have invited a variety of private uses.[96] Krims had established a reputation as an imaginative provocateur with various series of staged photographs, such as *The Incredible Stack O'Wheats Murders*

(1972), which depicted beautiful slain women, nude, in a style somewhere between police forensic photography and *Playboy* magazine. In 1974 he began making his Fictocryptokrimsographs (fig. 21). The "Fictos," as the name implies, were fictional, cryptic documents of scenes springing from Krims's own imagination. As with Heinecken's treatment of pornography, Krims applied a light, absurdist touch. The Fictos don't set out to shock so much as they attempt to poke fun at the notion of a rational society. The "directorial mode," as it was called, is applied here to the staging of pseudo-scientific experiments—*Bubble Gum Test; Optical Illusion; Pencil Test #7; Magnified Heat Sources*; the results are provocatively inconclusive.[97] The Polaroid could be manipulated during development by pushing the pigments around with a stylus, allowing the artist to create patterns and distortions, thus interfering with the documentary character of the photograph. In a 1975 publication of this work, Krims described the process as "a totally integrated mind-machine-hand generative system."[98] To some works, Krims added an additional decorative and obsessive touch by painting the borders with psychedelic patterns, escalating the sense of fantasy. Krims has talked about the personal nature of his images and the role they played in his sense of himself in the world: "There's certainly a sense of satire and irony in many of them, even a vengeful and aggressive tone; I don't like to admit that, but it's true. I react strongly to events in my life and in the world, and the pictures are meant to be as forceful as I can possibly make them."[99]

A photography professor since the 1960s (counting Cindy Sherman among his students), Krims brought an attitude of conscious irreverence to recent photographic traditions.[100] Although artists had constructed scenes to be photographed from the beginning of photography's history, modernist photography, with its basis in documentary, held such actions to be "impure."[101] Thus the legions of artists who began constructing images, both in and out of the studio, during the mid- to late 1970s were often seen as radical in their approach. Many such artists, including Sherman, split off to produce work in other art discourses; others remained within the photography community, introducing artifice as a new reference point for art photography.

A last vestige of social photography may be seen in an early series by Joel Sternfeld (fig. 22). Printed within visible black borders, these photographs of anxious, self-absorbed citizens look like stills from a television news broadcast—or, perhaps, an art video of a television news broadcast.[102] Just as occasional blurring in the pictures suggests a constant stream of movement, Sternfeld's use of strobe lends the images a heightened sense of artifice and spatial disorientation, an effect Sternfeld equated with a "feeling of malaise characterizing American life in 1976."[103] The strobe also intensified the color. An admirer of Levitt's color work, exhibited at MoMA two years earlier, Sternfeld was similarly compelled by the idea of a historical sense of color. Of this series, he has said, "In the summer of 1976 one could see a dazzling color phenomenon—a day-glo, acrylic palette non existent before this decade. Studies in the physical and perceptual properties of color quickly formed and dissolved as intersections were crossed and commuter trains caught."[104] Sternfeld's purpose was similar to Levitt's in that he sought to capture a sense of grace and gesture in the loosely choreographed movements of pedestrians. Yet here color is politicized, noted and emphasized by the photographer for the worry it cannot quite conceal.

As the seventies progressed, a growing sense of nostalgia and an aversion to large social and political concerns becomes evident in diverse bodies of work. Certain artists, such as William Christenberry, began a searching investigation of their immediate environments, following the trail of ancestors and attachments like exiles in their own backyards. Christenberry took up color photography quite naively and for practical reasons. Salvaging a primitive Brownie camera from his parents' closet, he used it to record landscapes and buildings as aides-memoires for his paintings—color suited his purposes. But the 3 × 5 inch prints he got back from the drugstore, with their blurred outlines and strange colors,

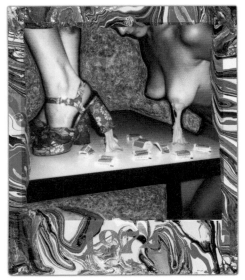

"Bubble Gum Test, 1974."

21. Les Krims, *Bubble Gum Test*, 1974. Inkjet print after unique Polaroid 5 × 3 ¼ in.

22. Joel Sternfeld, *New York City, 1976 (Park Avenue?)*, 1976. Chromogenic print

began to take on a life of their own, evincing a sense of loss, memory, imagination, and degradation, exactly the themes Christenberry was exploring in his paintings of gravesites and jerry-built houses in the South.[105]

Christenberry had met Walker Evans in New York in 1961 and showed him his paintings and photographs. He had long admired Evans's work, particularly his photographs appearing in *Let Us Now Praise Famous Men* (1941), produced with James Agee and based on sharecroppers in Hale County, Alabama, where both sets of Christenberry's grandparents had lived. People Christenberry knew as a child appeared in the book. Christenberry was fascinated by the documentary aspect of the work—both in the writing and the photographs—and decided to extend this project, traveling to Hale County each summer to record the fading vernacular architecture of the region. Throughout the 1970s Christenberry returned to the same sites, documenting with uninflected frontality certain buildings that spoke to him—Coleman's Café, the Green Warehouse, the Palmist Building (fig. 23)—sometimes stealing an old metal sign or two.[106] Christenberry's small-format photographs have a miniaturizing effect, making the buildings pictured look like small sculptures. He in fact made sculptures of these buildings based on the photographs, replicating the textured surfaces and other defects to perfection. The artist flummoxed critics with the first New York show of this work—three sculptures and approximately seventy photographs—at Zabriskie Gallery in 1976. "The sense of artlessness is very strong" . . . there is a "lack of a clearly defined point of view" . . . "they are almost irritatingly ambiguous"—the comments applied to sculpture and photographs alike.[107] Yet in some instances, the artist's purpose came through: "Christenberry's self-effacing fixation on his low-key material gives it an almost paradoxical monumentality."[108]

The opacity of Christenberry's work for critics at the time reveals the extent to which the art-documentary tradition of Evans and others was still very much alive during the mid-1970s. Christenberry had claimed Evans's subject matter but drained it entirely of any political content. Where Evans had shown the human face of the Great Depression, Christenberry projected a personal history, confounding ex-

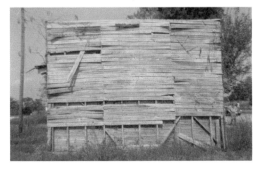

23. William Christenberry, *South End of Palmist Building, Havana Junction, Alabama (Walker Evans to right)*, 1973. Ektacolor print

pectations. Christenberry had also eliminated any sign of pictorial rhetoric from his imagery. There was no intervention into the image—none of Heinecken's hand manipulation, or any sign of Krimsian staginess, not even any evident lighting effects, as Sternfeld had used—to show his intent. He did not arrange the pictures in series, as had Shore, Levitt, and Sonneman, nor did he structure the work around a declared formula, as had Slavin. He did not even offer a nod to the pictorial conventions of social photography, as had Winogrand, Epstein, and Meyerowitz. What he presented instead was a photography of ambiguity, imbued with private meanings and personal associations, bordering on decadence in its insistent nostalgia. Such characteristics were scandalously evident in an exhibition of photographs by Christenberry's friend, Bill Eggleston, also on view that summer of 1976.[109]

"When people ask me what I do, I say that I'm taking pictures of life today."—William Eggleston[110]

William Eggleston had shown his photographs to Szarkowski in 1967 and the curator proposed an exhibition. The show would not happen for another nine years, posing one of the most intriguing paradoxes of seventies photography: much of the body of work most closely associated with 1970s color photography was taken during the late 1960s (fig. 24).[111] Eggleston was eager for his pictures to be known but Szarkowski urged patience. Whether Szarkowski felt Eggleston's work was not sufficiently developed or that MoMA's audience was not ready for his quietly incisive color photographs is not clear.[112] Over the next several years, Eggleston continued to photograph in and around the towns of the Mississippi Delta, documenting family and friends as well as tract houses, parked cars, cemeteries, suburban children, shower stalls, plates of food, domestic interiors, bare light bulbs, shoes under beds, open fields, and downtown buildings around the region. For unlike Christenberry, who focused exclusively on evidence of the past, Eggleston also faced the future. He was uncomfortable with it, in fact, and so pressed himself: "I began to go out to places that were to me either foreign or confusing or ugly, or many different adjectives."[113] He visited shopping centers and treeless housing developments, photographing bare dirt, trash, tricycles. He photographed broadly yet within the narrow purview of his native region, confirming what he knew and acknowledging what he had not previously known. His critics would later fault him for trendiness, for capitalizing on the "pop syndrome," Photo-Realism, and "snapshot chic," not buying that these were just pictures "about the photographer's home, about his place . . . one might say about his identity," as Szarkowski explained in the show's catalogue.[114] People cried emperor's new clothes over MoMA's Eggleston show, implicating Szarkowski as well. Something about it viewers could not see or simply refused to see.

All of the photographs selected for the "most hated show of the year" were taken in the period just after Szarkowski's endorsement, between 1969 and 1974, and nothing past 1971 was selected for the catalogue.[115] Eggleston allowed Szarkowski to do the bulk of the editing. Szarkowski and Eggleston sorted through hundreds of slides, from which the curator chose seventy-five for printing in the dye transfer process.[116] Eggleston had settled on this process two years earlier, choosing to exhibit dyes for his first exhibition at Jefferson Place Gallery in Washington, D.C. Also that year, Eggleston published a portfolio titled *14 Pictures*, which included *Memphis*, depicting a variety of plastic toy animals (see p. 37) and *Memphis*, a photograph of a gravestone marked "Father" (see plate 125), using the expensive commercial process.[117] Dye transfer prints, which were until that time strictly associated with advertising, were intensely saturated and could look garish. From the artist's perspective, there was a great benefit in that the process could be controlled, allowing adjustments to color at various stages.[118] Eggleston was temperamentally passive, both in the editing of his own work and in relation to his photographic subjects, but he insisted on dye transfer prints. Dye transfer rode a line between garishness and lyricism, depending on what was pictured, and this ambiguity served Eggleston's interests in a profound way:

24. William Eggleston, *Memphis*, c. 1969–70. Dye transfer print

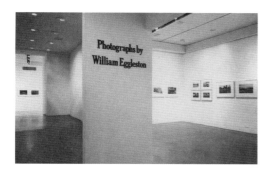

25. Installation view of the exhibition *Photographs by William Eggleston*, May 24, 1976 through August 1, 1976, the Museum of Modern Art, New York. Photographic Archive, The Museum of Modern Art Archives, New York

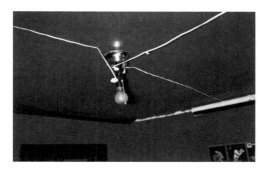

26. William Eggleston, *Greenwood, Mississippi*, 1973. Dye transfer print

the effect was noncommittal, expressing by turns irony and sincerity and often shades of both. Eggleston's reluctance to take a position in regard to subject matter—his refusal to declare a clear attitude toward Southern contemporary life or his own—revealed a palpable apathy, a sense of decadence, that shocked many Northerners when the work was shown. It is impossible to know what Szarkowski saw in the pictures in 1967 but by 1976 this constellation of truths about Eggleston had no doubt become evident. What's more, the attitudes expressed in Eggleston's photographs had aligned with the times. Nixon had resigned in 1974, the stock market crashed in 1975, and inflation was at 12 percent. In Szarkowski's eyes, Eggleston was now ready for a show.

Photographs by William Eggleston opened in May 1976 and ran until August 1 (fig. 25). The walls were white and the frames minimal; pictures hung in straight rows, sometimes paired or grouped according to orientation, size, and subject matter. The exhibition was considerably different from *The Guide*, MoMA's first catalogue devoted to color photography.[119] *The Guide* comprised just forty-nine photographs (counting the tricycle on the cover) and included numerous pictures that were not in the exhibition, such as *Memphis* (see plate 123), *Greenwood* (see plate 127), and *Sumner* (see fig. 1). The exhibition included many photographs not in *The Guide*, some of them unforgettable, yet among them was *Greenwood, Mississippi*, better known as the *Red Ceiling* (fig. 26), which hung next to *Memphis* ("Father"), also not included in the book.

To walk through the installation views today is to confront a very different idea of the Eggleston known from *The Guide*. The first thirty or so pictures flow like a condensed version of the book, offering a sense of home (and the vague sense of frustration one often feels at home) in images such as *Tallahatchie County*, which depicts a living room with a card table and puzzle, sickeningly lit, and another image of the same title, featuring a man walking in a cemetery (see plate 133). The entire sequence suggests a world of cousins and visits, overheated living rooms, sports on television, drunken uncles, children playing in bedrooms, sinks full of dirty dishes, and the buildings outside the car window on the way home. At around picture number 30 in the exhibition, Szarkowski has Eggleston venturing out, as if in search of the "foreign or confusing or ugly," which appears in the form of rusty stock tanks, alfalfa fields, abandoned buildings, dive bars, and sunsets crisscrossed by telephone wires. The pictures in this section are largely unpeopled. Punctuating this bleak procession are harsh and morbid images, such as the *Red Ceiling*, a discarded tire, shoes under a bed, a dog statue, and various gravestones. If *The Guide*, in its resemblance to a family album, contained the range of pictures one would expect—of people and familiar places, such as they are—the exhibition experience was more like being dumped inexplicably at the edge of town.

Critical response to Eggleston centered mainly on the ordinariness of the subject matter and its slight treatment. In reference to the *Red Ceiling*, Ansel Adams quipped, "If you can't make it good make it red."[120] Yet the intensity of the criticism revealed something more, something that is never quite articulated in reviews: critics blanched at the decadence. In the baroque patterning of the compositions and the randomness of the subject matter, Eggleston's photographs presented a culture in the advanced stages of decay. Decay had long been an appreciated romantic element in Southern culture, extending as far back as the Civil War and the fall of Vicksburg. The problem for Eggleston's New York critics was that his pictures did not look like the South; they showed instead a vision of an interchangeable suburban America, a place that was culturally neither North nor South. To this Eggleston added an overlay of Southern decay, which seemed to comment on America as a whole—America in a state of decay. Though Eggleston clearly harbored a mild affection for this world of bland suburbs and cemeteries, critics, particularly those in the North, found this take on American society intolerable.[121] After so

much striving and achievement, how had America come to this? At its core, Eggleston's tone is one of affectless loafing. The pictures don't even convey a sense of searching; rather, they portray the activity of biding time, of having nothing to do and nowhere to go. The pictures are profoundly passive in this regard; pressed to divulge their meaning, they retreat into a private realm of personal meanings and muttered explanations, never allowing for a broader social reading. Coming on the heels of the politically engaged 1960s, such a visual statement was a severe letdown to America's self-image as a noble, purposeful, and industrious country. Eggleston's work seemed to accept defeat, passively acknowledging the pervasive cloud of apathy that had settled over the nation by 1976.

Eggleston's make-of-it-what-you-will attitude was most evident in the deadpan shots of bare light bulbs, shower stalls, and open ovens; these were the images that incensed viewers most. In such pictures, Eggleston's irony is evanescent; the oven picture is surely a joke. Other images, such as a photograph of a dish drainer illuminated by glowing light, convey a genuine sense of revelation. Here the artist's apathy seems to be momentarily sloughed off, the senses awakened to a fleeting, if melancholy, sense of beauty. Yet neither position is firm. Such indecision—such an express lack of commitment to subject matter—was exacerbated by Eggleston's unwillingness to settle on a particular approach in his treatment of subject matter. Were the works formal? Social? Diaristic? Interestingly, other artists photographed similar subject matter at this time and received an entirely different response.

Jan Groover migrated to photography from painting during the mid-1970s, starting with a series of conceptual "actions," in which she photographed passing cars and trucks, often assembling the photographs into triptychs according to color.[122] The artist gained much attention in 1977 with a series of new work, shown at Sonnabend Gallery, New York: a series of photographs of her own kitchen sink (fig. 27). Described by Ben Lifson as "the most exciting event in photography this fall," the show consisted of large-scale color semi-abstractions based on arrangements of ordinary kitchen utensils—forks, graters, glass bowls, and the odd pepper.[123] These Kitchen Still Lifes incorporated many threads of interest, in that they challenged assumptions about photography while also playing up the seduction of photographic seeing—Groover's pictures, Lifson wrote, "make intoxicating lists."[124] The pictures also obviously incorporated traditions from painting, Cézanne in particular, thus proposing to update through contemporary technology questions of perception and space begun nearly a century before.[125] Although Groover's subject matter seemed inconsequential (the artist is on record saying, "I have a notion that everything can be pictured, that content is not that relevant"), allusive fragments generated speculation.[126] The common domestic subject matter suggested a feminist revolt against the "bourgeois kitchen"; the peppers and a cake mold in the shape of a shell seemed to quote Edward Weston; and the placement of voluptuous curved forms in relation to elongated pointed forms alluded to sexual content—such were the theories floated at the time.[127] Why was Eggleston so offensive and Groover so popular? Her work, after all, was far more opaque than his and contained none of the social or political content viewers expected to find in photography. The answer has to do with a sense of stated purpose. Where Eggleston's photography conveyed apathy and indecision, Groover's communicated an ambitious (if obscure) exploration of photographic ideas and aesthetics. In Eggleston's hands, color photography seemed to dead end; in Groover's, it took off in an ambitious direction, declaring a sense of high purpose. Photographic discourse was back on critical terra firma.

On the West Coast, Barbara Kasten was engaged in a similar process of formal exploration that was equally serious yet yielded entirely different results. Like Groover, Kasten had crossed over from other media (painting and fiber art in this case) and was quickly adopted by the photographic community as one of their own. Kasten's first forays into photography, in 1975, were in part an exploration of Minimal-

27. Jan Groover, *Untitled*, 1978. Chromogenic print, 20 × 16 in.

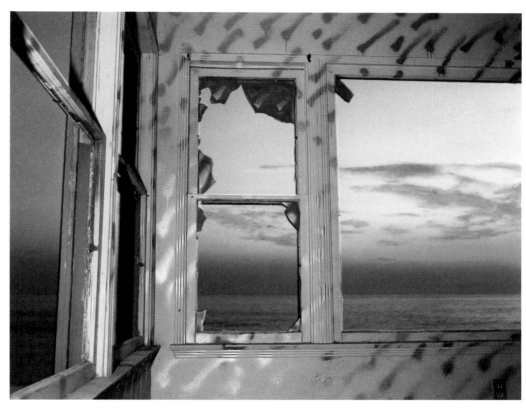

29. John Divola, *Zuma #21*, 1977. Dye transfer print

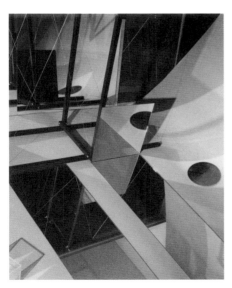

28. Barbara Kasten, *Construct 11-B*, 1979.
Polaroid photograph

ist concepts; she thus chose two of photography's most primitive processes, the cyanotype and the photogram, which she used to produce large-scale images of rippling fabrics (see plates 150–52), making use of the "clear and reliable light of Southern California," as one reviewer explained.[128] These images engaged an academic dialogue concerning the fundamentals of various mediums—photography, painting, and also sculpture—yet those fields of inquiry were overwhelmed by the sensuality of the fabric and its function as a subject at the limit of recognizability.[129] In 1979 Kasten began the work she is best known for, the Constructs (fig. 28). Unlike Groover's work, which suggested passages of humor and drama, Kasten's appeared as something much more analytical and cerebral, drawing from 1920s Constructivism and the work of Hungarian artist Moholy-Nagy in particular. The Constructs, Kasten pointed out, were "50 percent sculpture and 50 percent photography," in that she constructed the subject matter using metal, mirrors, and colored fabrics for the explicit purpose of photographing.[130] Early on, she liked to display the sculptures and the photographs together.[131] Kasten's ability to suggest certain cultural nuances of color invited interpretation from Andy Grundberg, who discerned in the Constructs the "esthetics of Hollywood with the ambiance of a dollhouse, a Disneyland-like alliance that addresses social issues as well as formal ones."[132]

Just as Kasten liked to get inside her sculptures, moving pieces around to be photographed, John Divola interacted with the interior of an abandoned beach house in Zuma Beach, California (fig. 29), spray painting patterns on the walls and sometimes tossing objects such as magazines into the air, photographing them to record the mark of time.[133] The resultant series of images are thus documents of a process, "provisional markers" as historian David Campany has written, that comment on both the nature of a disposable culture and on the state of photography circa 1977 as well.[134] One particularly

30. John Pfahl, *Slanting Forest, Artpark, Lewiston, NY*, 1975. Dye transfer print

intriguing aspect of this series is Divola's integration of landscape and interior. Color plays a central role here as Divola contrasts classically kitsch sunsets seen through the house's windows with the building's interior, which is illuminated by flash. Here two exaggeratedly different aspects of color photography are placed on display for comparison: the sunset with natural lighting is juxtaposed to the artificially lit interior. The pairing offers a larger meditation on the question of photographic realism itself as the "real" image and the "fabricated" one are considered through the differing values of color.[135] This deconstruction of photographic vision as practiced by Groover, Kasten, and Divola, in which the medium of photography itself becomes part of the content of the image, hinged on the transparency of the color photographic image and assumptions about the act of seeing based on conditioning by the medium. Mark Johnstone notes that in Divola's images "what is assumed to be transparent has become opaque and the invisible has been made visible."[136]

Two photographers who exported these ideas to the landscape are John Pfahl and Richard Misrach. Pfahl composed classically picturesque landscapes, "dangerously close to the empty virtuosity of *Arizona Highways*," which he then disrupted in the spirit of Land Art by adding lengths of yarn, bands of foil, and oranges in different sizes (fig. 30).[137] The order established in such images—in which points in space are connected, structures are masked, and sizes are unified, respectively—was comprehensible only within the pictorial system of the photograph. Such interventions toyed with the norms of photographic seeing, in particular viewers' ability to read photographs by extrapolating three-dimensional space from a two-dimensional object. Pfahl's series, *Altered Landscapes*, received much attention and was shown in numerous museums, especially around 1978, contributing to a conceptually-based dialogue around color photography.[138]

31. Richard Misrach, *Hawaii IX*, 1978. Dye transfer print

Misrach went into the jungles of Hawaii and Kauai, photographing randomly in the dark with flash photography, which yielded a series of unplanned compositions that were eerily illuminated by unnatural light (fig. 31). Like Pfahl's work, Misrach's images rely on a disruption of expectations. Misrach chose a stereotypically picturesque landscape—the "tropical paradise"—and reversed the treatment, using flash to alter the colors of the lush environment. Rather than exhibiting conventional beauty, the resulting images have a forensic quality. Misrach's intent in this series was to force a repatterning of vision. In a statement for an exhibition titled *American Images*, organized in 1979, he wrote, "I think the photographs create a kind of subconscious vertigo because they're not based on normal landscape perspectives, the color isn't intended to be conventionally beautiful, the image is chaotic and claustrophobic. If you look at enough examples of this apparent chaos, though, order eventually emerges, becomes internalized, and starts to reshape your patterns of visual perception."[139]

Color photography is "a little more real, but not really real."—Harry Callahan[140]

Simultaneous to such deconstructive investigations, numerous artists were exploring the naturalism suggested by color photography, discovering new subjects and new modes of objectivity. Stephen Shore continued to work throughout the 1970s, refining his imagery into carefully framed windows onto the American cultural environment (fig. 32). Soon after the American Surfaces snapshots were shown at Light Gallery, Shore decided he wanted to eliminate the vernacular element and began photographing with a 4 × 5–inch view camera; a year later, he had worked up to 8 × 10.[141] This step marked a radical change in Shore's work, initiating a reduction in the sense of irony and an open embrace of photography's classical tradition. Shore continued to travel, to Amarillo and other destinations, between 1973 and 1979, standing this old-fashioned device on its tripod and crawling under the dark cloth to make views along the way. (A photograph of Shore at work, published in *American Photographer* in 1979, is a vision out of the nineteenth century, relating Shore to photographers of the American West, such as Timothy O'Sullivan and Carleton Watkins.)[142] In 1975 Shore was included in the important *New Topographics* exhibition at George Eastman House in Rochester, New York, along with Robert Adams, Lewis Baltz, Bernd and Hilla Becher, Joe Deal, Frank Gohlke, Nicholas Nixon, John Schott, and Henry Wessel. Shore was the only color photographer in the group but his uneventful, highly transparent and rectilinear views of buildings, intersections, and telephone wires fit right in.[143]

32. Stephen Shore, *Mount Blue Shopping Center, Farmington, Maine, July 30, 1974*, 1974. Chromogenic print

Shore was also exhibited at MoMA in 1976, intriguing and puzzling critics who still had no framework for interpreting his seemingly unmediated approach.[144] "Is it 'Shore photographer' we really like," wrote one reviewer, "or simply the designer of the movie marquee he photographs, the sign-maker who painted the fruit stand, the architects and planners who allowed a huge purple glass building to be juxtaposed with a California bungalow?"[145] Like Eggleston, Shore interlaced irony with lyricism, yet the overall effect was much more subdued and the formalism more obvious. Moreover, Shore's work lent itself to a broader discussion occurring within the realm of urban architecture and renewal. Also in 1976, Shore's work appeared—as framed photographs and as 16 × 20–foot blowups—in an exhibition by architects Robert Venturi and Denise Scott Brown at the Renwick Gallery of the Smithsonian Institution.[146] Titled *Signs of Life: Symbols in the American City*, the exhibition proposed vernacular and commercial architecture as well as signage as a future direction for American architecture, a theoretical position sounding much like Szarkowski's arguments for photography.[147] In reviewing the exhibition, Carter Ratcliff perceptively observed that "the transformations [Shore] brings about by his affectionate vision seem related to Venturi and Scott Brown's acceptance of 'what is' as the proper starting-point for the redemption of the American scene."[148] A comparable call could be heard in the realms of politics, religion, and literature throughout the rest of the decade. The following year, Shore had major shows in Germany,

where his work became enormously influential among Dusseldorf School photographers, taught by the Bechers.[149] And in a symbolic conclusion to the color decade, *Aperture* published Shore's work in 1982 as *Uncommon Places*, so titled as a play on the word *commonplace*.[150]

Joel Meyerowitz began using a large-format camera in 1976, continuing with his pursuit of more description.[151] This was a decisive step in what one critic called the "confusing and lonely business of breaking away from Winogrand's concerns," a laying aside of the "social ax" of 35 mm photography for what was at that moment a riskier goal of capturing the ephemeral beauty of light in all its forms.[152] Meyerowitz seems to have had an epiphany in response to Cape Cod, where he spent his summers, taking up the 8 × 10–inch view camera as a way "to learn the language of the medium in the original."[153] Meyerowitz's heavy-breathing exposures of sunsets, beaches, and cottage architecture skirted dangerously close to the clichés—postcards, calendar art, and Sierra Club pictures—yet managed to transcend those low genres through the subtle effects of the chromogenic print (fig. 33). The saturation of the color, the density of detail, allowing even for glimpses of trash here and there, offered a purity of vision, which seemed to signal a return to traditional photographic values. The work was well received when it appeared at Witkin Gallery in New York in 1977 and the Museum of Fine Arts, Boston, the following year. Critics noted a hint of escapism. Writing for the *SoHo Weekly News* in 1979, Andy Grundberg proclaimed: "This combination of subject and format conspires to make us—in these troubled times—feel suddenly freed of gas lines, nuclear leakage and the Ayatollah Khomeini. Our forefathers' conquest of the continent is somehow rationalized; the status quo . . . is somehow validated." Grundberg goes on to wrestle with the idea that Meyerowitz's photographs might be "reactionary," but ends on a more positive note: "What Meyerowitz seems to have done . . . is to redefine and update the picturesque."[154] Today *Cape Light*, as the series was called, has the values of a conventional, well-executed photo essay. It was precisely these traditional qualities that generated such enthusiasm at the time. *Cape Light* was an expression of reassurance, a return to order after a period of cultural unease. The malaise seemed at last to be lifting.

This notion of reinvesting the clichés, seen in numerous bodies of color work—by Meyerowitz, Shore, Divola, Pfahl, Misrach, even Groover and Kasten—suggests not only a retreat from the world and its concerns, as Grundberg speculated, but also a return to traditional artistic values. If artists were questioning the assumptions of representation during the late 1970s, aided by the color photograph's resemblance to and divergence from the visible world, they were also often proposing a way forward through a rejuvenated appreciation of the traditional values of modernism. In popular terms, this was an embrace of the values expressed by Robert Pirsig in his bestseller *Zen and the Art of Motorcycle Maintenance* of 1974, which recast modernism in a positive light and offered hope for redemption through a return to "classical" living—the future was in the past.[155] Groover and Kasten had returned to art history, reexamining the formal traditions of painting and Constructivism; Divola, Pfahl, Misrach, and Meyerowitz were each seeking to reinvent the picturesque; Shore and Meyerowitz had returned to photography itself, forging through old-fashioned processes a new way of looking at the contemporary world. In light of the recent controversies over color photography, a "return to order" by, say, 1976 might have seemed unlikely to those on the ground at the time. However, by that date there is evidence—even in Eggleston's controversial show—that color photography had not only arrived but was also stabilizing the discourse of the medium by affirming and conforming to photography's traditions. This was carried out through the testing of distinctions and similarities between photography and other mediums, shining a self-examining light on photography as a discrete artistic medium. Color was finding its own self-definition and this was on the terms of its own processes and formal values—the terms of modernism, in other words.[156] This return to order is evident not only in the work photographers produced by the end

33. Joel Meyerowitz, *Red Interior, Provincetown*, 1976. Chromogenic print

34. Harry Callahan, *Untitled*, c. 1977. Chromogenic print, 11 × 14 in.

of the 1970s but in the work galleries and museums were interested in showing based, presumably, on what audiences were prepared to appreciate. The shift may also be gauged by changes in the critical reception of certain photographer's reputations. For example, Heinecken had been the darling of critics in 1970 but, by the late 1970s, responses to his work were severe, calling it "hollow" and "parading of social conscience."[157] Strident political activism and artistic innovation had fallen out of favor, replaced by traditional art genres and approaches.

Harry Callahan had been photographing since the 1940s, moving through one experimental style after another. In 1977, the year of his retirement from the Rhode Island School of Design at the age of sixty-five, he had yet another breakthrough, this time in color. Callahan had, of course, photographed in color from the beginning and returned to color from time to time over the decades, most recently during the early 1970s, when he made a series of multiple-exposure semi-abstractions of buildings in Providence that were very much in keeping with 1950s and 1960s notions of color photography's potential as an art form. Sally Stein notes that, by the late 1970s, Callahan was loosening up. Known for his "relentless purism" and disinterested formalism, Callahan was listening to rock 'n' roll and had acknowledged the impact of color TV and its pervasive conditioning of society to an "electronic palette."[158] In a 1977 interview Callahan indicated that he was turning to color photography exclusively because he had so many negatives in black and white and could no longer process them. Photographing in color would thus liberate him from working in the darkroom while allowing him to continue to shoot all he liked (his color negatives would be processed by a commercial lab).[159] The Providence series of 1977 was thus a kind of retirement project, something constructive to do on a walk; it was a form of visual exercise.[160] When the pictures debuted a year later at Light Gallery, viewers were impressed by the quality and sensuality of these images. Callahan was praised for allowing the "signs of common clutter"—automobiles, laundry, garish house colors—to enter his viewfinder and for his skill at imposing order (fig. 34).[161] Indeed, it was

precisely the tension between Callahan's elegant organization of volumes and the "banal complications of an ordinary locale," further emphasized through color, that made these pictures so exciting.[162]

Another convert to the 8 × 10–inch view camera was Joel Sternfeld. Sternfeld won a Guggenheim Fellowship based on his street photography and began touring the United States in a Volkswagen bus in 1978. Leaving behind the political investment of his previous work, Sternfeld adopted a more distanced, philosophical approach, which the view camera encouraged. Many of Sternfeld's photographs, such as *Wet'n Wild* (see plate 234), were taken from a slightly elevated perspective, lending the images a classicism associated with painting—this was intended, along with the subdued, tonalist palette of the chromogenic print, to reveal the "man-altered" landscape in all its contradictions and grandeur.[163] Sternfeld's work might be seen as a synthetic culmination of so many photographic styles of the 1970s, incorporating the humor and social perspicacity of street photography with the detached restraint of New Topographics photographs and the pronounced formalism of works by so many late-decade colorists. His ostensible subject, Americans' anxious relation to nature, is examined through a series of images whose coloration mimics both the tensions and the consistencies occurring between the natural and the man-made. Through his use of color, Sternfeld tightens the chromatic knot: grasses, skies, and mountains appear dressed in the same colors as the painted tract houses, automobiles, and clothes of the people inhabiting the landscape (fig. 35). One reviewer stated that Sternfeld's pictures were "descriptive rather than prescriptive," and that is no doubt true, in the sense that the photographs offer no obvious political perspective;[164] they emanate an attitude of acceptance, even forgiveness, toward their subject. Sternfeld relates a story, not unlike a scene from Wim Wenders's film *Alice in the Cities* (1974), in which, during the mid-1970s, he was photographing on the beach at Coney Island in a state of depression. Looking down the beach at a block of public-housing buildings, softened by the afternoon light, he suddenly had a harmonious vision, as light, color, and form blended into one. He took a picture of the ugly buildings.[165] Sternfeld's vision was a long philosophical view of himself in his environment, an embrace of life with all its mysteries and limitations. The artist understood that day a natural function of color photography: in both its precision and sweeping neutrality, it could specify a time and place and, at the same time, invoke a sensation of universal order. Color photography encompassed hope and despair and an infinite number of feelings in between.

By 1981, the year *The New Color Photography* opened at the International Center for Photography in New York, color photography was beginning to be perceived as an uncontroversial medium—it had become a part of photography's history. Reviewing the show, Ben Lifson wrote that "the background of 'The New Color Photography' is not the old color but the long tradition of serious photography itself and the longer tradition of painting. This makes us wonder why most of these pictures are in color to begin with . . . because in most of today's work, 'color photography' is not the defining term."[166] In the same review, Lifson covered Leo Rubinfien's first solo show, on view at Castelli's uptown gallery. Lifson brushed past the pictures "suffused with a single gorgeous color" and moved on to the straightforward photographs of people taken around the world, often suspended in transit: "these pictures look almost like brute fact, dumb mirrors held up to nature," he wrote.[167] Here were color photographs not made to be understood in relation to anything else—snapshots, commercial photography, painting, not even travel photography. They conveyed content: humanity in its current state, hovering in between places, cultures, identities. The tone of these pictures was provocatively ambiguous. The locations, as titles indicated, were exotic—Hong Kong, London, Burma—but the scenes depicted were unremarkable, suggesting anonymous train cars, ferry platforms, loading docks. If the pictures could be said to resemble anything, it would be film stills, in the faint suggestion of narrative, in the palpable beauty and loneliness of figures inhabiting a given scene (fig. 36). Perhaps such connections were intended, though

35. Joel Sternfeld, *Pendleton, Oregon, June 1980*, 1980. Chromogenic print

36. Leo Rubinfien, *At Trafalgar Square, London,* 1980. Chromogenic print, 19 ⅜ × 23 ¾ in.

not as a comment on color photography's relation to film; rather, they engaged a common method for understanding oneself in the world, particularly in attenuated situations: "It was just like a movie."[168] Rubinfien's pictures strike at something universal in that they seem to reassert the drama of the self within the global culture of standardization and anonymity. They reveal an effort to salvage individuality within an increasingly homogeneous culture of global consumerism.[169] Coming off the seventies, they also represent an attempt at verification of human dignity after a long decade of social disaffection.

In a photograph titled *Leaving Bangkok at Sunrise* (see plate 239), taken in 1979, Rubinfien records the view out the window of a commercial flight, which in moments will be over Vietnam. How the world had changed in a decade. Ten years earlier, the war was in its darkest phase, inspiring some of Heinecken's most impassioned art. Such political engagement would soon devolve into widespread disillusionment, as the Cold War, economic hardship, political turmoil, and a host of other problems blanketed the country. The political engagement characterizing Heineken's work, and photography before him, gave way in the seventies to detachment, irony, ambiguity and, in some instances, nostalgia and decadence, as artists retreated from public life and searched for new sources of meaning. By the end of the decade, a climate of globalization had moved in, replacing domestic social and political problems with a larger set of concerns. Rubinfien's photographs mark the beginning of an exploration of questions relating to nationalism, commerce, and individualism. In other words, his photographs show a return to political engagement but they address a new list of issues and on a new set of terms. If the period before the 1970s had held faith in notions such as progress and social egalitarianism, the period after the seventies

took a more hesitant view. Black-and-white photography had told social truths; color photography now asked questions.

"A gold trophy can mean something different from a silver trophy and the distinction cannot be rendered in black and white."—Neal Slavin[170]

The controversy over color photography had ended by the time the word "color" was dropped from exhibition and book titles: Jeff Wall's first big show in 1984 was titled *Jeff Wall: Transparencies* (Institute of Contemporary Art, London) and Nan Goldin called her 1986 breakthrough book and exhibition *The Ballad of Sexual Dependency* (Aperture/Jay Gorney Gallery). Not only had "color" been dropped from titles but "photography" as well, signaling the assimilation of photography to the mainstream of contemporary art—color absorbed by photography, photography absorbed by art. This might be seen as a long-awaited victory for photography, what advocates for the medium's acceptance and appreciation as an art form had dreamed of all along. Yet the phenomenon also represents a form of erasure, a submersion of the historical record. Today an entire complex and unique history, which is to say photography's modernist history, is undergoing transformation as photography is increasingly swept into the framework of a post-1960s, postconceptual, postmodern paradigm. As older proponents of photography's history fade out or loose their prominence within the art world, the history of photography, including chapters on events such as color photography, runs the risk of being seen as relevant only in relation to what came after.[171]

Does it matter? There are surely advantages to artists working in photography today as part of an assimilated medium. The broader exposure they enjoy within contemporary galleries and museum departments, both in terms of the breadth of the discourse generated and the valuation of work sold in the market, far exceeds what it might achieve in a narrower photographic context. The great commingling that occurred between photography and contemporary art after 1980 has brought photography out of the ghetto. Yet that wave of interest in photography largely obscured what had come immediately before—1970s color photography and the burst of ideas that came with it. Certain artists, such as Stephen Shore and William Eggleston, have been successful in making the leap from the 1970s to the contemporary scene, enjoying a revival of their seventies photographs through recent publications and exhibitions. Yet one wonders how well those pictures are understood by their contemporary audience—if they are not now appreciated through some combination of nostalgia and a resemblance to current photographic art. If only work showing obvious relevance to the interests and attitudes of contemporary art is able to make the leap—both Shore and Eggleston might be seen as photographic variants of Warhol and Jeff Koons, fusing the ironic and the sincere—what is left behind? Shore and Eggleston are, of course, photographers of great nuance and complexity, much of which derives from photographic traditions as well as the period of the 1970s. And if the contemporary art market drives photographers' careers and sets the terms for their revivals (which it does with increasing power), who is left behind? Is it possible today to assess the work of Groover, Sonneman, Krims—of any artist in this book—on its own terms, the terms of its creation, and not those of a separate discourse asking a different set of questions at a different time? This, of course, is the challenge of history but it is an augmented challenge for photography because of its history as a subsidiary art. The unembellished past has much to offer. Just as the decade of the 1970s continues to hold many of the keys to understanding our present political, economic, and cultural state, color photography of the 1970s shows both the range of what was once thought possible and what photography would indeed become.

COLORS OF DAYLIGHT

LEO RUBINFIEN

Being lit up early with nervous ambition, I moved to New York even before I was quite out of school, but it was 1975, 1976, and indolent sumac and junkyard ailanthus wasted the parks, while burned-out muscle cars hulked, rusting, not only along the Cross Bronx Expressway, but right there on Central Park West, right on Riverside Drive. In the bucolic friezes beside the steps down to Bethesda Fountain, the head of every delicate bird had been smashed off, and all this outward wreckage seemed to represent an inner damage that, though it was hard to define or measure, one knew was there. You recognized it in certain heart-eaten protagonists of film—the doomed disco-boys in *Saturday Night Fever*; the detective hollowed out by hate in *The French Connection*—and you could see it in the epidemic of desertions of men by women and women by men, of parent by child and even child by parent, that characterized the age. Stories of license were everywhere, and now and then someone would describe an orgy that he or she had been part of, but it rarely seemed that much joy had been in it. One heard the word *glitz* for the first time. Lobbies and living rooms and bedrooms too were hung with floor-to-ceiling mirrors and metallic wallpaper, and if the flash of the nightclub and casino was all over the clothes and adornments of women (and even many men), you felt persistently that the gilt was thin and the makeup desperate.

Not just New York—the whole nation had the feeling of the morning after a debauch. A few years before, at the height of the 1960s, Diane Arbus had written that it seemed to her like the city was about to explode, but some kind of implosion occurred instead, and a great many Americans still now remember the seventies best for a series of appalling failures. There were the disgrace of the Nixon presidency and the breakdown of the Carter; the collapse of South Vietnam and the rooftop evacuations from Saigon; there were the founderings of the American economy and of the dollar itself, the flight of the Shah, and as a sort of coda that came right after the decade ended, the botched rescue mission to Teheran, which aborted when a helicopter crashed down onto a fuel ship in a cloud of desert sand, they blew each other up, and the Americans had to flee into the night. These and yet other public events, and still other innumerable calamities that touched just two or three or ten people weighed heavily, and many Americans now spoke with a smug contempt of being disillusioned. Irony was held to be more authentic than sincerity, and many even called themselves cynics, though one couldn't help wondering if this wasn't a new affectation, another kind of mask. The era before—famed and eruptive—had been a period of towering idealisms, which expressed themselves in evangelistic war, scientific adventure, passionate appeals for social justice and some serious efforts to answer them; the seventies were to a great degree the sixties' sullen, shambling twin, a time of disorder and exhaustion, when despair was near the surface and the ebullience of ten years before seemed far out of reach to those who were still hopeful, and a fraud to many of the rest.

In the sixties (and for a while after), the taste of heroic purpose and the taste of shameful defeat were so permeating that the ordinary face and building and street grew heavy with a symbolic load, standing beyond themselves for actions and ideas that were lofty, or, again, pernicious. In this moralized landscape, truths were seen to be stark, large, and dire, and perhaps because it was still ingenuously thought that the camera didn't lie, the role of the cameraman briefly took on a stature that it has not had since then, and may never have had before. He was at once a witness, prosecutor, and judge. "Each time I pressed the shutter release it was a shouted condemnation hurled with the hope that the picture . . . might echo through the minds of men in the future," Eugene Smith said in his retrospective book of

1. William Eggleston, *Untitled (Memphis, Tennessee)*, 1971. Dye transfer print, 16 × 20 in.

2. Robert Adams, *Lakewood, Colorado*, 1974. Gelatin silver print, 11 × 14 in.

1969.[1] "Black and white are the colors of photography," Robert Frank had written as the decade began. "To me they symbolize the alternatives of hope and despair to which mankind is forever subjected."[2] In the sixties, pronouncements like these did not seem grandiose. They were a starting point for any number of photographers.

Black and white—the inky, grainy black and the bleached, glaring white of the photographs that each day threw urgently at the world on newsprint—were, at any rate, the colors of starvation in Biafra; of the spacesuit of the astronaut and the galactic emptiness beyond him; of the shocked, screaming children running from the napalm attack; of the presidential house and the serious, troubled men inside it; of the motorcycle jacket; of Desolation Row; of either and or. Now it is a fact that the strongest American photographers of the sixties and early seventies were rather less morally confident than many of their contemporaries, that their work was full of skepticism, and that it looked askance at the great collective emotions that carried the nation. There was vastly more subtlety in Arbus's amazed, self-deprecating, unanswerable queries, for example, than there was in what you heard people everywhere say and shout and sing. Yet it is true just the same that for all that the irony in her work speaks of her individual history and her sense of fate, it replies in its every step to the paradoxes of her time in American life. You can never say of Arbus, Winogrand, and Friedlander that the condition of the American nation and its soul was not their subject, and black and white were their colors too, of course, no matter how much gray was present in them as well.

Despite the inflation that was eating away everyone's money, a moment arrived when color film and air tickets to far places had both become cheap. Among professional photographers, color had long been a privilege of the fashion and advertising people and the photojournalists who worked for the glossier magazines; Kodachrome cost three or four times what Tri-X did, and a set of dye transfer prints from a first-rate lab cost a fortune—but while one wasn't quite looking, there had become available new color films and papers that one could process in one's own darkroom. And if for generations Ceylon and Bali had meant slow voyages by sea, or required one's editors to spend lavishly to rush a photographer there by plane, now there were huge jets whose seats the airlines needed to sell by the millions. You could read about Jesselmere and go to see it on your own, without giving months away to blinding dust and soaking monsoon. The world was becoming compact; it was becoming a bit like a city.

3. Mitch Epstein, *Canale della Giudecca, Venice, Italy,* 1977. Chromogenic print, 16 × 20 in.

For me, at least, Kodacolor negative film and economy class, Pan Am, began to suggest a way out of the cul-de-sac into which the years of eruption and despondency had led. There were various routes that people took, of course: Bill Eggleston passed up the public scene, as a subject, for the private (fig. 1); the conflicts that had lately torn America seemed to mean nothing to him. Robert Adams was devoted to a great national issue, the despoliation of the American land, but neither self-importance nor irony could be found in his work, just a modest bookkeeper's precision, and a conviction that there were more questions in the world than answers (fig. 2). The path I followed—it led in yet another direction, and as icy winds roared in over the Hudson and the frail septuagenarians of the Upper West Side struggled up the sidewalks and even clung to the signposts to stay on their feet, I would pore by yellow lamplight over the *Indonesia Handbook,* and a map of Siam that I had, and try to imagine Java. This was in part the photographer's habitual longing to roam the world, but there was more to it than that. It was a way of departing not just from a certain place, but also from a certain time, a certain mind; it was a way of re-opening the world for oneself. There were other kinds of country one could go to where such anguish as infected the air of New York City was neither well known, nor terribly important.

4. Len Jenshel, *Pacifica, CA,* 1978. Chromogenic print, 20 × 24 in.

5. Leo Rubinfien, *Cherry Blossom Party in a Grove, Miyajima, Japan*, 1984. Chromogenic print, 19⅜ × 23¾ in.

There were intimations of what I was hoping to find in the work of some of the photographers I knew. One year, Mitch Epstein brought home from Venice a shimmering picture full of pale blue and palest autumn gold (fig. 3). Nothing was really happening in it (a man was reading as another skipped up some steps; a small boat was passing as a distant ship shone in its dock lines), but you felt nonetheless as if an event was unfolding with a marvelous, ineffable order, and maybe the whole point was that you couldn't say what that event was. A short time later, Len Jenshel brought a photograph back from the San Francisco coast, and there in it, too, were the same unity and radiance and the same sense of splendid but undefined promise (fig. 4). It was not just that I found these qualities beautiful, it was (you could see) that there were whole warehouses-full of subject and feeling that the colors of things—the yellow-white that lit the air above the Giudeccan Canal, the gold-silver that the sea wind revealed when it blew the dune grass back—could unable you to unlock. Perhaps in your own proof sheets you found a frame from a railway compartment on the way out of London (see plate 237): why did the bright-orange flaring-up at the tip of the cigarette of the woman riding there seem significant, remarkable, when it was just a minute thing that in black-and-white would not have been visible at all? Did it say something important about her, or about how time passes on a slow train in midwinter, or even, perhaps, about transiency itself? Why was the disparity between that bright-hot speck and the cold gray of the city rolling by outside the window enough to support the whole picture? The half-second when a smoker draws in and his cigarette glows sharply—who would have thought that something so trivial could be a decisive moment?

6. Leo Rubinfien, *In an Alley, Jakarta*, 1987. Chromogenic print, 19 ⅜ × 23 ¾ in.

In large part all this arose from the new color materials themselves. If, for instance, you were looking at the sky, they would allow you to say "robin's egg," "azure," "wedgwood," or "cobalt," where in days before you'd have been limited to "blue." The dye transfer prints made from positive film had wonderful, deep saturation, or richness of color, but C-prints, the new kind, which were made from negative film, had greater sensitivity to nuance—especially if you used a camera of medium or large size—and thus made the whole world seem a subtler, more complex place than one had known it to be. Sometime back, Walker Evans had denounced color photography as "vulgar," and though he must have been thinking first of the sentimental, meretricious, and flashy ways in which it was mostly employed, he must also have had in mind traits that were inherent in the earlier materials themselves. The new film and paper brought you closer to the vast range of colors that were familiar in nature but had no names, and thus closer to the pure phenomenon, the subject whose symbolic content was not yet clear. Black and white were the colors of the sooty brick of New York, the wet paving stones of Paris, the crepuscular fogs of London, and the blinding fogs of Los Angeles; they were the colors of what you knew already. Color was the color of what you didn't yet know—how, for example, to repose beneath a bough of cherry blossoms of the rarest, whitest pink was not the same as to repose beneath blossoms that were the hue of cotton candy (fig. 5).

The new materials could move you, then, toward truths that were not so stark and dire, but multivalent, and they could make the photographer himself less of a witness and judge, and more of an investigator, more of an appraiser. Among the photographers a generation older than I was, it was common to say that a picture one liked was "interesting," or "intelligent," or perhaps "tough," or "terrific." Among the younger ones I knew, it was common to say "beautiful." There was even a year when "gorgeous" went

around. I am speaking of course of a subset of a subset of a subset of people, and really, one ought not to speak of any set at all. There was no *school* of color photographers at the end of the 1970s, there was no *movement*—not if you mean a group of artists that has formed around a common style, and, perhaps, a common theory of how pictures work or should look. The photographers and their styles ran in many directions. Yet you cannot say, either, that all they had in common was a set of techniques, dispensed to them by the big companies that made their materials. Looking back, it seems plausible that the absence of a set of shared convictions expressed a widely felt eagerness to be done with a time of crisis that had been overfull of big ideas that were stridently, if not truculently advanced; a time when, with their demands, what-is-right and what-is-wrong oppressed the honest mind, and took the air out of too many rooms.

Many of the photographers who were active in the seventies soon gave it up, some of the older ones retiring. For others—I was one of the latecomers—the decade was a launching place, and they went on to do the largest part of their work in the eighties or nineties, or even in the years beyond. Most of these found themselves waved on into a world that saw a special beauty in photographs that were ambiguous, idiosyncratic, and highly aware of style—pictures that often gave strong dramatic emphasis to tiny gestures of uncertain meaning. Much work would still serve the larger journalistic enterprise that had dominated professional photography four and five decades before, but it was, probably, a far smaller proportion of all the photographs that were made. You could say that journalistic values were draining out of photography; in time they would become marginal to it, if not largely vestigial. The enormous stories according to which people organize so much of how they understand their lives—stories of nation, war, suffering, invention, conquest, the creation of wealth, and the endurance of want—came to occupy no more of the mental life of most photographers than of anyone else. Photographers, that is to say, migrated still more fully into the world of art, where the journalistic function had mostly been abandoned long before, and where a lot of space is made for peculiar genres like still life, in which the dullest combination of two apples and a pear can be as profound as any subject there is, if the painter sees well enough into raw sienna and thundercloud gray. One part of that larger journey was made by the artist-photographers who took up color photography in the decade when I did.

Much farther on, I would go back to monochrome and find it not at all constraining, but there *had* been days when you could, say, wander up an indigent alley in Jakarta (fig. 6), and find that because you could get the colors of the house fronts onto film, poverty would not be the prime concern of your pictures, as it might well have been in black and white. Instead, their prime concern would be something less well mapped, more mysterious, delicious, and far-reaching. This thing would seem a great discovery, perhaps because it was *not* just a matter of art—of the overtaking of one look by another—but had everything to do with the expiration of a certain era and with the advent of the time of possibilities numberless and global that is easy to perceive today. The new time was still out of sight in those days but you felt its nearness, much as on some northern afternoon in any February you may suddenly notice that the light in the sky is the light of spring, and feel how it will be to break open the sealed-up house to damp, sweet air. In those days, black and white were still the colors of hope and despair, but durian, mauve, rust, and aquamarine—they were colors of daylight.

POST-CHROMATIC SHOCK:
CONTEMPORARY ART PHOTOGRAPHY AFTER 1980

JAMES CRUMP

It took several years following John Szarkowski's wildly controversial exhibition *Photographs by William Eggleston* for the art world to fully absorb its impact and the implications for what in hindsight seemed like a bombshell. Although Eggleston's work was greeted sternly by critics of photography, the exhibition and its companion book, *William Eggleston's Guide,* reverberated well into the next decade and lead to a full embrace of color generally and, in particular, photography's nascent rise as the defining medium of contemporary art. But if that was a shock in 1976, audiences were in for much greater shocks as the decade closed. The terms of art production were tipping. Artists folded photography into their practice as a tool in representation while ongoing critical debates contested the slippery slope of meaning of pictures. Szarkowski's promotion of Eggleston's formalist vernacular description—the pinnacle of his theoretical structure for an authorless photographic transparency that had come forward with *The Photographer's Eye* (exhibition, 1964; book, 1966) and *New Documents* (1967)—crashed headlong into an ever-widening field of image-making. A new generation of artists was far less interested in photography's identity, per se, than they were in its utility as a medium capable of interrogating itself and the surfeit of everyday images from television, films, and advertising. For these artists, photography had much greater proximity than painting or sculpture; photography was ubiquitous and they grew up with it together. Armed with postmodern theory, their work sought to tear down the boundaries once prescribed for the medium. These were the apparent heirs to the legacy of color photography of the 1970s.

"Photography has now been welcomed to the esthetic sanctum of our culture on a scale that even its most devoted champions of an earlier day might have hesitated to predict," wrote Hilton Kramer of the New American photography in an article splashed across the cover of *The New York Times Magazine* in 1978: "We see the evidence of this change wherever we look. Museums and galleries . . . now accord photography a significant place both in their exhibition schedules and in their acquisition budgets. Publishers, among them some of the most hardnosed commercial operatives in the business, now sponsor photography books in lavish profusion, and there seems no end to the courses, workshops and special conferences currently devoted to the subject.[1]

1. Cover, *New York Times Magazine,* July 23, 1978

Kramer, among the most vocal critics of Szarkowski and Eggleston, while championing its popularity remained uncomprehending of photography's condition at this moment. He wasn't alone. The changes ushered in by the Eggleston exhibition would unleash a torrent of "new" methods in which color was the dominant mode. Opposing aesthetic camps would begin to utilize photography in ways that both questioned and borrowed from the past. Artists were exploring the nature of the medium itself as Szarkowski long advocated; simultaneously, the issue of subject matter resurfaced. Gene Thornton had uttered the phrase "postmodern photography," observing a renewed humanist spirit predicated on formalism, narration, and content, while Kramer's Eggleston rant hinged on the artist's "anti-formalist aesthetic" that to Kramer belonged "to the world of snapshot chic." Both writers were unprepared for the complexity that lay ahead.[2]

In light of MoMA's exhibition schedule during most of the 1980s, Szarkowski's Eggleston show appeared more and more like an aberration. Szarkowski's "heirs of the documentary tradition" would come to resemble a cast of younger artists that only sampled this elusory "style."[3] They comprised a first wave exposed to the pervasive and increasingly polemical writing about (or against) the medium. Their work

2. Jeff Wall, *Church, Carolina St., Vancouver, Winter 2006*, 2006.
Transparency in lightbox, 78¾ × 97⅝ in.

not only fueled an ideological debate about images but also, in some instances, evolved out of it as savvy artists greedily dipped into theory for their own purposes. Rosalind Krauss, Douglas Crimp, and other writers in *October*, for example, used photography as a device to defend their definition of postmodern art.[4] Originality, photographic authority, and the notion of truth in representation were dominant themes, but these texts also showed to artists photography's connection to earthworks, body art, image/text works, and video. Artists using photography increasingly mined conceptual interests that cut across media. It is difficult to explain the rapid ascendance in this period of Cindy Sherman, for example, or Richard Prince and Louise Lawler without recognizing the interconnectedness between art making and the academy. On the West Coast, artist and CalArts professor John Baldessari maintained a utilitarian view, advocating a "post-studio" photography that broke photo-derived media loose from their contexts and gave license to a broadened field where anything was possible and nothing sacrosanct. Photography was no longer seen as a narrowly defined, self-referential technical process, but rather more broadly as simply another means to image making.

Other artists, such as Nan Goldin, took their cues from art-school icons like Danny Lyon and Larry Clark, renegades themselves in the transformation of documentary photography. Like Clark and Lyon before her, Goldin turned the camera onto herself and her personal milieu, in diaristic representations noted for their immediacy and emotional depth. Goldin's first slideshow projections in 1978, later titled *The Ballad of Sexual Dependency*, however, showed greater resemblance to Duane Michals's photographic sequences than to the formalism underlying Eggleston's work. Yet unlike Michals's elaborate black-and-white fictions, Goldin's photographs were supposed real stories of real people, told in lurid colors, turning any clear-cut meaning of "postmodernism" sideways. *Ballad of Sexual Dependency* perhaps

3. Philip-Lorca diCorcia, *Eric Hutseil, 27 Years Old, Southern California, $20*, 1990–92. Chromogenic print, 15¼ × 23⅛ in.

best underscored this decidedly antimodern turn in photography that admitted an ambiguous impulse toward narrative. Goldin was equally fascinated with color photography's flashier, sometimes eroticizing attributes found in contemporary fashion advertising.[5] Combined with the visceral and sometimes gritty subjects she portrayed, the work Goldin showed at Castelli Graphics, in the group exhibitions *Pictures/ Photographs* (1979), *Likely Stories* (1980) and *Love is Blind* (1981), made her both an estimable and divisive presence in the burgeoning gallery scene for contemporary photography.[6]

The content in photographs and what constituted acceptable subject matter had preoccupied critics of the New Color artists during the 1970s. By the 1980s, a taut struggle between conceptual interests and photography's putative power to reproduce real life erupted in works that played off this tension. Canadian artist and writer-theorist Jeff Wall's highly experimental, staged images from this period challenged viewers to find meaning in ordinary situations. Redolent of literary and art historical references, Wall's photographs are often compared by critics with nineteenth-century tableaux, but they possess even stronger relationships with sculpture, film, and video in their technical execution. However, for Wall, the cinematic style in which he constructs his images—using actors, sets, and the apparatus of moviemaking—is less a means of challenging the presumed authority of documentary than of materially stretching the photograph to its outer limits as an art object. His highly influential work inexorably pushed the photograph onto a critical field already shared by painting and sculpture, while it pointed toward the present and younger artists working today, notably Philip-Lorca diCorcia and Gregory Crewdson, among others. In his exploration of color (which is in fact simply an exploration of realism), Wall's images tread a fine line between illusion and reality, postmodern content and earlier concerns with photography's inherent material qualities. The object-ness of the photograph—in Wall's case, backlit transparencies mounted on light boxes—showed the futility in labeling his work simply according to the narrow terms of recent theory.

"The combination of overstated means and understated meaning is a defining characteristic of the art of the 1980s," wrote museum director Neal Benezra.[7] This potent combination would appeal to artists using photography, the medium that more than any other was continually evolving technologically as it does today, changing and facilitating the very means of producing images. By the end of this decade, however, color was no longer simply an aesthetic novelty. With its newness worn out as the controversies waned, color was now equated with the medium itself. Photography (we no longer have to say "color") of the 1980s, more than the previous decade, underscored a coalescence of themes that addressed issues in representation but also many more concerned with contemporary life, for example, gender, sexuality, identity politics, and the environment, among a panoply of others. The urge to construct and stage photographic images took off in this period and came to dominate the field, though the medium continued to remain rooted in "documentary."

DiCorcia's work of the 1980s best illustrates this progression. First shown in the second installment of the Museum of Modern Art's New Photography series in 1986, diCorcia's "subtly theatrical tableau," as MoMA described them, point to interior themes and the anomie of contemporary life. Although like Goldin, he chose close friends and family to appear in his images, they are fictional actors in an elaborate play the artist directs with his camera. DiCorcia's work built on a fascination with the look of ordinariness and the snapshot to extend to far more complexly staged works. Among his best-known series are his photographs of male prostitutes (Hustlers) that seem as closely allied with a type of street photography associated with the 1970s as they are to recent noirish films that exploit color in similar fashion—visceral, raw, supersaturated color consonant with the motion pictures of, say, David Lynch or Peter Greenaway. The power of these pictures resides in their ambiguity and our uncertainty in reading their contents. These photographs' seamless construction is a tour-de-force in representation that leave the viewer seduced or titillated by the scene at hand, but endlessly pondering their potential veracity or falsehood. The viewer is forced to ask: Are these people and their circumstances real? Taking street photography more literally as the foundation stone in representation, diCorcia's images made in major Asian, European, and American cities seem to foreclose any doubt about "truth" in representation, and yet these photographs are the result of staged productions on a scale that might rival a motion picture set.

4. Jeff Wall, *Diagonal Composition*, Transparency in lightbox, 15¾ × 18⅛ in.

By the 1990s the photo-based conceptualism of postmodernism gave way to a middle ground that ironically circled back to modernist practices and a rehabilitated interest in formalism. Through means of digital technology, the size of photographs grew to proportions that rivaled any painted canvas, as artists explored new tools such as digital retouching and color enhancement to alter content. A new kind of photographic objectivity became a mainstay of contemporary artists deeply interested in such concerns as over consumption, alienation, consumer culture, work and leisure, technology, transportation, overpopulation, and suburban sprawl. Initially a European phenomenon, a great deal of this work has roots in the influential teachings of Bernd and Hilla Becher at the Kunstakademie Düsseldorf—the Becherschule. Increasingly artists returned to typological constructions found earlier in Neue Sachlichkeit photography between the two wars. Collectively, the work of artists such as Rineke Dijkstra, Thomas Struth, Andreas Gursky, Candida Höfer, and Elger Esser, among numerous others underscore a much broader contemporary urge to create large-scale photographs that are autonomous, self-contained works of art, unmediated by texts or other materials. Like Wall, whose large-scale photographs often referenced French painting, many of these artists were strongly inspired by American photography, the work of Stephen Shore, Richard Misrach, Joel Sternfeld, and Joel Meyerowitz, among others working in color in the late 1970s. Shore, who had exhibited with the Bechers in *New Topographics: Photographs of a Man-Altered Landscape* at George Eastman House in 1975, was a known quantity in Germany, later exhibiting his work at the Kunsthalle Düsseldorf in 1977.

Premised on rarity in very small editions and idealized photographic form made possible with computers and software, a new paradigm evolved that combined, for example, the studied observation of August Sander, Karl Blossfeldt, and Albert Renger-Patzsch with the pristine attributes found in the photographs of Alfred Stieglitz, Edward Weston, and Ansel Adams. The implications for this manifest shift in the 1990s continue to play out in the present day, as photography is increasingly exhibited in much larger scale.

Rineke Dijkstra's series of beachside portraits of youthful swimmers admit these relationships and yet they hark back to American color of the 1970s and Joel Meyerowitz's similarly composed images. Dijkstra's subjects, however, lack the confidence and sureness of Meyerowitz's. Their sometimes-awkward gestures and facial expressions indicate vulnerability and unease. Are they taxonomical samples proving some condition of youth and modern life, or are they a metaphor for our own mortality, as we stand face-to-face with the life cycle and our future passing? The muted colors of the beach and the drab gray sky shared by many of these pictures lend painterly attributes to otherwise somber, introspective images of summertime activity. Color in Dijkstra's pictures is a very different matter than the dazzling palette found in Meyerowitz's earlier portraits. Dijkstra's photographs seem to communicate that color simply is, no longer desperate for our attention.

If Dijkstra's work returned focus to the human subject, Andreas Gursky's work is situated at the opposite end of new objectivity. Gursky's images of nature, Alpine landscapes, and treacherous seas possess equivalency with his photographs showing fragments of man-made objects and materials (a close-up view of hotel carpeting, for example), architectural details, and lighting. Paradoxically, the artist's most compelling works distinguish themselves precisely for their capacity to dehumanize their viewers. The human in relation to the vastness of space, both in nature and the built environment, is a recurring theme in these outsized photographs. The intimate viewing pleasure once afforded by modernist photography of an earlier era is here dispensed with in favor of sweeping wall-mounted tableaux. With some of Gursky's very large-scale pictures we are often reminded of the painterly sublime. Though far from straight camera images, the precision, perfectionism, and attention to detail recall the paintings of the nineteenth-century artist Albert Bierstadt. Like Bierstadt, who pioneered novel ways to exhibit his paintings—using special lighting, curtains, and encouraging viewers to use magnifying devices that allowed immersion into pictorial space—Gursky is himself a master showman, both in terms of his technical virtuosity and in the glossy presentation of his work. One stands dwarfed before Gursky's photographs, drawn in to them by the minute and individual elements made possible only with the latest reproduction technology. With Gursky, too, there is type of moralizing implied by the vast size of his photographs that is at one with the modernist enterprise of aesthetic wholeness. As Martin Hentschel wrote in his text for the recent *Andreas Gursky: Works 80-08:* "There is no mistaking his lofty ambitions and the ethics behind his goal, which is directed to the 'human species.' His singular achievement consists in bringing together abstraction and representation on a metaphorical level. He manages to capture itinerant parts of the world that at first sight seem to have no cohesion, but which from his perspective are 'pieces in the puzzle' that interact when faced with the totality of the world."[8]

This modernist urge to expose the hidden, essential detail in nature might have begun with Blossfeldt in Germany in the 1920s, but certain New Color photographers made it all the more relevant to younger artists like Gursky. In his 1978 portfolio *Hawaii,* for example, Richard Misrach used artificial light to "reveal a different side of nature, one in which complexity, density and impenetrability are virtues" and not aberrant vices, as they might have been interpreted by Hilton Kramer.[9] Misrach's nocturnal images of Polynesian flora are precursors to this American artist's later work in the desert that did not go un-

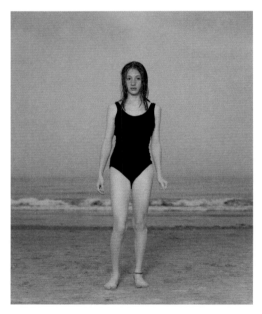

5. Rineke Dijkstra, *Coney Island, N.Y., USA,* 1993. Chromogenic print, 60¼ × 50¾ in.

6. Richard Misrach, *Untitled (#669–02)*, 2002, from the series On the Beach. Chromogenic print, 71¼ × 110¼ in.

noticed by the Europeans. Misrach's recent series On the Beach (2002), perhaps more than any previous body of work, culminates with this artist's preoccupation with human disengagement or acquiescence in the face of disaster (this also happens to be one of the motifs in Nevil Shute's 1950 Cold War novel of the same name). Misrach's On the Beach holds up the promise of color photography in the 1970s, combining content, subtle meanings and allusions with exquisite form and an astounding palette.

* * *

A few years before his death in 2007, Szarkowski cast a withering eye on large-scale works, suggesting that photographic paper does not have any physical beauty or surface qualities that hold up with scale. "Big photographs," for Szarkowski, "have that problem to deal with. Some deal with it more success-fully than others, but it is a real problem."[10] The collector Sam Wagstaff declaimed the converse limita-tion of smaller photographs when he stated at a symposium at Washington's Corcoran Gallery of Art in 1978, "photography is the least decorative of all the arts, we certainly can say that. They don't hold the wall terribly well."[11] Frozen in time, when few photographs were ever larger than eleven by fourteen inches, Szarkowski, like Kramer and Thornton in the 1970s, was uncomprehending of what was happen-ing to photography in 2004. (It is tempting to consider how Wagstaff, who died of AIDS in 1987, might have responded to the increasingly large-scale photographs beginning to appear in prominent New York galleries.) Although his observations about such works were completely out of touch with reality, certainly in relationship to Gursky's pictures, Szarkowski underscores the conundrums the medium con-tinues to present in this brave new world of digital image making. The New Color photographers of the 1970s were all about experimentation. Their work deviated from the dominant language of photogra-phy up until that time, but as Wall has recently stated, "there was no interest in larger-scale photography and no grounds for it."[12] Facilitated by new media and technology, and perhaps motivated to some

7. Andreas Gursky, *Cocoon II*, 2008. Chromogenic print, 83 ⅛ × 199 ⅜ in.

extent by market trends and newfound demand, some of these photographers have begun to recast their earlier works in larger formats. In a more startling switch, Gursky has gone backward: in 2008 he re-presented nearly the entirety of his known corpus from 1980 onward with small-format prints. Oscillating between conceptual approaches, formats, materials, and techniques, these events underscore photography's perennially uncertain future, with artists fighting to distinguish their work in the face of increasing homogeneity brought forth by digitization.

In a parallel to these aesthetic fluctuations, Marvin Heiferman postulated, "the art world . . . seems to have a cyclical interest in photography that lies dormant for thirty or forty years, then re-erupts in a flurry of excitement."[13] Heiferman's observations are useful in evaluating the recent climax of the art market's dizzying speculative climb and photography's self-congratulatory status as a collectible within this larger trend. Interest in the medium goes on unabated and remains as steady as ever, as curators, dealers, and collectors attempt to advance photography's long-term popularity and viability. "We are in an exceptional time for photography," curator Charlotte Cotton proclaimed, "as the art world embraces the photograph as never before and photographers consider the art gallery or book the natural home for their work."[14] The democratization of technology now ensures the continued surplus production and distribution of the photographic image. Sounding a great deal like Hilton Kramer in 1978, Cotton's statement raises the specter of the medium's collapse in its present, neo-modernist form—crashing under the weight of its endless profusion. By reexamining American color photography in the 1970s and its subsequent influence on what followed in photography worldwide—the exhibitions, the books, the auctions, the galleries, and the pioneering artists and individuals that left a lasting impression—we might better comprehend the medium's present condition and its ongoing prospects as contemporary art.

ROBERT HEINECKEN

10. Robert Heinecken, *Untitled* ("What's now"), c. 1970.
Offset lithography on magazine page

11. Robert Heinecken, *Untitled* ("DuBarry"), c. 1970.
Offset lithography on magazine page

12. Robert Heinecken, *Untitled*, c. 1970.
Offset lithography on magazine page

13. Robert Heinecken, *Untitled*, c. 1970.
Offset lithography on magazine page

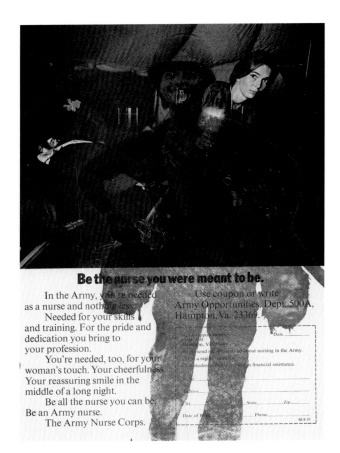

14. Robert Heinecken, *Untitled* ("Be the nurse you were meant to be"),
c. 1970. Offset lithography on magazine page

15. Robert Heinecken, *Untitled* ("Introducing a new country"),
c. 1970. Offset lithography on magazine page

16. Robert Heinecken, *Untitled* ("B&L lights up the fashion eye in golden
shades of autumn"), c. 1970. Offset lithography on magazine page

17. Robert Heinecken, *Untitled* ("Almay"), c. 1970.
Offset lithography on magazine page

18. Robert Heinecken, *Untitled*, c. 1970. Offset lithography on magazine page

OCTOBER 1971

ONLY 25c

Woman's Day

75 FUN THINGS TO MAKE:
Knit & crochet fashions, candles, toys, etc., etc.

Dr. Reuben: sexual myths about women

Exercises to make you feel just great

What Drs. now know about how to live longer

Money-saving menus

Special section kitchens full of work-savers

Apple pie favorites plus our foolproof pastry recipe

Menus for easy entertaining

"I feed six on $100 a month"

Prizewinning rooms

INSTRUCTIONS FOR PINK HOOD ON PAGE 14

19. Robert Heinecken, *Untitled* ("Woman's Day"), cover of *Periodical #6, 12 of 16*, 1971. Reconfigured magazine

20. Robert Heinecken, *Untitled* ("Revlon says"), spread from *Periodical #6 (3rd Group)*, 1971.
Offset lithography on magazine

REVLON SAYS:

It's fashion's newest flashback: nails for a new kind of ice-cool blonde.

'THE PLATINUM BLONDE'

Shell Platinum		Blonde Platinum	Bronze Platinum	HoneyPink Platinum

You've got to hand it to Revlon, right? Another fashion first for nails: a richer, deeper, frostier frost. Like molten platinum. A far cry from that 'tinselly' type that turned you off frosteds till now. True, precious shades of blonde—each as light as the ladyfinger, yet sensationally sexy. (And they wear like iron.) Fragile silver-ash blonde. A blonde with an oh-baby blush. A pale brown-beige. A tawny auburn-blonde. A blaze of shine-and-roses pink. Prediction: We've got a 5-star hit on our hands—and yours!)

THE 'SUPER-CRYSTALLINES' BY REVLON

(They stay frosted through and through. Won't streak, separate or settle. We wouldn't settle for less!)

21. Robert Heinecken, *Untitled* ("How a woman can protect herself on city streets"), spread from *Periodical #1*, 1969. Reconfigured magazine

22. Robert Heinecken, *Untitled* ("Reed & Barton"), spread from *Periodical #1*,
1969. Reconfigured magazine

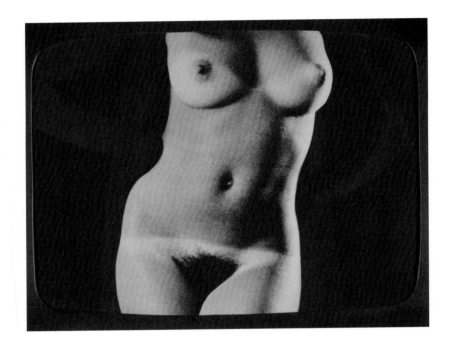

23. Robert Heinecken, *TV/Time Environment*, 1970. Photolithographic transfer on polyester film

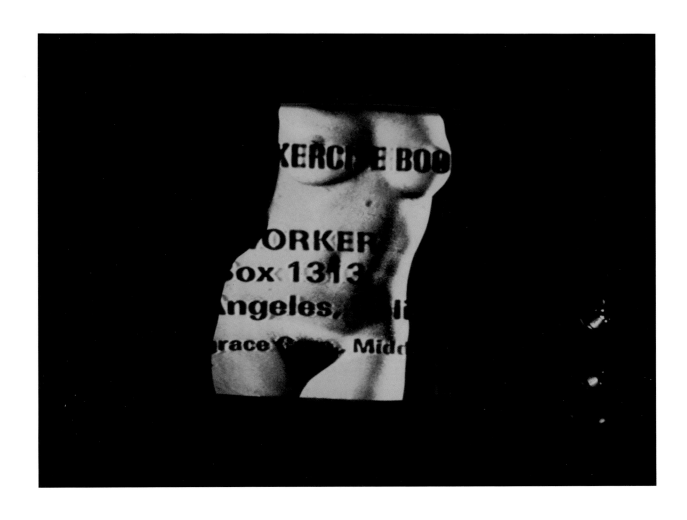

24. Robert Heinecken, *Daytime Color TV Fantasy* ["Xercise boo"], c. 1975, Produced
after the installation *TV/Time Environment*. Four-color photolithograph

STEPHEN SHORE

American National Bank Building
7th & Tyler

PLACE
STAMP
HERE

Pub. by S. Shore - T. Wagner

Post Card

82811-C

dp MADE BY
DEXTER PRESS, INC.
WEST NYACK, NEW YORK

Verso of *American National Bank Building* (plate 26)

25. Stephen Shore, *Civic Center, 3rd and Buchanan*, from the series Amarillo—"Tall in Texas," 1971. Postcard

26. Stephen Shore, *American National Bank Building, 7th & Tyler*, from the series Amarillo—"Tall in Texas," 1971. Postcard

27. Stephen Shore, *Capitol Hotel, 401 S. Pierce*, from the series Amarillo—"Tall in Texas," 1971. Postcard

28. Stephen Shore, *Polk Street*, from the series Amarillo—"Tall in Texas," 1971. Postcard

29. Stephen Shore, *Potter County Courthouse, Betw. 5th & 6th on Taylor*, from the series Amarillo—"Tall in Texas," 1971. Postcard

30. Stephen Shore, *Feferman's Army Navy Store, 201 E. 4th*, from the series Amarillo—"Tall in Texas," 1971. Postcard

31. Stephen Shore, *Doug's Bar B Q No. 1, 3313 S. Georgia*, from the series Amarillo—"Tall in Texas," 1971. Postcard

32. Stephen Shore, *Fenley's Café, 322 W. 3rd*, from the series Amarillo—"Tall in Texas," 1971. Postcard

33. Stephen Shore, *St. Anthony's Hospital, 735 N. Polk*, from the series Amarillo—"Tall in Texas," 1971. Postcard

34. Stephen Shore, *Double Dip, 1323 S. Polk*, from the series Amarillo—"Tall in Texas," 1971. Postcard

35. Stephen Shore, *Albuquerque, New Mexico, June 1972,* from the series American Surfaces, 1972. Inkjet print after commercially processed chromogenic print

36. Stephen Shore, *New York City, April 1972*, from the series American Surfaces, 1972.
Inkjet print after commercially processed chromogenic print

37. Stephen Shore, *Santa Fe, New Mexico, June 1972*, from the series American Surfaces, 1972. Inkjet print after commercially processed chromogenic print

38. Stephen Shore, *Oklahoma City, July 1972*, from the series American Surfaces, 1972. Inkjet print after commercially processed chromogenic print

39. Stephen Shore, *Toledo, Ohio, July 1972*, from the series American Surfaces, 1972. Inkjet print after commercially processed chromogenic print

40. Stephen Shore, *Normal, Illinois, July 1972,* from the series American Surfaces, 1972. Inkjet print after commercially processed chromogenic print

41. Stephen Shore, *N. M. 44, New Mexico, June 1972,* from the series American Surfaces, 1972. Inkjet print after commercially processed chromogenic print

42. Stephen Shore, *Chicago, Illinois, July 1972,* from the series American Surfaces, 1972. Inkjet print after commercially processed chromogenic print

MITCH EPSTEIN

43. Mitch Epstein, *West Side Highway, New York City*, 1977. Chromogenic print

44. Mitch Epstein, *Central Park IV, New York City*, 1977. Chromogenic print

45. Mitch Epstein, *French Quarter II, New Orleans, Louisiana*, 1975. Chromogenic print

46. Mitch Epstein, *Houston, Texas,* 1974. Dye transfer print

47. Mitch Epstein, *Madison Avenue, New York City*, 1973. Dye transfer print

48. Mitch Epstein, *Mardi Gras I, New Orleans, Louisiana*, 1975. Dye transfer print

49. Mitch Epstein, *Miami Beach II, Florida*, 1976. Chromogenic print

50. Mitch Epstein, *Springfield, Massachusetts*, 1973. Dye transfer print

51. Mitch Epstein, *Topanga Canyon, California*, 1974. Dye transfer print

52. Mitch Epstein, *Massachusetts Turnpike,* 1973. Dye transfer print

53. Mitch Epstein, *Vietnam Veteran's Parade, New York City*, 1973. Dye transfer print

HELEN LEVITT

54. Helen Levitt, Untitled still from *Projects: Helen Levitt in Color, 1971–74,* The Museum of Modern Art, New York, 1974. Forty color photographs shown in continuous projection

55. Helen Levitt, Untitled still from *Projects: Helen Levitt in Color, 1971–74*, The Museum of Modern Art, New York, 1974. Forty color photographs shown in continuous projection

56. Helen Levitt, Untitled still from *Projects: Helen Levitt in Color, 1971–74*, The Museum of Modern Art, New York, 1974. Forty color photographs shown in continuous projection

89

59. Helen Levitt, Untitled still from *Projects: Helen Levitt in Color, 1971–74,* The Museum
of Modern Art, New York, 1974. Forty color photographs shown in continuous projection

60. Helen Levitt, Untitled still from *Projects: Helen Levitt in Color, 1971–74*, The Museum of Modern Art, New York, 1974. Forty color photographs shown in continuous projection

57. Helen Levitt, Untitled still from *Projects: Helen Levitt in Color, 1971–74*, The Museum of Modern Art, New York, 1974. Forty color photographs shown in continuous projection

58. Helen Levitt, Untitled still from *Projects: Helen Levitt in Color, 1971–74*, The Museum of Modern Art, New York, 1974. Forty color photographs shown in continuous projection

61. Helen Levitt, Untitled still from *Projects: Helen Levitt in Color, 1971–74*, The Museum
of Modern Art, New York, 1974. Forty color photographs shown in continuous projection

62. Helen Levitt, Untitled still from *Projects: Helen Levitt in Color, 1971–74*, The Museum of Modern Art, New York, 1974. Forty color photographs shown in continuous projection

JOEL MEYEROWITZ

63. Joel Meyerowitz, *From the Car, New York Thruway*, 1975. Chromogenic print 64. Joel Meyerowitz, *From the Car, New York Thruway*, 1973. Chromogenic print

65. Joel Meyerowitz, *From the Car, Stonehenge, England*, 1966. Chromogenic print

66. Joel Meyerowitz, *From the Car, New York Thruway*, 1975. Chromogenic print

67. Joel Meyerowitz, *From the Car, Taos, New Mexico*, 1971. Chromogenic print

68. Joel Meyerowitz, *From the Car, New York Thruway*, 1974. Chromogenic print

EVE SONNEMAN

69. Eve Sonneman, *Landscape/Cloud, New Mexico,* 1978. Two Cibachrome prints

70. Eve Sonneman, *Sight/Sound: For Mike Goldberg, Samos, Greece*, 1977. Two Cibachrome prints

71. Eve Sonneman, *Photo Novellas, Bordeaux*, 1980. Two Cibachrome prints

72. Eve Sonneman, *Newspaper, New York*, 1980. Two Cibachrome prints

73. Eve Sonneman, *Cropduster, Clovis, New Mexico*, 1980. Two Cibachrome prints

74. Eve Sonneman, *Goldfish, Athens*, 1979. Two Cibachrome prints

75. Eve Sonneman, *The Instant and the Moment*, Greece, 1977. Two Cibachrome prints

76. Eve Sonneman, *Oranges, Manhattan*, 1978. Two Cibachrome prints

NEAL SLAVIN

77. Neal Slavin, *International Twins Association, Muncie, Indiana,* c. 1976. Chromogenic print

78. Neal Slavin, *Salt Lake Mormon Tabernacle Choir*, c. 1976. Chromogenic print

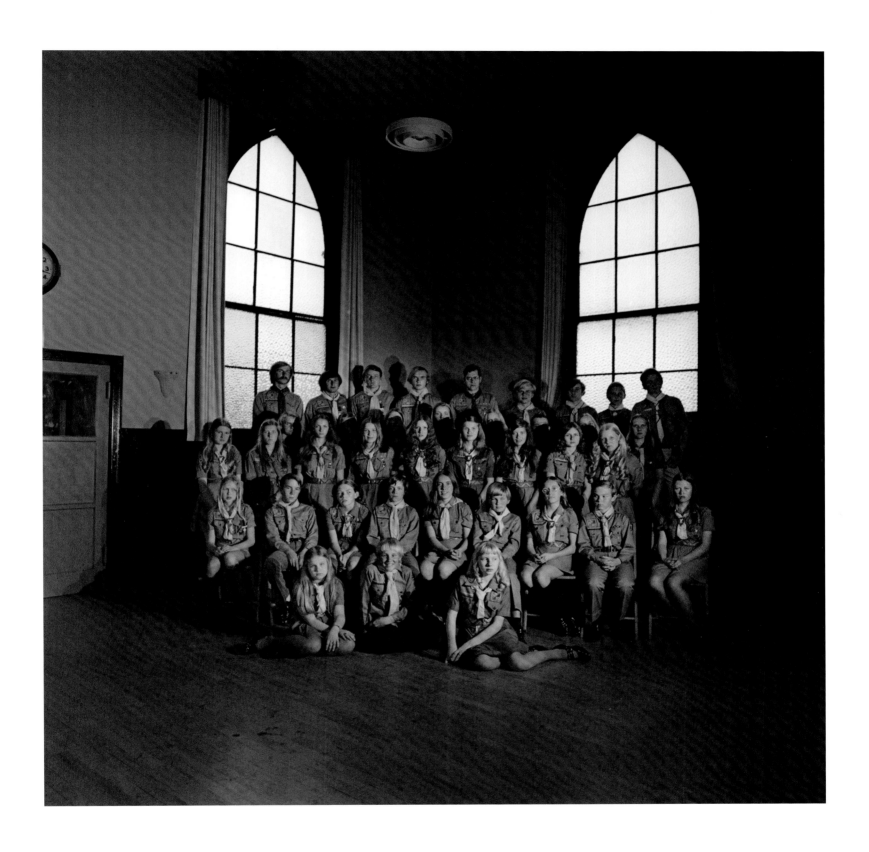

79. Neal Slavin, *Lithuanian Scouts Association, Inc., Rancho Palos Verdes, California*, c. 1976. Chromogenic print

80. Neal Slavin, *Continental Baths, New York, New York*, c. 1976. Chromogenic print

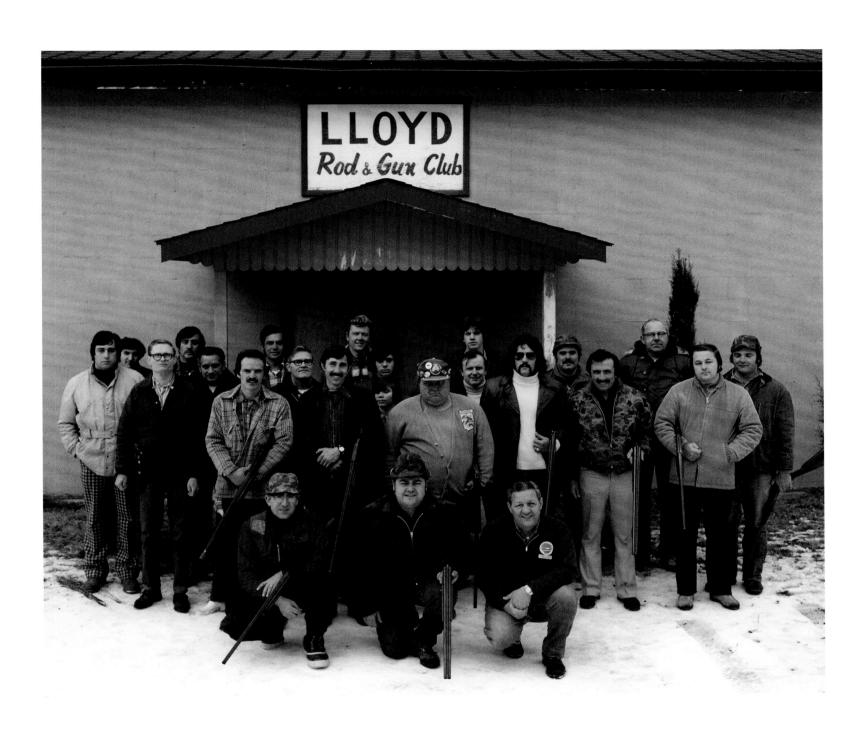

81. Neal Slavin, *Lloyd Rod and Gun Club, Highland, New York*, c. 1976. Chromogenic print

82. Neal Slavin, *Wilhelmina Models, Inc., New York, New York*, c. 1976. Chromogenic print

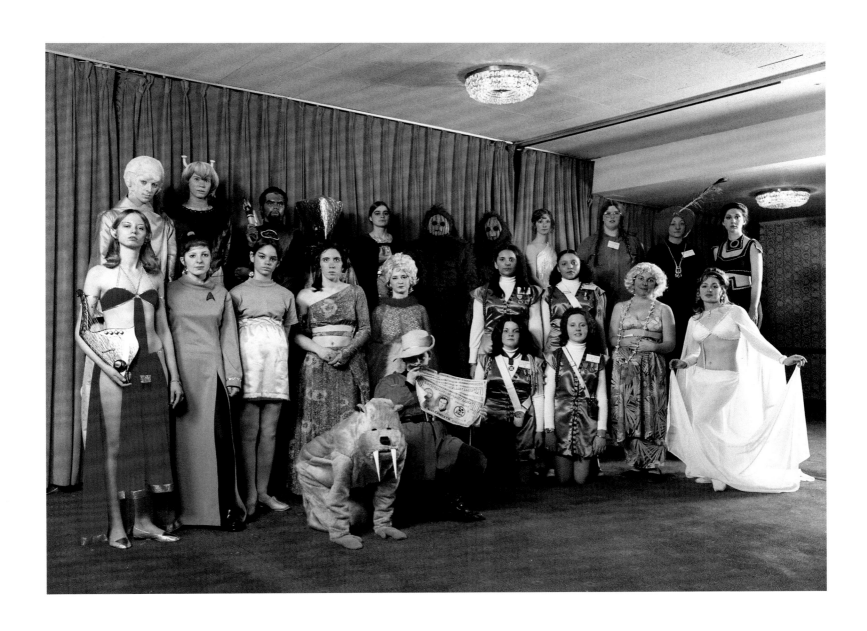

83. Neal Slavin, *The Star Trek Convention, Star Trek Associates, A Division of Tellurian Enterprises, Inc., Brooklyn, New York*, c. 1976. Chromogenic print

84. Neal Slavin, *Camp Tahoe, Loch Sheldrake, New York*, c. 1976. Chromogenic print

85. Neal Slavin, *Miss U.S.A. Pageant, Miss Universe, Inc., New York, New York*, c. 1976. Chromogenic print

LES KRIMS

86. Les Krims, *Nude with Balanced Severed Ear and Pasted Peanuts,* 1974. Inkjet print after unique Polaroid

87. Les Krims, *Goldfish Bowl Press and Plug*, 1974.
Inkjet print after unique Polaroid

88. Les Krims, *Attacking Banana Marauders*, 1974. Inkjet print after unique Polaroid

89. Les Krims, *Kosher Pickles, Gentile Woman*, 1974. Inkjet print after unique Polaroid

90. Les Krims, *Man with Tattoo of a Satyr Displaying the "Up Yours" Sign*, 1975. Inkjet print after
unique Polaroid

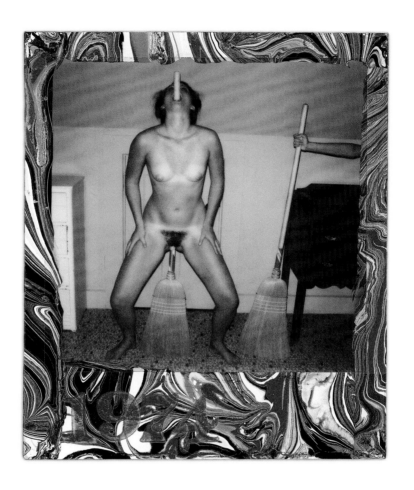

91. Les Krims, *Optical Illusion*, 1974. Inkjet print after unique Polaroid

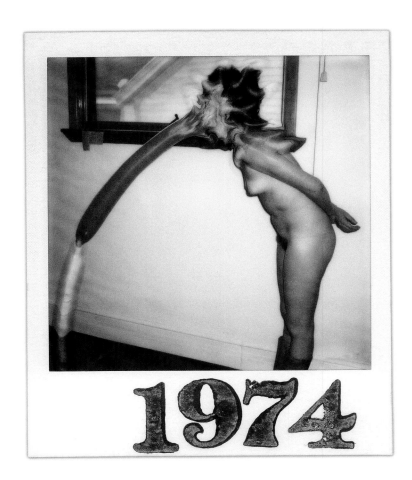

92. Les Krims, *High-Speed, Red Shape Impact Image*, 1974.
Inkjet print after unique Polaroid

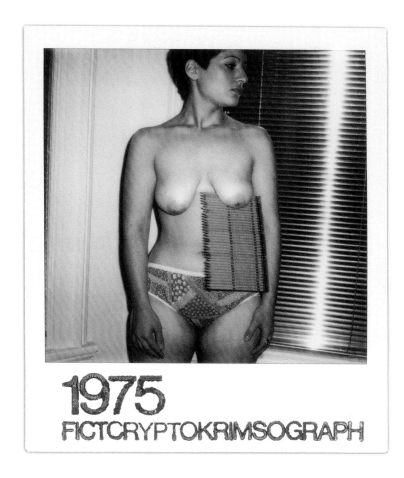

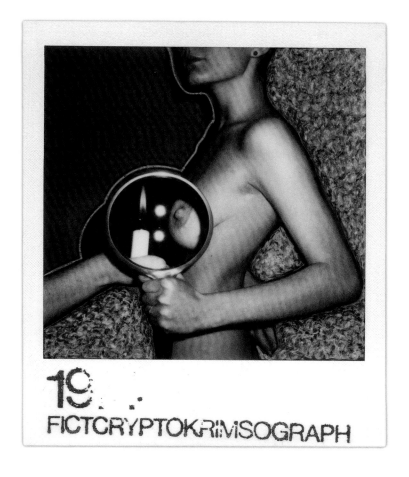

93. Les Krims, *Pencil Test #7*, 1975. Inkjet print after unique Polaroid

94. Les Krims, *Magnified Heat Sources*, 1974. Inkjet print after unique Polaroid

JOEL STERNFELD

95. Joel Sternfeld, *Summer 1976, Chicago?*, 1976. Chromogenic print

96. Joel Sternfeld, *Chicago, August 1976 (On the L)*, 1976. Chromogenic print

97. Joel Sternfeld, *New York City, June 1976 (Chelsea)*, 1976. Chromogenic print

98. Joel Sternfeld, *Summer 1976, probably Chicago*, 1976. Chromogenic print 99. Joel Sternfeld, *Chicago, August 1976*, 1976. Chromogenic print

100. Joel Sternfeld, *New York City, 1976 (Eighth Avenue?)*, 1976. Chromogenic print 　　　101. Joel Sternfeld, *New York City, 1976 (Park Avenue?)*, 1976. Chromogenic print

102. Joel Sternfeld, *July 1976, Chicago*, 1976. Chromogenic print 103. Joel Sternfeld, *New York City, May 1976 (SoHo)*, 1976. Chromogenic print

WILLIAM CHRISTENBERRY

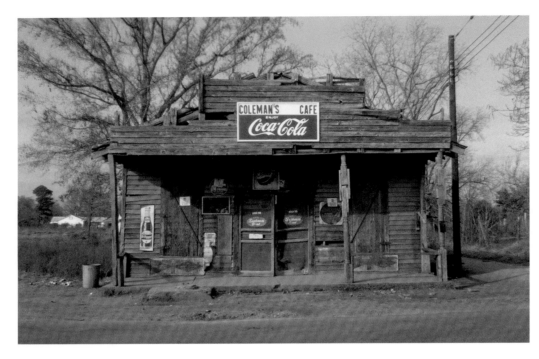

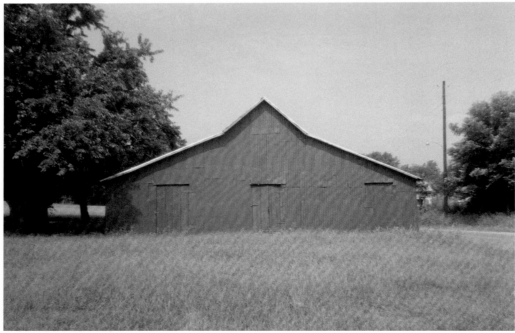

104. William Christenberry, *Coleman's Café, Greensboro, Alabama*, 1971. Dye transfer print 105. William Christenberry, *Green Warehouse, Newbern, Alabama*, 1973. Pigment print 134

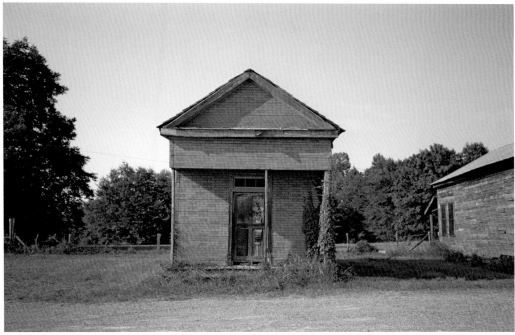

106. William Christenberry, *South End of Palmist Building, Havana Junction, Alabama (Walker Evans to right)*, 1973. Ektacolor print

107. William Christenberry, *Building with False Brick Siding, Warsaw, Alabama*, 1974. Dye transfer print

108. William Christenberry, *Grave with Egg Carton Cross, Hale County, Alabama*, 1975. Ektacolor print

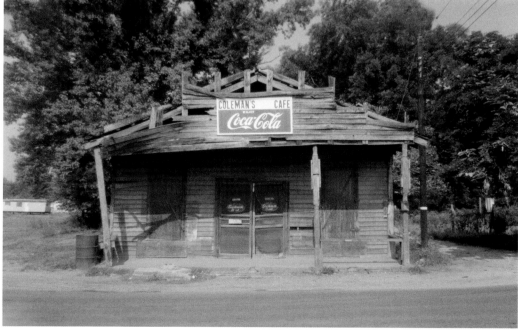

109. William Christenberry, *Green Warehouse, Newbern, Alabama*, 1976. Evercolor print 110. William Christenberry, *Coleman's Café, Greensboro, Alabama*, 1976. Pigment print

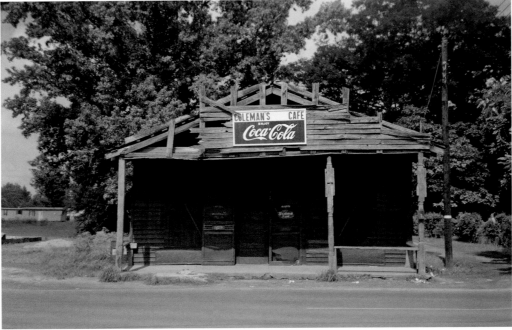

111. William Christenberry, *Corn Sign with Storm Cloud, near Greensboro, Alabama,*
1977. Dye transfer print

112. William Christenberry, *Coleman's Café, Greensboro, Alabama,* 1977. Pigment print

113. William Christenberry, *House and Car, near Akron, Alabama*, 1978. Dye transfer print

114. William Christenberry, *Green Warehouse, Newbern, Alabama*, 1978. Pigment print

115. William Christenberry, *Kudzu with Sky (Summer), near Akron, Alabama*, 1978. Ektacolor print

116. William Christenberry, *Black House, Red Roses, and Rooster (for William Eggleston), Hinds County, Mississippi*, 1979. Ektacolor print

117. William Christenberry, *Coleman's Café, Greensboro, Alabama*, 1979. Pigment print 118. William Christenberry, *Coleman's Café, Greensboro, Alabama*, 1979. Pigment print

WILLIAM EGGLESTON

119. William Eggleston, *Memphis*, c. 1972. Dye transfer print

120. William Eggleston, *Sumner, Mississippi, Cassidy Bayou in Background*, c. 1970. Dye transfer print

121. William Eggleston, *Jackson, Mississippi,* c. 1969–70. Dye transfer print

122. William Eggleston, *Southern Environs of Memphis*, c. 1969–70. Dye transfer print

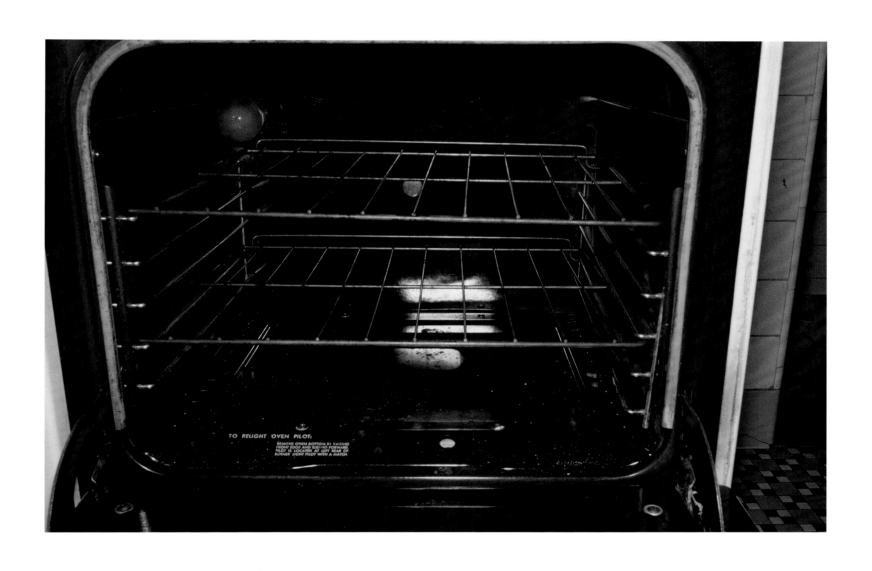

123. William Eggleston, *Memphis*, c. 1969–71. Dye transfer print

124. William Eggleston, *Greenwood, Mississippi*, 1973. Dye transfer print

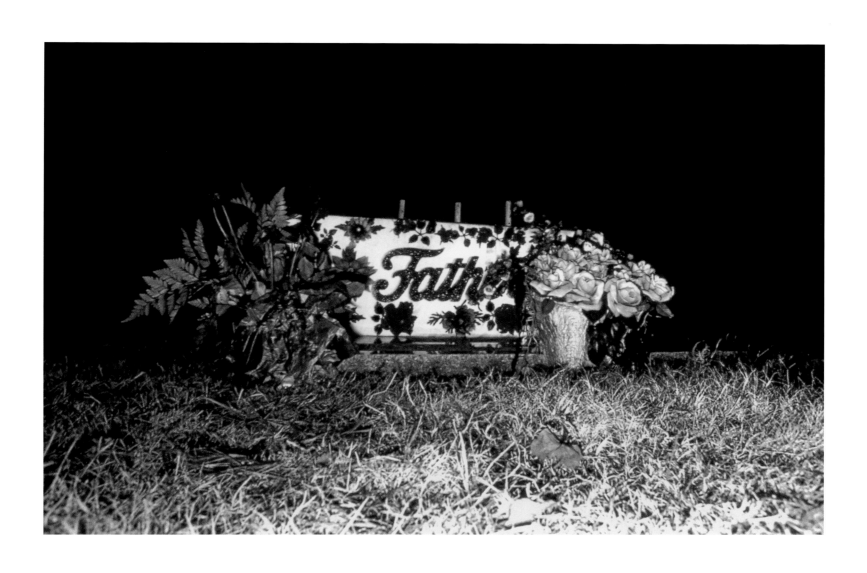

125. William Eggleston, *Memphis, Tennessee*, 1971. Dye transfer print

126. William Eggleston, *Tallahatchie County, Mississippi,* c. 1972. Dye transfer print 127. William Eggleston, *Greenwood, Mississippi,* c. 1972. Dye transfer print

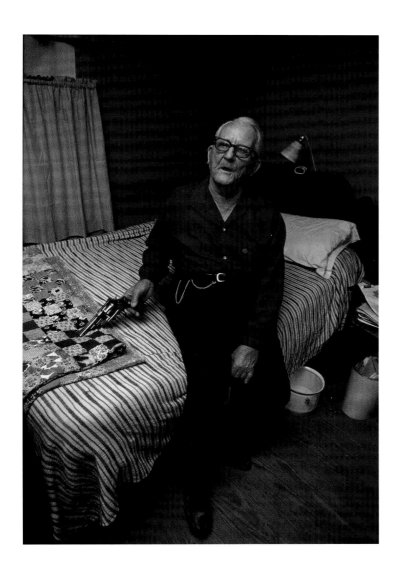

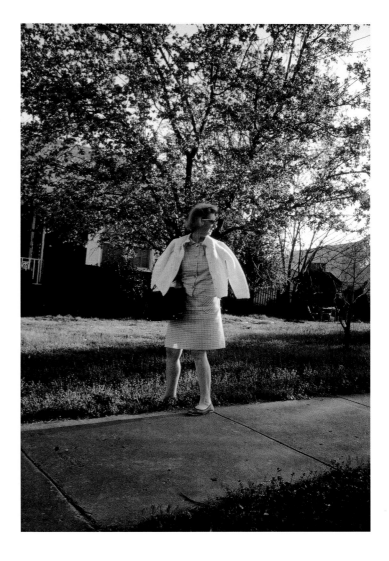

128. William Eggleston, *Morton, Mississippi*, c. 1969–70. Dye transfer print

129. William Eggleston, *Memphis*, c. 1969–70. Dye transfer print

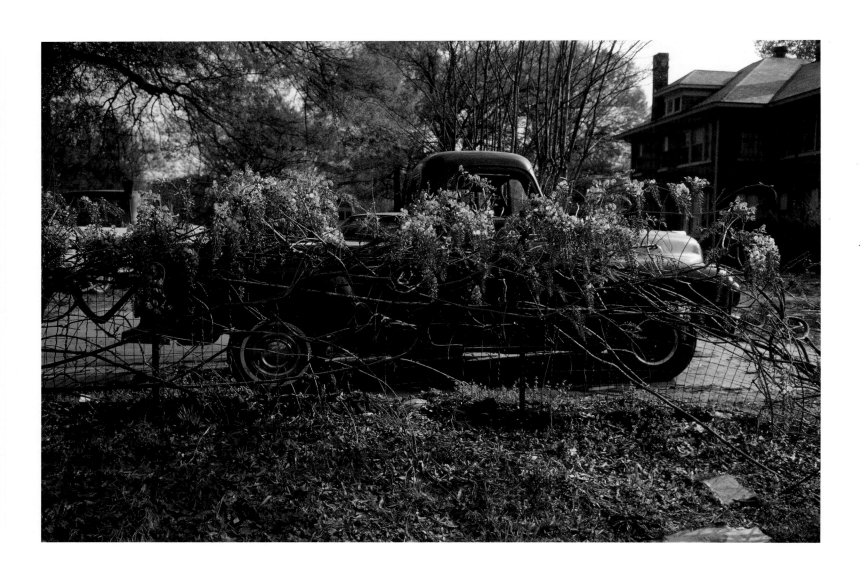

130. William Eggleston, *Memphis*, c. 1969–70. Dye transfer print

131. William Eggleston, *Highway 78, Northern Mississippi*, 1972. Dye transfer print

132. William Eggleston, *Huntsville, Alabama*, c. 1972. Dye transfer print

133. William Eggleston, *Tallahatchie County, Mississippi*, c. 1969–71. Dye transfer print

134. William Eggleston, *Morton, Mississippi*, c. 1972. Dye transfer print 135. William Eggleston, *Near Greenwood, Mississippi*, c. 1971. Dye transfer print 156

136. William Eggleston, *Near Minter City and Glendora, Mississippi*, c. 1969–70. Dye transfer print 137. William Eggleston, *Huntsville, Alabama*, c. 1969–70. Dye transfer print

138. William Eggleston, *Memphis*, c. 1969–70. Dye transfer print

139. William Eggleston, *Memphis*, c. 1969–70. Dye transfer print

140. William Eggleston, *Nashville, Tennessee*, 1971. Dye transfer print

141. William Eggleston, *Peaches, Near Greenville, Mississippi*, c. 1973. Dye transfer print

142. William Eggleston, *Downtown Morton, Mississippi*, c. 1969–70. Dye transfer print

JAN GROOVER

143. Jan Groover, *Untitled*, 1979. Chromogenic print

144. Jan Groover, *Untitled*, 1978. Chromogenic print

145. Jan Groover, *Untitled*, 1978. Chromogenic print

146. Jan Groover, *Untitled*, 1978. Chromogenic print

147. Jan Groover, *Untitled*, 1978. Chromogenic print

148. Jan Groover, *Untitled*, 1979. Chromogenic print

149. Jan Groover, *Untitled*, 1980. Chromogenic print

BARBARA KASTEN

150. Barbara Kasten, *Untitled 11*, c. 1975. Cyanotype

151. Barbara Kasten, *Untitled 9*, c. 1975. Cyanotype

152. Barbara Kasten, *Untitled 28*, c. 1975. Cyanotype

153. Barbara Kasten, *Construct II-B*, 1979. Polaroid photograph

154. Barbara Kasten, *Construct II-D*, 1980. Polaroid photograph

155. Barbara Kasten, *Construct I-A*, 1979. Polaroid photograph

156. Barbara Kasten, *Construct II-A*, 1980. Polaroid photograph

157. Barbara Kasten, *Construct IV-C,* 1980. Polaroid photograph 158. Barbara Kasten, *Construct III-D,* 1980. Polaroid photograph

159. Barbara Kasten, *Construct III-C,* 1980. Polaroid photograph

160. Barbara Kasten, *Construct III-F,* 1980. Polaroid photograph

161. Barbara Kasten, *Construct IV-B*, 1979. Polaroid photograph

JOHN DIVOLA

162. John Divola, *Zuma #3*, 1977. Dye transfer print

163. John Divola, *Zuma #7*, 1977. Dye transfer print

164. John Divola, *Zuma #5*, 1977. Dye transfer print

165. John Divola, *Zuma #38*, 1978. Dye transfer print

166. John Divola, *Zuma #12*, 1977. Dye transfer print

167. John Divola, *Zuma #19*, 1978. Dye transfer print

168. John Divola, *Zuma #21*, 1977. Dye transfer print

169. John Divola, *Zuma #25*, 1978. Dye transfer print

170. John Divola, *Zuma #14*, 1978. Dye transfer print

171. John Divola, *Zuma #29*, 1978. Dye transfer print

JOHN PFAHL

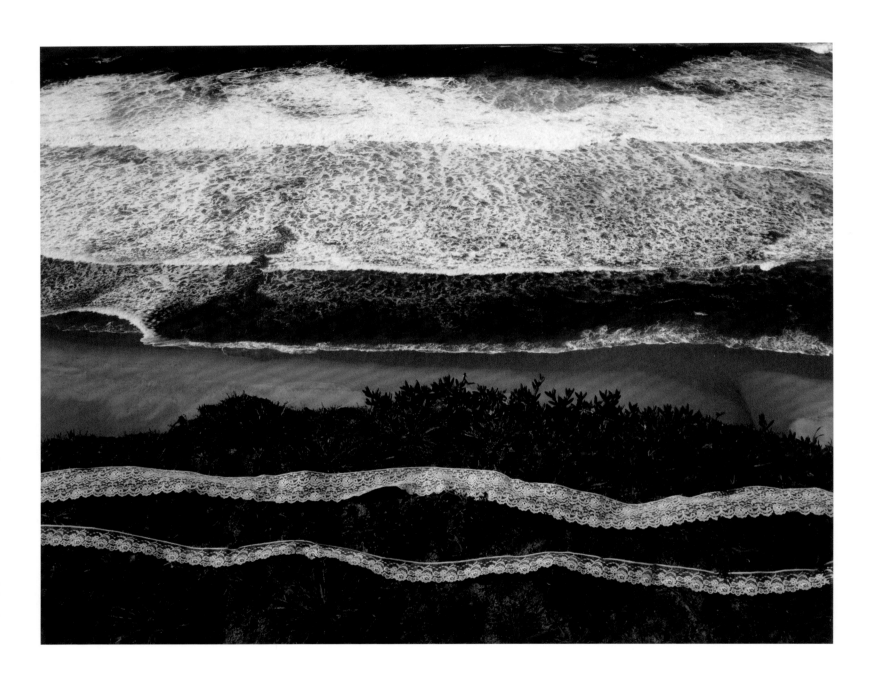

172. John Pfahl, *Wave, Lave, Lace, Pescadero Beach, CA*, 1978. Dye transfer print

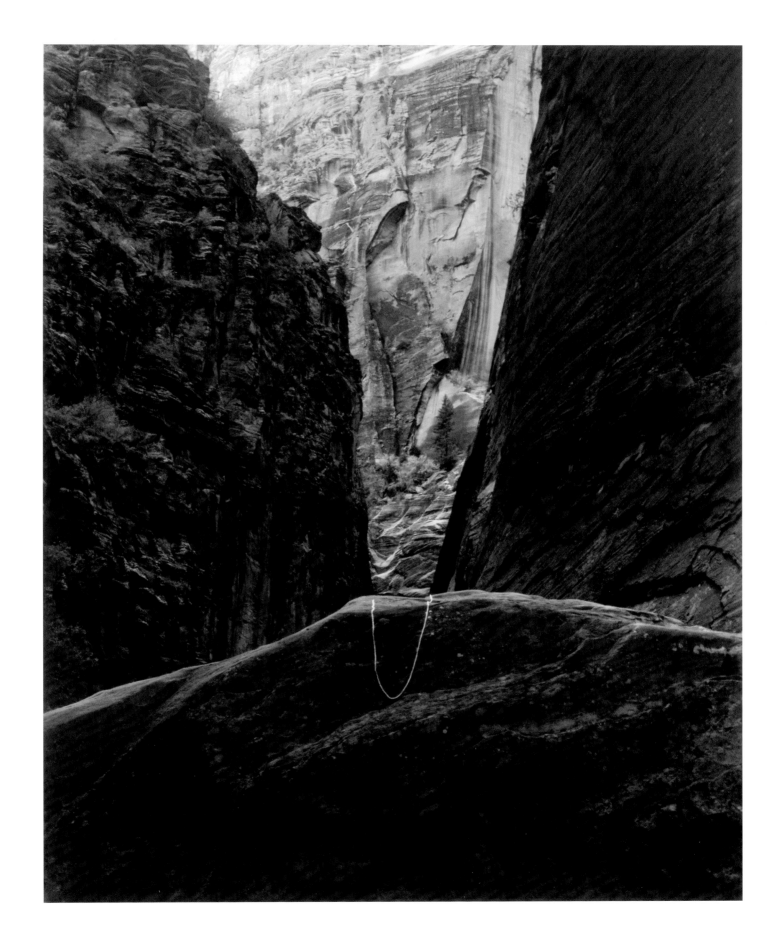

173. John Pfahl, *Canyon Point, Zion National Park, UT*, 1977. Dye transfer print

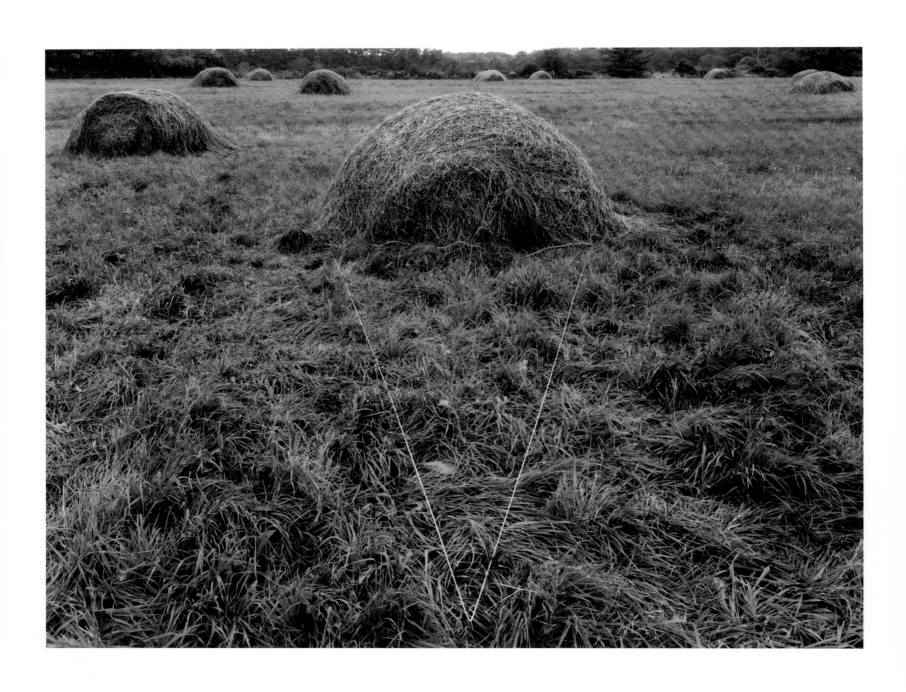

174. John Pfahl, *Haystack Cone, Freeport, ME*, 1976. Dye transfer print

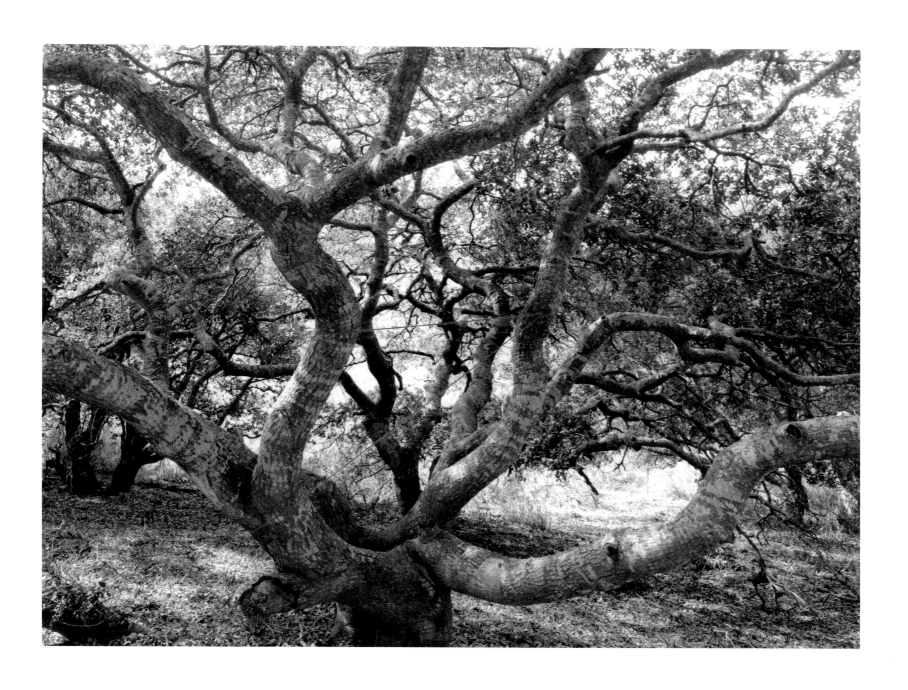

175. John Pfahl, *Live Oak Lightening, Lompoc, CA*, 1978. Dye transfer print

176. John Pfahl, *Australian Pines, Fort Desoto, FL*, 1977. Dye transfer print

177. John Pfahl, *Slanting Forest, Artpark, Lewiston, NY*, 1975. Dye transfer print

178. John Pfahl, *Shed with Blue Dotted Lines, Penland, NC*, 1975. Dye transfer print

179. John Pfahl, *Six Oranges, Delaware Park, Buffalo, NY*, 1975. Dye transfer print

180. John Pfahl, *Red Setters in Red Field, Charlotte, NC*, 1976. Dye transfer print

181. John Pfahl, *Pink Rock Rectangle, Artpark, Lewiston, NY*, 1975. Dye transfer print

RICHARD MISRACH

182. Richard Misrach, *Hawaii XVII*, 1978. Dye transfer print

183. Richard Misrach, *Hawaii*, 1978. Dye transfer print 184. Richard Misrach, *Hawaii XV*, 1978. Dye transfer print

185. Richard Misrach, *Hawaii XIII*, 1978. Dye transfer print 186. Richard Misrach, *Hawaii XIV*, 1978. Dye transfer print

187. Richard Misrach, *Hawaii VI*, 1978. Dye transfer print

188. Richard Misrach, *Hawaii VII*, 1978. Dye transfer print

189. Richard Misrach, *Hawaii IV*, 1978. Dye transfer print

190. Richard Misrach, *Hawaii XII*, 1978. Dye transfer print

191. Richard Misrach, *Hawaii V,* 1978. Dye transfer print 192. Richard Misrach, *Hawaii IX,* 1978. Dye transfer print

193. Richard Misrach, *Hawaii VIII*, 1978. Dye transfer print

STEPHEN SHORE

194. Stephen Shore, *Church Street and Second Street, Easton, Pennsylvania, June 20, 1974*, 1974. Chromogenic print

195. Stephen Shore, *Holden Street, North Adams, Massachusetts, July 13, 1974*, 1974. Chromogenic print

196. Stephen Shore, *Meeting Street, Charlestown, South Carolina, August 3, 1975*, 1975. Chromogenic print

197. Stephen Shore, *U.S. 10, Post Falls, Idaho, August 25, 1974*, 1974. Chromogenic print

198. Stephen Shore, *Proton Avenue, Gull Lake, Saskatchewan, August 18, 1974*, 1974. Chromogenic print

199. Stephen Shore, *Presidio, Texas, February 21, 1975*, 1975. Chromogenic print

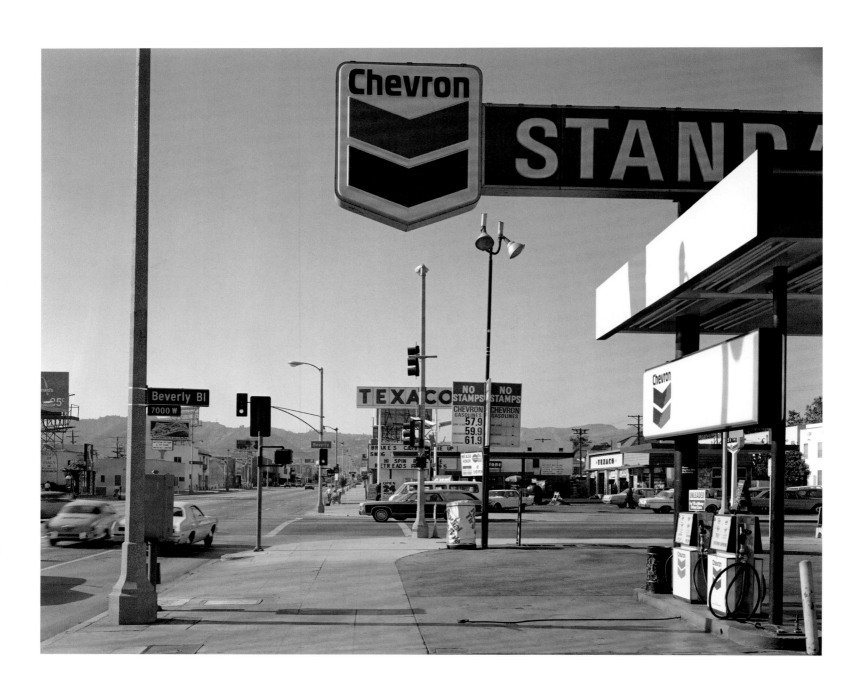

200. Stephen Shore, *Beverly Boulevard and La Brea Avenue, Los Angeles, California, June 21, 1975*, 1975. Chromogenic print

201. Stephen Shore, *Sault Ste. Marie, Ontario, August 13, 1974*, 1974. Chromogenic print

202. Stephen Shore, *Fifth Street and Broadway, Eureka, California, September 2, 1974*, 1974.
Chromogenic print

203. Stephen Shore, *Mount Blue Shopping Center, Farmington, Maine, July 30, 1974*,
1974. Chromogenic print

204. Stephen Shore, *U.S. 22, Union, New Jersey, April 24, 1974*, 1974. Chromogenic print

205. Stephen Shore, *West Fifteenth Street and Vine Street, Cincinnati, Ohio, May 15, 1974*, 1974. Chromogenic print

JOEL MEYEROWITZ

206. Joel Meyerowitz, *Red Interior, Provincetown*, 1976. Chromogenic print

207. Joel Meyerowitz, *Cumberland Farms, Provincetown*, 1976. Chromogenic print

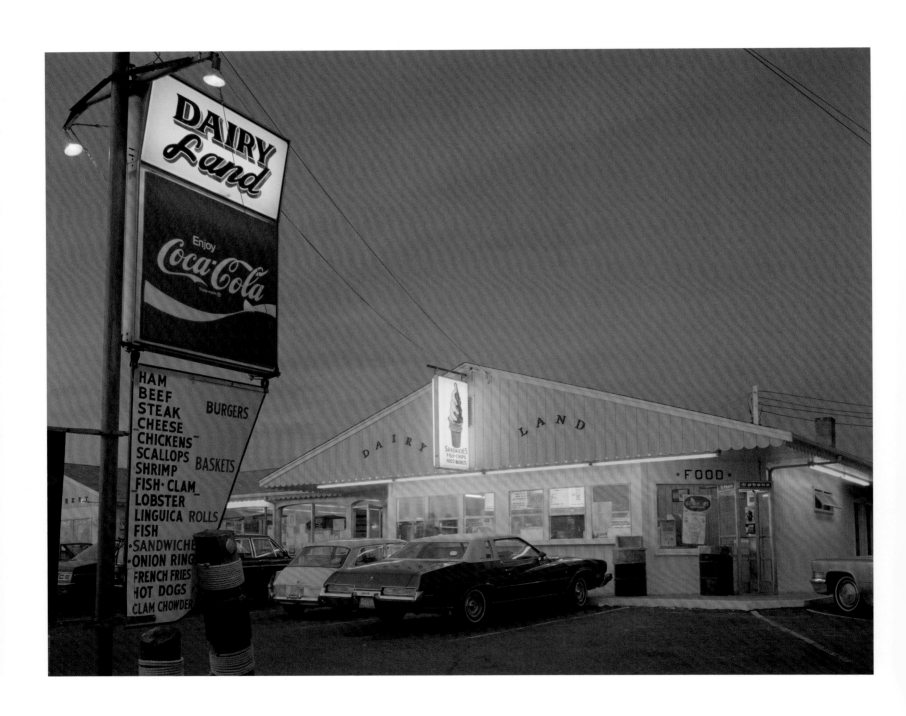

208. Joel Meyerowitz, *Dairy Land, Provincetown*, 1976. Chromogenic print

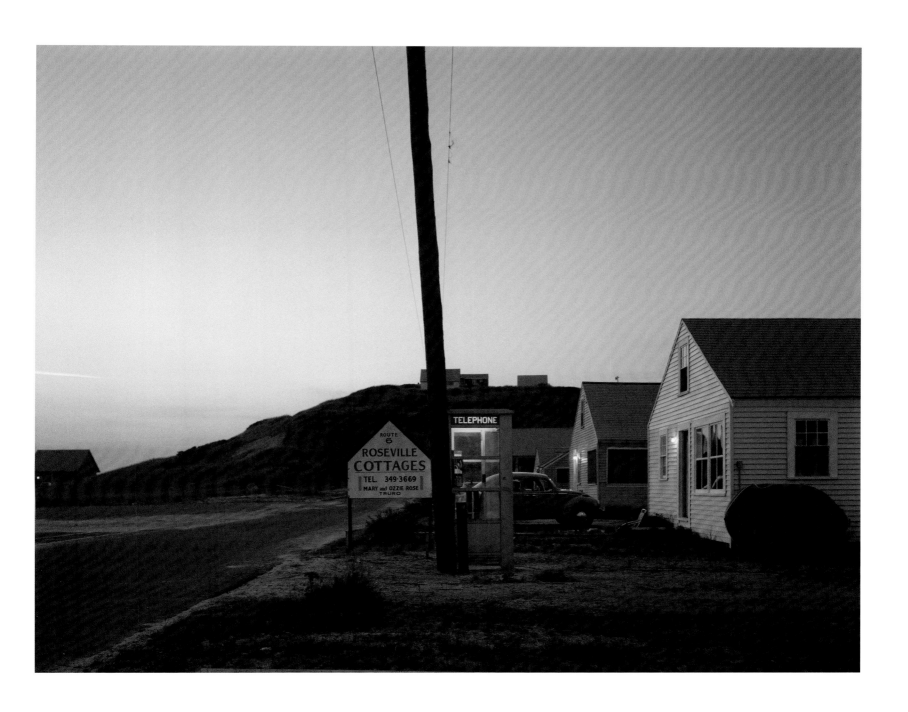

209. Joel Meyerowitz, *Roseville Cottages, Truro*, 1976. Chromogenic print

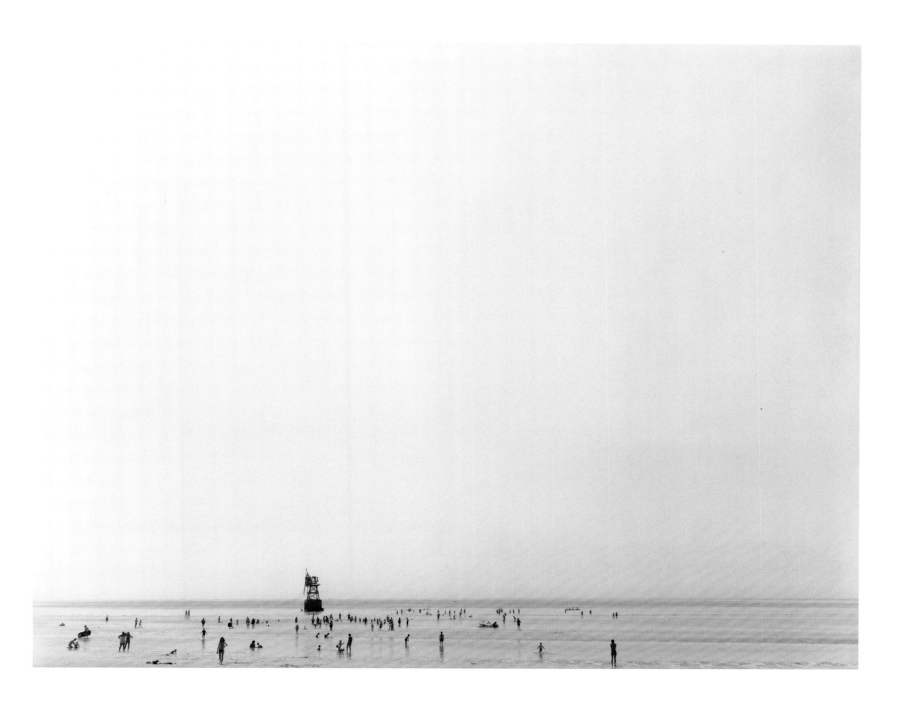

210. Joel Meyerowitz, *Cold Storage Beach, Truro*, 1976. Chromogenic print

211. Joel Meyerowitz, *Diane, Cape Cod*, 1982. Chromogenic print

212. Joel Meyerowitz, *Caroline, Cape Cod*, 1983. Chromogenic print

213. Joel Meyerowitz, *Eliza, Cape Cod*, 1982. Chromogenic print

214. Joel Meyerowitz, *Darrell, Cape Cod*, 1983. Chromogenic print

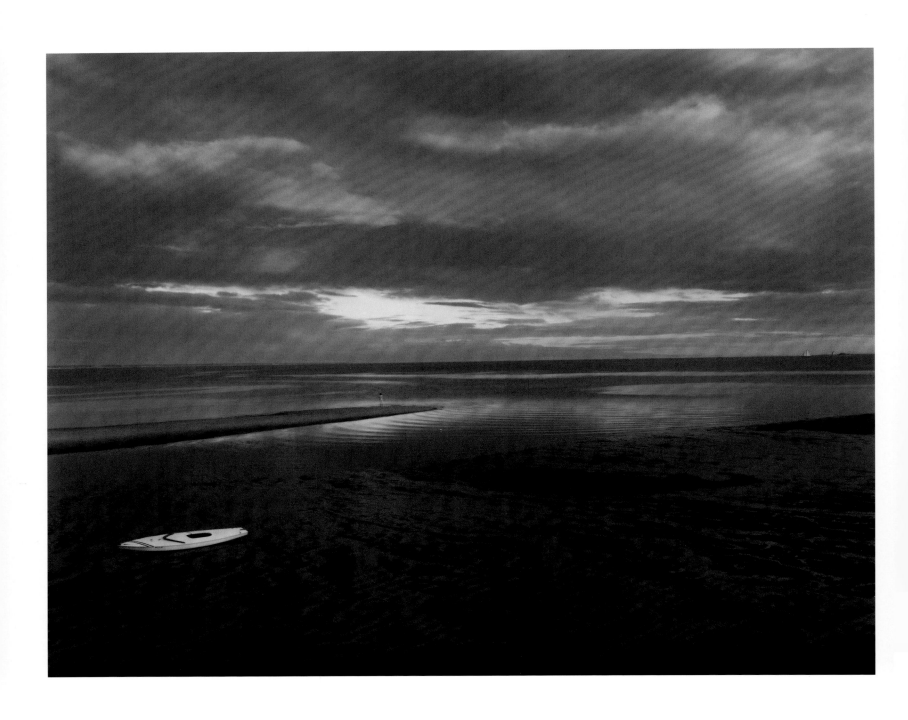

215. Joel Meyerowitz, *Bay/Sky, Provincetown*, 1977. Chromogenic print

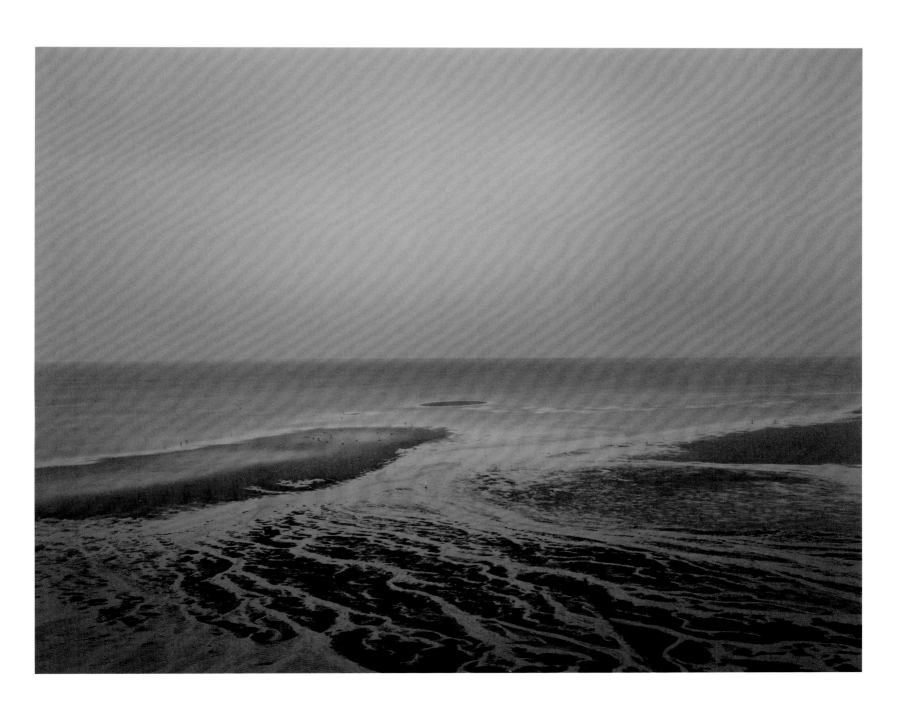

216. Joel Meyerowitz, *Bay/Sky, Provincetown*, 1977. Chromogenic print

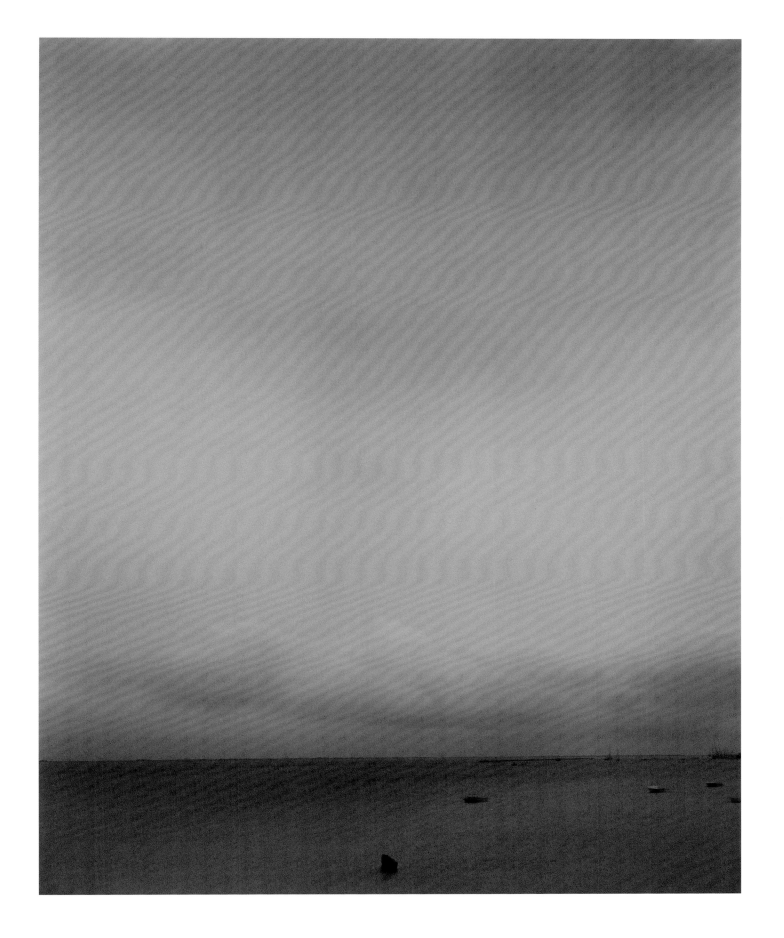

HARRY CALLAHAN

218. Harry Callahan, *Untitled*, c. 1977. Chromogenic print

219. Harry Callahan, *Untitled,* c. 1977. Chromogenic print

220. Harry Callahan, *Untitled*, c. 1977. Chromogenic print

221. Harry Callahan, *Untitled*, c. 1977. Chromogenic print

222. Harry Callahan, *Untitled*, c. 1977. Chromogenic print

223. Harry Callahan, *Untitled*, c. 1977. Chromogenic print

224. Harry Callahan, *Untitled*, c. 1977. Chromogenic print 225. Harry Callahan, *Untitled*, c. 1977. Chromogenic print

226. Harry Callahan, *Untitled*, c. 1977. Chromogenic print

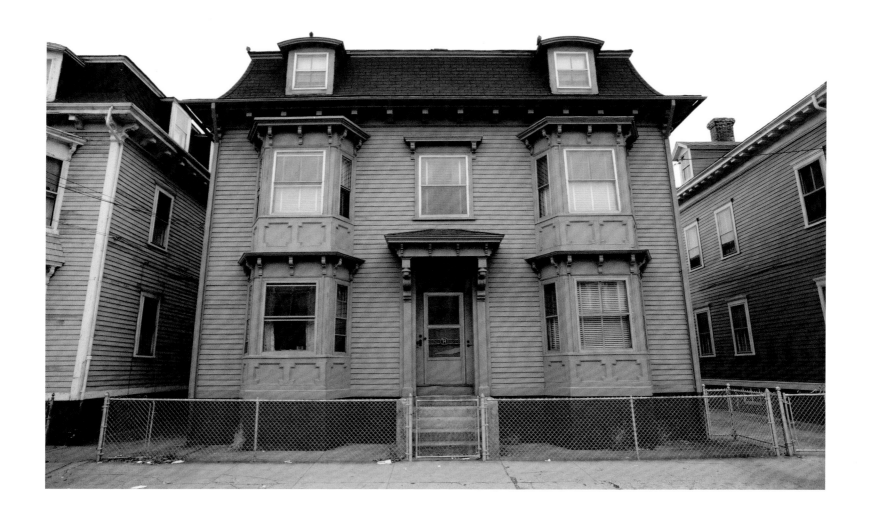

227. Harry Callahan, *Untitled*, c. 1977. Chromogenic print

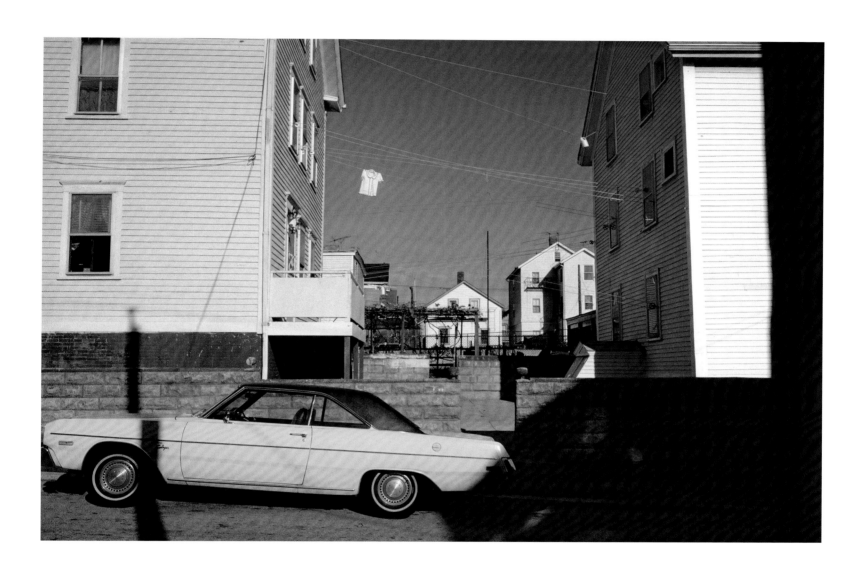

228. Harry Callahan, *Untitled*, c. 1977. Chromogenic print

JOEL STERNFELD

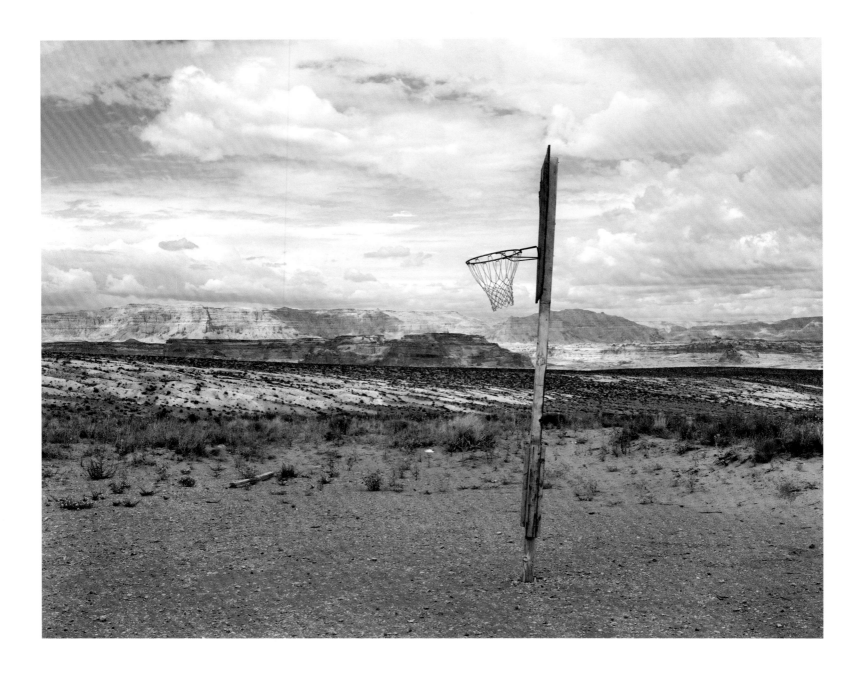

229. Joel Sternfeld, *Near Lake Powell, Arizona, August 1979*, 1979. Chromogenic print

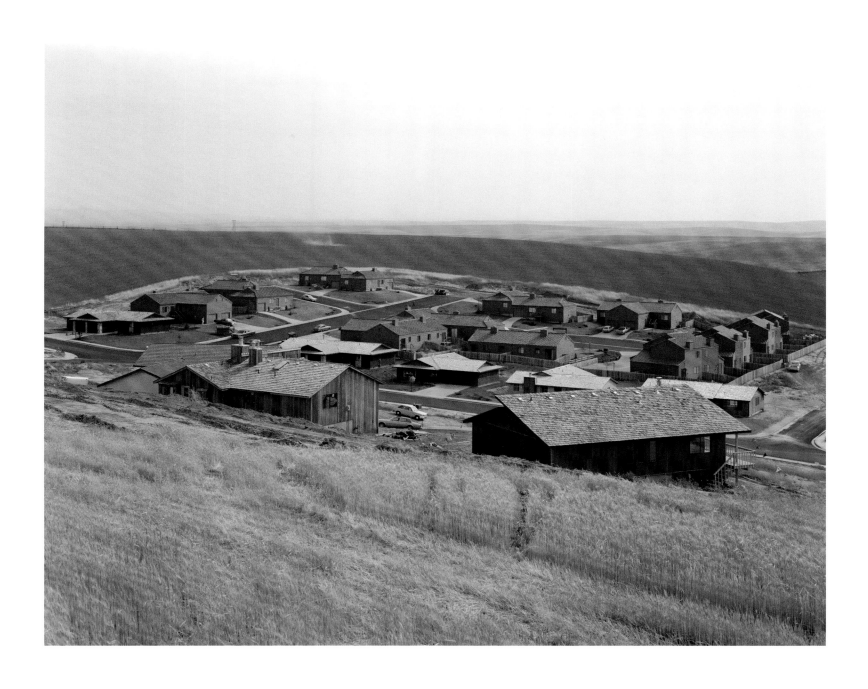

230. Joel Sternfeld, *Pendleton, Oregon, June 1980*, 1980. Chromogenic print

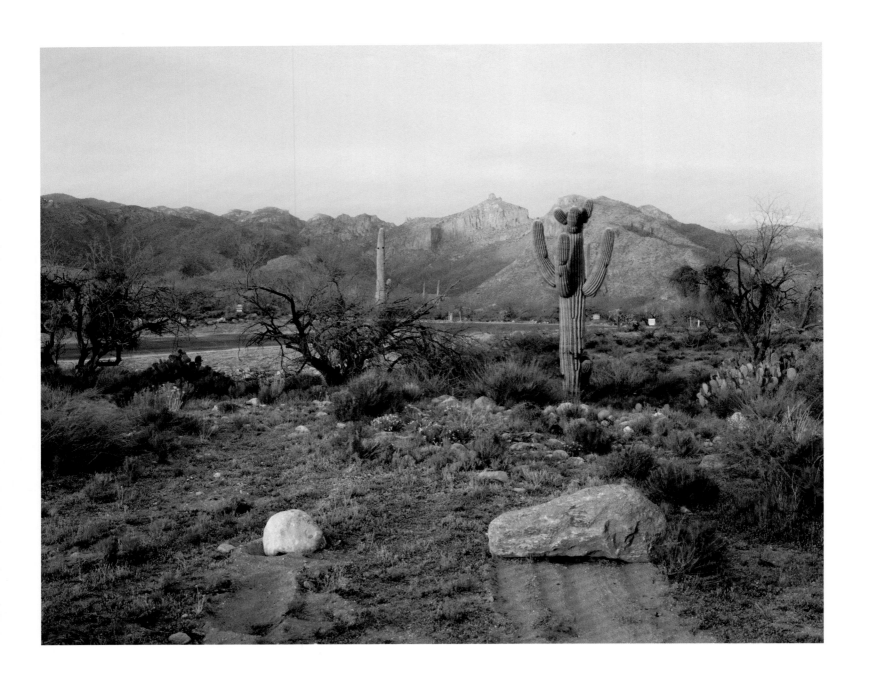

231. Joel Sternfeld, *Near Tucson, Arizona, April 1979*, 1979. Chromogenic print

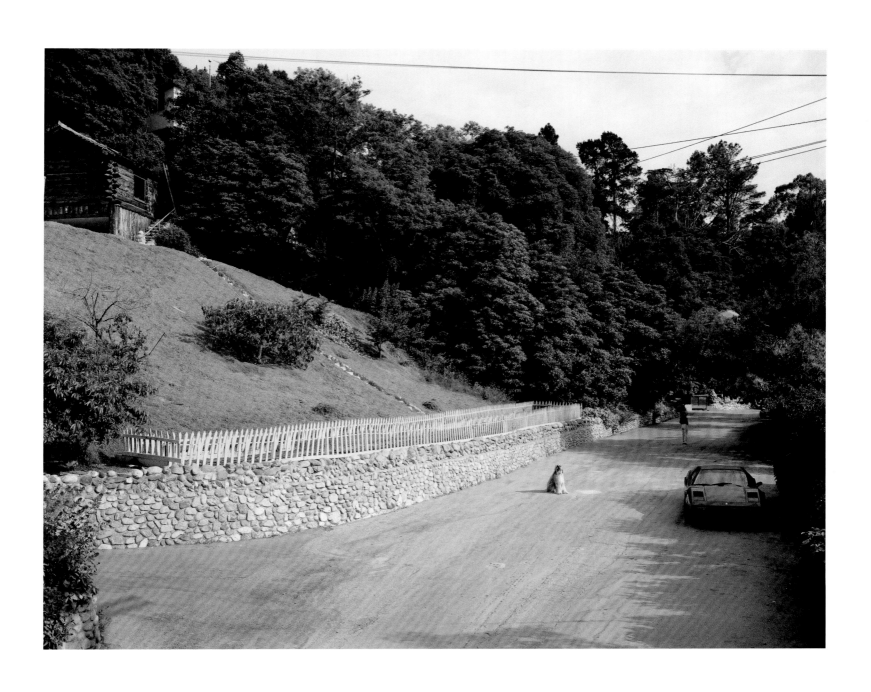

232. Joel Sternfeld, *Rustic Canyon, Santa Monica, California, May 1979*, 1979. Chromogenic print

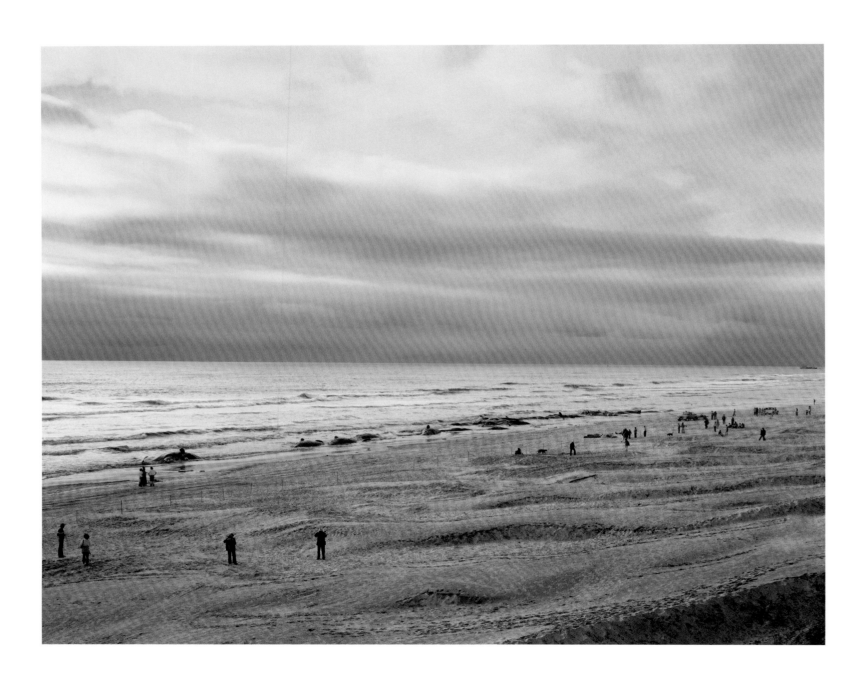

233. Joel Sternfeld, *Approximately 17 of 41 Sperm Whales That Beached and Subsequently Died,*
Florence, Oregon, June 1979, 1979. Chromogenic print

234. Joel Sternfeld, *Wet'n Wild Aquatic Theme Park, Orlando, Florida, September 1980*, 1980.
Chromogenic print

LEO RUBINFIEN

235. Leo Rubinfien, *At Los Angeles International Airport,* 1981. Chromogenic print

236. Leo Rubinfien, *In Hamburg Harbor,* 1981. Chromogenic print

237. Leo Rubinfien, *On a Train to Brighton, England,* 1980. Chromogenic print

238. Leo Rubinfien, *Americans in the Breakfast Room of the Chateau d'Artigny, Montbazon, France*, 1981. Chromogenic print

239. Leo Rubinfien, *Leaving Bangkok at Sunrise*, 1979. Chromogenic print

240. Leo Rubinfien, *On the West Side Highway, New York*, 1980. Chromogenic print

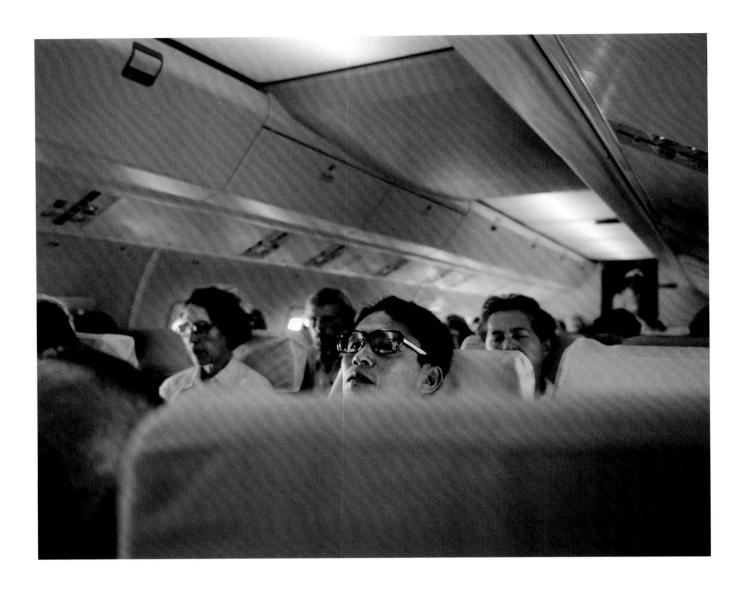

241. Leo Rubinfien, *On a Flight to Pagan, Burma*, 1980. Chromogenic print

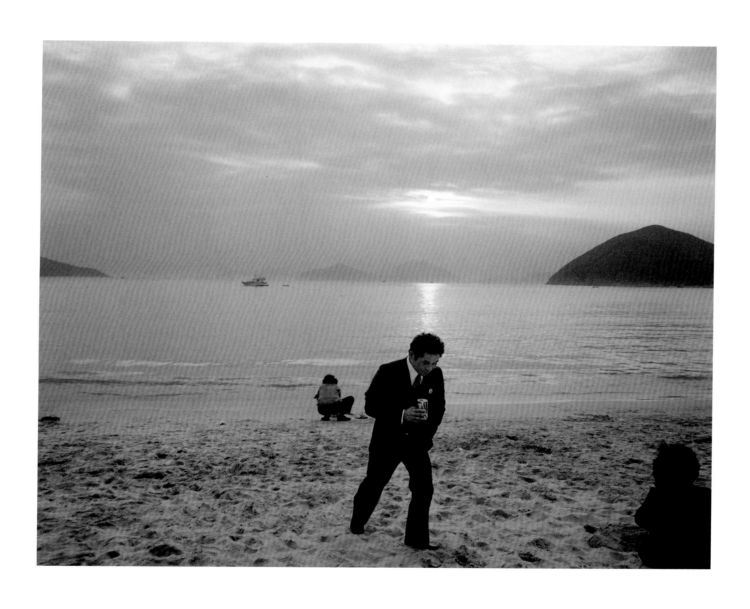

242. Leo Rubinfien, *On Repulse Bay Beach, Hong Kong, Christmas Day*, 1980. Chromogenic print

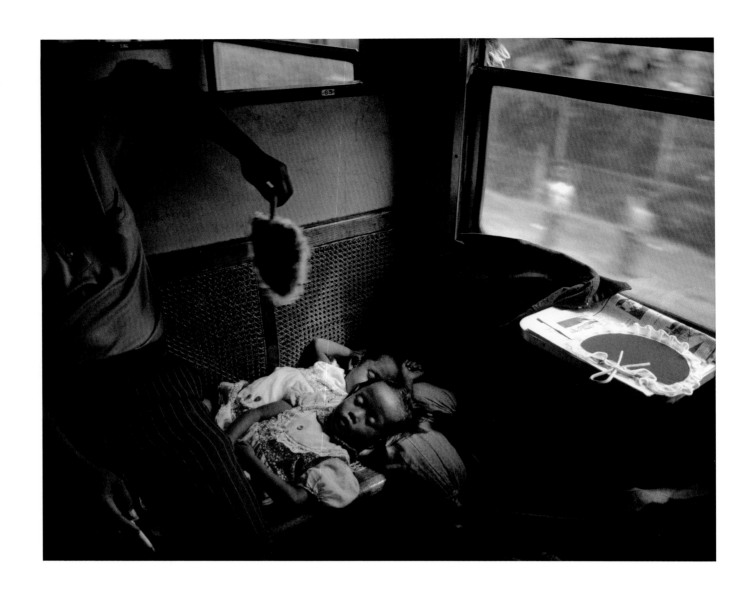

243. Leo Rubinfien, *On a Slow Train to Surabaya*, 1980. Chromogenic print

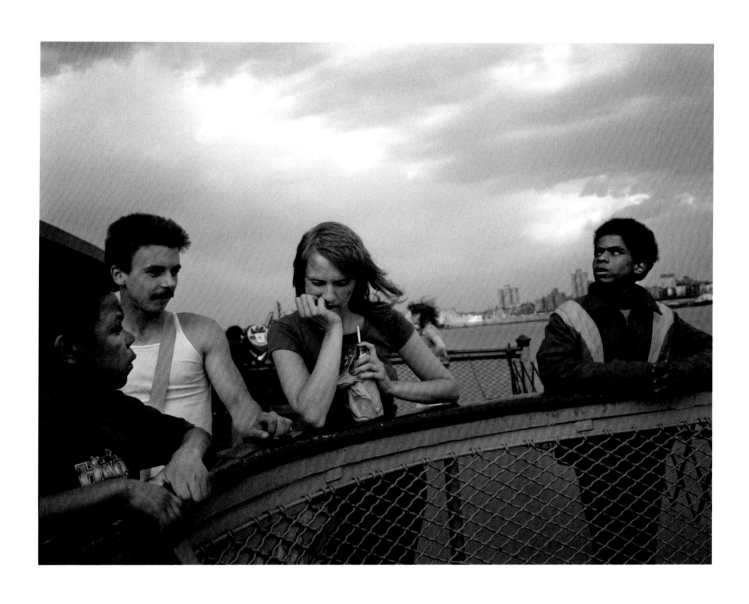

244. Leo Rubinfien, *On the Staten Island Ferry, New York*, 1980. Chromogenic print

245. Leo Rubinfien, *At Yaumati Typhoon Shelter, Kowloon, Hong Kong*, 1980. Chromogenic print

APPENDICES

NOTES

MOORE (PP. 8–36)

Special thanks to Joel Smith and Leo Rubinfien for their extensive comments and suggestions on drafts of this essay.

1 Gene Thornton, "The New Photography: Turning Traditional Standards Upside Down," *Artnews* 77 (Apr. 1978), p. 74.

2 Janet Malcolm, "Photography: Color," *The New Yorker*, Oct. 10, 1977, p. 107.

3 John Szarkowski, *William Eggleston's Guide*, exh. cat. The Museum of Modern Art (New York, 1976), p. 14.

4 Hilton Kramer, "Art: Focus on Photo Shows," *New York Times*, May 28, 1976, p. 62.

5 Ibid., p. 62. The Eggleston exhibition was not the museum's first solo exhibition of color photography, as is commonly believed, but *William Eggleston's Guide* was MoMA's first catalogue devoted to color photography. Szarkowski further confused matters by referring to Eggleston in several interviews as "the inventor of color photography." Elisabeth Sussman and Thomas Weski, *William Eggleston: Democratic Camera: Photographs and Video, 1961–2008*, exh. cat. Whitney Museum of American Art (New York, 2008), p. 11.

6 Blake Stimson makes a similar argument, describing America's loss of a sense of nationalism following the Second World War, resulting in a search for "nation," i.e., "alternative forms of political belonging." Blake Stimson, *The Pivot of the World: Photography and Its Nation* (Cambridge: MIT Press, 2006), p. 7.

7 Cornell Capa, *The Concerned Photographer* (New York: Grossman Publishers, 1968). Capa's book, which included work by six photographers—Werner Bischof, Robert Capa, David Seymour ("Chim"), André Kertész, Leonard Freed, and Dan Weiner—was so popular, a second installment, titled *The Concerned Photographer 2*, was released in 1973. These books led to the establishment of the International Center of Photography (ICP), New York, in 1974.

8 Sally Eauclaire, *The New Color Photography* (New York: Abbeville, 1981). The show also traveled to the Everson Museum of Art in Syracuse, New York. The book was described as "useful" by most reviewers but criticized for the "extravagant critical language and endless categorization." Douglas Davis, "A Call to Colors," *Newsweek*, Nov. 23, 1981, p. 115. Also see Pepe Karmel, "Photography Raising a Hue: The New Color," *Art in America* 70, no. 1 (Jan. 1982): 27—31.

9 Baltz used the phrase "rush to color," conspicuously avoiding the New Color label. Lewis Baltz, "American Photography in the 1970s," in *American Images: Photography 1945—1980*, exh. cat. Barbican Art Gallery (London, 1985), p. 163.

10 Two recent surveys of those subjects have brought the breadth of photographic activity during the 1970s into better focus. See Britt Salvesen, *New Topographics*, exh. cat. Center for Creative Photography (Tucson, 2010) and Douglas Eklund, *The Pictures Generation, 1974—1984*, exh. cat. Metropolitan Museum of Art (New York, 2009).

11 Szarkowski's 1960s MoMA exhibitions, such as *The Photographer's Eye* (1964) and *New Documents* (1967), did much to promote such ideas.

12 Other prominent members were Michael Bishop, Mark Cohen, Len Jenshel, Roger Mertin, Bill Ravanesi, and Arthur Taussig. Eauclaire included in her project artists working in photography, such as David Hockney and Lucas Samaras, a decision that received some criticism from the press. Although these artists participated in group shows at Castelli and elsewhere, they do not form part of the critical discourse around New Color in reviews of the period.

13 Other prominent artists from the West Coast were Kenneth McGowan, JoAnn Callis, Sandy Skogland, and Steven Collins. See Andy Grundberg and Julia Scully, "Currents: American Photography Today," *Modern Photography* 77 (Oct. 1980), pp. 94–97, 160–61, 166, 168, 170, 173.

14 The roster of personnel associated with Light Gallery is in itself remarkable: Charles Traub, Peter MacGill, Laurence Miller, Robert Mann, Victor Schrager, Marvin Heiferman, Renato Danese; see the commemorative history titled *Light* (New York: Light Gallery, 1981). On the photography gallery scene in general see Jacob Deschin, "Photo Galleries: Idealism and Hopes for Profit Keep Them Alive," *Popular Photography* (1972), pp. 22, 26, Center for Creative Photography Archives, University of Arizona, Tucson.

15 Baltz noted, "While it was extremely difficult to see photographs exhibited as art on New York gallery walls in 1967, by 1977 it was extremely difficult not to." Baltz 1985 (see note 9), p. 159.

16 There were, of course, color photographers in other parts of the world and exhibitions of color photography, such as *European Color Photography*, organized by The Photographer's Gallery, London, in 1978, but the phenomenon overseas did not have the critical density it had in the United States, especially in New York.

17 Baltz 1985 (see note 9), p. 163.

18 Author's conversation with Marvin Heiferman, July 2009.

19 A. D. Coleman, "Is Criticism of Color Photography Possible?" *Camera Lucida* 5 (June 1982), p. 29.

20 As late as 1980, permanence issues were still a problem with financial and legal consequences. Andy Grundberg writes, "A search for more permanent, fade-free color prints is now going on amid a flurry of lawsuits against Kodak and a general uneasiness among collectors. Hung in the light, the average Ektacolor-type print will undergo drastic changes in appearance within a decade. The negative from which it is made meanwhile, will also lose color unless stored in a frost-free freezer." Grundberg, "Some Fare over the Rainbow," *SoHo Weekly News*, May 21, 1980, p. 43. One of the most important researchers of color technologies since the 1970s is Henry Wilhelm, who published the standard technical text on the subject in 1993 and continues to study permanence issues in color photography: Henry Wilhelm, *The Permanence and Care of Color Photography: Traditional and Digital Prints, Color Negatives, Slides, and Motion Pictures* (Grinnell, IA: Preservation Publishing Company, 1993).

21 Andreas Killen uses this term, characterizing the 1970s as "an incubator for many of the developments that now define our contemporary political and cultural zeitgeist." Andreas Killen, *1973 Nervous Breakdown: Watergate, Warhol, and the Birth of Post-Sixties America* (New York: Bloomsbury, 2006), p. 1.

22 Just as social reforms of the 1960s became repackaged (blandly institutionalized) during the seventies, national arts funding proliferated, with the NEA and other organizations offering support for various projects, including museum exhibitions of photography, a move some described as a buyoff of the intelligentsia, resulting in a professionalization or "deadening" of the arts. Baltz further notes that by the mid-1970s "teaching had supplanted commercial or magazine work as the 'other' work of most serious photographers." Baltz 1985 (see note 9), p. 157. On the constraints inadvertently caused by increased institutionalization during the 1970s, see Stephen Paul Miller, *The Seventies Now: Culture as Surveillance* (Durham and London: Duke University Press, 1999).

23 Wolfe's essay, "The 'Me' Decade and the Third Great Awakening," was published in *New York* magazine, August 23, 1976.

24 Quoted in "Why Color?" *SoHo Weekly News*, May 20, 1980, p. 41.

25 Histories of color photography are largely technical. For a short history that tries to assess the cultural meanings of color photography as well, see Michel Frizot, "A Natural Strangeness: The Hypothesis of Color," in *A New History of Photography* (Cologne: Köneman, 1998), pp. 411–22.

26 Walt Disney's *Snow White and the Seven Dwarfs* had appeared in 1937; *Gone With the Wind* also appeared in 1939.

27 Els Rijper, *Kodachrome: The American Invention of Our World* (New York: Delano Greenidge Editions, 2002).

28 For a history of Polaroid and a selection of artistic uses, see Deborah Martin Kao, *Innovation/Imagination: 50 Years of Polaroid Photography* (New York: Abrams/Friends of Photography, 1999).

29 *Taken by Design: Photographs from the Institute of Design, 1937–1971*, exh. cat. Art Institute of Chicago, David Travis and Elizabeth Siegel, eds. (New Haven: Yale University Press, 2002).

30 Despite a flush of enthusiasm for color, Weston eliminated all color prints from his selection of 880 images—called the "project" prints, made by his son Brett—which he intended to represent his life's work. See Terence Pitts, *Edward Weston: Color Photography*, exh. cat. Center for Creative Photography (Tucson, 1986), p. 21.

31 On Steichen's color program at MoMA, see Sally Stein, *Harry Callahan: Photographs in Color/The Years 1946–1978*, exh. cat. Center for Creative Photography (Tucson 1980), pp. 13–27.

32 Milton W. Bradley, reviewing the show for *Photo Notes*, is quoted in Pitts 1986 (see note 30), p. 13.

33 Stein 1980 (see note 31), p. 14–15.

34 Jacob Deschin makes this point about Haas in a review of a slide lecture on color by Steichen titled "Experimental Color Photography" in 1957. Ibid., p. 26.

35 Jacob Deschin writing for the *New York Times* in 1950, quoted in ibid., p. 15.

36 Quoted in Mark Alice Durant, *Robert Heinecken: A Material History* (Tucson: Center for Creative Photography, 2003), p. 64.

37 Quoted in Christy Lange et al., *Stephen Shore* (London: Phaidon Press, 2007), p. 52.

38 Charles Hagen, "Robert Heinecken," *Artforum* 28, no. 10 (Summer 1989), p. 142.

39 Peter Bunnell discusses the exhibition in "Photographs as Sculpture and Prints," *Art in America* 57, no. 5 (Sept.–Oct. 1969), pp. 56–57.

40 Lyndon Johnson served as president from 1963 to 1969. His escalation of the war from 1964 to 1968 resulted in a dramatic increase in casualties.

41 Joan Didion, "Slouching Towards Bethlehem," in *Slouching Towards Bethlehem: Essays* (New York: Farrar, Straus and Giroux, 1968), pp. 84–85.

42 "Photographism" is a term coined by art historian Arthur Danto to make the distinction between those who produced "photography as art" (Weston, Evans, Arbus) and those who used "photography in art" (Warhol, Rauschenberg, Baldessari). Refer to the discussion in A. D. Coleman, "'I Call It Teaching': Robert Heinecken's Analytical Facture," in *Robert Heinecken, Photographist: A Thirty-Five-Year Retrospective*, exh. cat. Museum of Contemporary Art (Chicago,1999), p. 4.

43 John Szarkowski, *Mirrors and Windows: American Photography Since 1960*, exh. cat. The Museum of Modern Art (New York, 1978), p. 23.

44 Grundberg described Heinecken in 1989 as the "most overlooked post-modernist precursor." Andy Grundberg, "Slices of Time, Preserved in Deft Images," *New York Times*, Mar. 31, 1989, p. C26.

45 Numerous exhibitions appearing around 1975 show the profound influence of Heinecken's mixed-media approach: *Light and Substance*, University Art Museum, University of New Mexico, Albuquerque, 1974; *Aspects of American Photography, 1976*, University of Missouri-Saint Louis, 1976; *Photographic Process as Medium*, Rutgers University Art Gallery, New Brunswick, 1976. Thanks to Larry Miller for calling these to my attention.

46 Heinecken's interest in Dada and Surrealist art, particularly Duchamp's concept of the readymade, inform this body of work. The appropriated magazine pages may be considered readymades bursting with "convulsive beauty." Heinecken discusses his interest in Duchamp in A. D. Coleman, "Heinecken: A Man for All Dimensions," *New York Times*, Aug. 2, 1970, p. 83.

47 Recounted in Durant 2003 (see note 36), p. 71.

48 A. D. Coleman, "Latent Image," *The Village Voice*, Oct. 15, 1970, p. 22.

49 In James Enyeart, ed., *Heinecken* (Carmel: Friends of Photography, 1980), p. 98.

50 See Coleman, "Heinecken," 1970 (see note 46).

51 Shore did a brief workshop with Minor White at the end of the 1960s but never cites this as having had influence on his work.

52 Shore was the first living photographer to show at the Metropolitan, an honor he says traumatized him. On Shore's show at that institution, see Lange 2007 (see note 37), p. 48.

53 Gene Thornton, "From Fine Art to Plain Junk," *New York Times*, Nov. 14, 1971, p. D38.

54 Quoted in Mark Haworth-Booth, "Amarillo—'Tall in Texas': A Project by Stephen Shore, 1971," *Art on Paper* (Sept.–Oct. 2000), p. 46.

55 Lange 2007 (see note 37), p. 52.

56 On Frank, see the recent National Gallery catalogue: Sarah Greenough, *Looking In: Robert Frank's The Americans*, exh. cat. National Gallery of Art (Washington, DC, 2009).

57 Quoted in Salvesen 2010 (see note 10), p. 26.

58 Quoted in Lange 2007 (see note 37), p. 59.

59 Max Kozloff, "Photography: The Coming to Age of Color," *Artforum* 13 (Jan. 1975), p. 35.

60 Shore claims that even the people working at the gallery "had a very hard time looking at it." See "Michael Fried in Conversation with Stephen Shore," in Lange 2007 (see note 37), p. 9. A major inspiration on younger photographers, the series has only recently been published: Stephen Shore, *American Surfaces* (London: Phaidon, 2005).

61 Mitch Epstein, *Mitch Epstein: Work* (Göttingen: Steidl, 2006), p. 14.

62 Walker Evans, "Quality: Its Image in the Arts," cited in Judith Keller, *Walker Evans: The Getty Museum Collection* (London: Thames & Hudson, 1995), p. 304.

63 Bruce Downes, "Let's Talk Photography," *Popular Photography* 25, no. 6 (Dec. 1949), p. 26.

64 Color television began airing in 1951 but did not become widespread until the late 1960s. On the cultural emergence of color, see A. D. Coleman, "Mama Don't Take Our Kodachrome Away," in Rijper 2002 (see note 27), pp. 8–11,

65 Szarkowski quoted in Tony Hiss, "The Framing of Stephen Shore," *American Photographer* 2, no. 2 (Feb. 1979), p. 36.

66 Keller 1995 (see note 62), p. 304.

67 See Leo Rubinfien, "Garry Winogrand," in *The Education of a Photographer*, ed. Charles Traub et al. (New York: Allworth Press, 2006), pp. 114–15.

68 There was no catalogue for this exhibition but Gilles Mora publishes the show's brochure in *The Last Photographic Heroes: American Photographers of the Sixties and Seventies* (New York: Abrams, 2007), pp. 48–49.

69 Apparently, the projector burned out after a couple of days of continuous projection and was not reinstalled; Winogrand had mixed feelings about showing his color work, which he tended to refer to as "studies." MoMA's archives contain installation views, in which the projector is present, and there are letters referring to this component of the show. Thanks to Susan Kismaric of MoMA for calling this aspect of *New Documents* to my attention. The first publication of Winogrand's color work, selected from the Center for Creative Photography, Tucson, appears in Trudy Wilner Stack, *Winogrand 1964: Photographs from the Garry Winogrand Archive* (Santa Fe: Arena Editions, 2002), see pp. 276–77.

70 On slide projection within the art institution, see Darsie Alexander, *Slide Show: Projected Images in Contemporary Art*, exh. cat. The Baltimore Museum of Art (Baltimore, 2005).

71 On Winogrand and his critics, see Mora 2007 (see note 68), pp. 54–58.

72 More interesting than this overused quote is Szarkowski's rumination on Winogrand's evasive explanations for photography and his own work in particular. See John Szarkowski, *Winogrand: Figments from the Real World*, exh. cat. The Museum of Modern Art (New York, 1988), p. 32.

73 The movement culminated in a special issue of *Aperture* titled *The Snapshot*, which featured a number of contemporary photographers working in a naive vein. *Aperture* 19, no. 1 (1974).

74 Kozloff 1975 (see note 59), p. 33.

75 Quoted in Rubinfien 2006 (see note 67), p. 120.

76 Epstein discusses Winogrand; see Epstein 2006 (see note 61), pp. 13–14.

77 Ibid., p. 14.

78 Anonioni developed a naturalistic, art house, color cinema style during the 1960s. On influences, see ibid., pp. 14–16.

79 These photographs were collected in a very influential book titled *Helen Levitt: A Way of Seeing*, with an essay by James Agee (New York: Viking, 1965).

80 John Szarkowski, in the press release for *Color Photographs by Helen Levitt*, Museum of Modern Art, 1974. The Museum of Modern Art Archives, New York.

81 Ben Maddow, introducing a portfolio of Levitt's photographs published in *Aperture* 19, no. 4 (1975), p. 36.

82 On Levitt, see Alexander 2005 (see note 70), pp. 119–20.

83 The "decisive moment" is, of course, Henri Cartier-Bresson's term from his book of the same name, published in 1952.

84 On seriality and the larger issues it heralded in post-war America, see the introduction of Stimson 2006 (see note 6).

85 Meyerowitz was driving a Volkswagen van, allowing him full visibility of the world outside. Author's email from the artist, Aug. 2009.

86 Author's conversation with the artist, May 2009.

87 Wall label copy from *My European Trip* is from the artist's personal files.

88 Jonathan Crary, "Eve Sonneman," *Arts Magazine* 53, no. 3 (Nov. 1978), p. 3.

89 Jeremy Gilbert-Rolfe, obviously an avid reader of French semiotic theory, makes this point in "Reviews," *Artforum* 12, no. 6 (Feb. 1974), p. 66.

90 Author's conversation with the artist, 2009.

91 Sonneman's early work is collected in a book titled *Real Time, 1968–1974* (New York: Printed Matter, 1976).

92 Jeffrey Deitch, "Eve Sonneman," *Arts Magazine* 51, no. 4 (Dec. 1976), p. 5.

93 Neal Slavin, *When Two or More Are Gathered Together* (New York: Farrar, Straus and Giroux, 1974), unpaginated.

94 Ibid.

95 See A. D. Coleman, *The Grotesque in Photography* (New York: Summit Books, 1977), pp. 72–89.

96 Warhol, Samaras, Hockney, and Heinecken each used the SX-70 to produce images most commercial developers would not have printed.

97 "Directorial mode" is a term A. D. Coleman uses to describe staged photographs by Krims and others. A. D. Coleman, "Violated Instants," *Camera* 20, no. 5 (July 1976), p. 35.

98 Published by Humpy Press, the cover of this small book has a repeating illustration of a man's face seen in profile with a penis for a nose. Hollis Frampton wrote the cryptic introduction, in which he notes, "We have acquired a certain taste for ritualized or mediated horror." *Fictocryptokrimsographs: A Book of Work by Les Krims* (Buffalo: Humpy Press, 1975), unpaginated.

99 Krims is discussing his earlier work in this article. A. D. Coleman, "Four Photographs That Drove a Man to Crime," *New York Times*, Apr. 11, 1971, p. D38.

100 Sherman studied with Krims at the State University of New York, Buffalo, in 1972.

101 Szarkowski's book of 1966, *The Photographer's Eye*, published two years after the exhibition of the same name, established the principles associated with photographic modernism, claiming documentary purity as its central tenet. Szarkowski 1966 (see note 11).

102 Sternfeld acknowledges that the conceit was trendy. Author's conversation with the artist, June 2009.

103 Statement by Joel Sternfeld in "Joel Sternfeld," *Camera* 11 (Nov. 1977), p. 16.

104 Ibid.

105 R. H. Cravens, *William Christenberry: Southern Photographs* (New York: Aperture, 1983), p. 13.

106 Christenberry's anecdotes about sign stealing are collected in Susanne Lange, ed., *William Christenberry: Working from Memory* (Göttingen: Steidl, 2008).

107 David Tannous, "William Christenberry at Zabriskie," *Art in America* 65 (July–Aug. 1977), p. 97.

108 Ibid., p. 98.

109 Christenberry and Eggleston, both born in the 1930s, became friends in 1962 in Memphis, where Christenberry was a young professor of painting. See Walter Hopps et al., *William Christenberry* (New York: Aperture, 2006), p. 200.

110 Quoted by Vince Aletti in "William Eggleston, *William Eggleston's Guide*," in *The Book of 101 Books*, ed. Andrew Roth (New York: PPP Editions, 2001), p. 234.

111 Dates on MoMA's checklist are vague, most listed as circa. The first twenty photographs are listed "c. 1969–70." "Checklist: Photographs by William Eggleston," in the Museum of Modern Art Archives, New York.

112 See Sussman and Weski 2008 (see note 5), p. 18, note 24.

113 Quoted in Mark Haworth-Booth, "William Eggleston: An Interview," *History of Photography* 17, no. 1 (Spring 1993), p. 51.

114 "Pop syndrome" stated by Michael Edelson, "MoMA Shows Her Colors," *Camera* 35 (Oct. 1976), p. 11; Photo-Realist painting in Malcolm 1977 (see note 2), pp. 107–9; "snapshot chic" in Kramer 1976 (see note 4), p. 62; Szarkowski 1976 (see note 3), p. 6.

115 The "most hated show" comment is by Gene Thornton, "Photography Found a Home in Art Galleries," *New York Times*,

Dec. 26, 1976, p. 29. On picture dates, see Dan Meinwald, "Color Me MoMA," *Afterimage* (Sept. 1976), p. 19.

116 See Sussman and Weski 2008 (see note 5), p. 19, note 43.

117 *14 Pictures* was produced by gallerist Harry Lunn. Dye transfer prints cost around $300 each, which was more than most photographs sold for in art galleries during the 1970s; see Grundberg 1980 (see note 20), p. 43.

118 Sussman and Weski 2008 (see note 5), p. 11.

119 Szarkowski's concept was that the book would function as a sort of *Michelin Guide* to the South but, as reviewers noted, it resembled a family album or school yearbook more. Sussman and Weski 2008 (see note 5), p. 12.

120 "Make it red" is Ansel Adams repeating a joke that was evidently circulating. Ansel Adams, "Color Photography as a Creative Medium," *Image* 25, nos. 3–4 (Sept.–Dec. 1982), p. 17.

121 A rare, incisive discussion of Eggleston, led by Gary Witt, occurred in Memphis, where the exhibition was shown at the Brooks Memorial Art Gallery. See Gary Witt, "Photographs by William Eggleston at Brooks," *Title Untitled* 2, no. 4 (Feb. 1977), pp. 1, 4.

122 These were exhibited at Max Protetch Gallery in 1976. Groover had exhibited previously at Light Gallery, thus the Protetch show was seen as something of an event in that it was one of the first "crossovers" of a photographer to a contemporary gallery. See Phil Patton, "Jan Groover, Max Protetch Gallery," *Artforum* 14, no. 8 (Apr. 1976), pp. 68–69.

123 Ben Lifson, "Jan Groover's Abstractions Embrace the World," *The Village Voice*, Nov. 6, 1976, p. 117.

124 Ibid.

125 A reviewer in 1979 wrote that Groover's photographs were "perhaps about seeing through photography" as Cézanne's paintings had been about seeing through painting. Jeff Perrone, "Jan Groover: Degrees of Transparency," *Artforum* 17, no. 5 (Jan. 1979), p. 43.

126 Quoted in a review by Mary Anne Staniszewski, "Jan Groover," *Artnews* 79, no. 5 (May 1980), p. 182.

127 The "bourgeois kitchen" is Hal Foster on this work in 1980, "Jan Groover, Sonnabend," *Artforum* 18, no. 8 (Apr. 1980), p. 76. Weston and sexuality is suggested by Lifson 1976 (see note 123), p. 117.

128 Belinda Rathbone, "Barbara Kasten: Picture Apparatus," *Polaroid Close-Up* 14, no. 1 (Apr. 1983), p. 19.

129 Interestingly, James Welling reports on these pictures in 1977. See Welling, "Working Between Photography and Painting," *Artweek*, Feb. 4, 1978, from the artist's personal files.

130 Kasten is paraphrased in Grundberg and Scully 1980 (see note 13), p. 161.

131 See Mark Johnstone, "Photography: Installation and Image," *Artweek*, Feb. 27, 1982, from the artist's personal files.

132 Andy Grundberg, "In the Arts: Critics' Choices: Photography," *New York Times*, Sept. 19, 1982, p. G3.

133 Divola states that one of the reasons he started working in abandoned houses was because he had no studio. See his

interview with Jan Tumlir in *John Divola: Three Acts* (New York: Aperture, 2006), p. 137.

134 David Campany, "Who, What, Where, With What, Why, How, and When? The Forensic Rituals of John Divola," in ibid., *Three Acts*, p. 131.

135 Mark Johnstone, "John Divola: Facts of the Imagination," *Exposure* 19, no. 1 (1981), p. 42.

136 Mark Johnstone, "Moving Beyond Description," from the artist's website, www.divola.com (accessed Sept. 17, 2009).

137 Lifson also invokes Ansel Adams in relation to Pfahl's landscapes. Ben Lifson, "You Can Fool Some of the Eyes Some of the Time," *The Village Voice*, Mar. 6, 1978, p. 68.

138 Besides showing annually at Robert Freidus Gallery in New York, Pfahl had solo exhibitions at the Visual Studies Workshop Gallery, Rochester, New York (1976), the Princeton University Art Museum (1978), and the Phoenix Art Museum (1978).

139 Misrach and nineteen other photographers, including Harry Callahan, William Eggleston, Jan Groover, Joel Meyerowitz, and Stephen Shore, were commissioned to make new bodies of work by AT&T, who exhibited the work in 1979 and donated it as a portfolio to various institutions. Misrach reportedly printed "huge murals" for the exhibition; see Grundberg and Scully 1980 (see note 13), p. 168. Misrach's statement appears in Renato Danese, *American Images: New Work by Twenty Contemporary Photographers* (New York: McGraw Hill, 1979), p. 170.

140 Callahan quoted in Stein 1980 (see note 31), p. 32.

141 Shore had become more attentive to composition following an offhand question by Szarkowski who, while looking at Shore's prints, asked, "How accurate is your viewfinder?" Recounted by Shore in Hiss 1979 (see note 65), p. 35.

142 The photograph is by Shore's wife, Ginger Seippel. See ibid., p. 37.

143 See the recent publication on this exhibition: Salvesen 2010 (see note 10).

144 Maria Morris Hambourg, who went on to become curator of the Department of Photographs at the Metropolitan Museum, curated this exhibition.

145 Phil Patton, "Captioned Pictures, Pictured Captions," *Artnews* 76, no. 1 (Jan. 1977), p. 109.

146 Salvesen 2010 (see note 10), p. 67, note 229.

147 *Signs of Life: Symbols of Life in the American City* (New York: Aperture, 1976).

148 Carter Ratcliff, "Route 66 Revisited: The New Landscape Photography," *Art in America* (Jan.–Feb. 1976), p. 90.

149 Hiss notes in 1979 that Shore is "now one of the most popular American photographers in Germany." Hiss 1979 (see note 65), p. 28.

150 *Uncommon Places: Photographs by Stephen Shore* (New York: Aperture, 1982).

151 Author's conversation with the artist, May 2009.

152 Ben Lifson, "The Journey to the Front Porch," *The Village Voice*, Dec. 5, 1977, p. 73. "Social ax" is Meyerowitz's own term.

153 Meyerowitz quoted in an excerpt from an article by Max Kozloff, appearing in *Camera* 9 (Sept. 1977), p. 23.

154 Andy Grundberg, "Joel Meyerowitz Gets His View," *SoHo Weekly News*, July 26, 1979, p. 32.

155 Robert Pirsig, *Zen and the Art of Motorcycle Maintenance* (New York: Morrow, 1974). The book sold over four-million copies and has been published in twenty-seven languages.

156 In a dialogue between Abigail Solomon-Godeau and Ben Lifson, published in *October* in 1981, Solomon-Godeau speculates along these lines, noting the prevalence of color photography in the recent Whitney Biennial and the resurgence of academic interest in photography which, in her view, perpetuated a "simplistic view of modernism wherein color photography is understood as exclusively about the conventions and color of photographic film." Ben Lifson and Abigail Solomon-Godeau, "Photophilia: A Conversation about the Photography Scene," *October* 16 (Spring 1981), p. 114.

157 See, respectively, Suzanne Muchnic, "Heinecken Exhibit: Feast and Famine," *Los Angeles Times*, Jan. 4, 1979, p. G19; and Alan Artner, "At Last! Art Celebrates Life's Simple Pleasures," *Chicago Tribune*, June 9, 1978, p. B12. In a 1979 interview, Arnold Crane said of Heinecken, "Enough is enough!" Elaine King, "Camera Interview with Arnold H. Crane," *Camera* 9 (Sept. 1979), p. 39.

158 "Relentless purism" is from an article by Leo Rubinfien, "Callahan's Détente with Experience," *The Village Voice*, Apr. 10, 1978, from the author's personal files. Stein discusses Callahan's interest in color, Stein 1980 (see note 31), pp. 30–31.

159 Recounted in ibid., p. 30.

160 Peter MacGill relates that Callahan was "stuck" and began walking the neighborhoods of Providence, photographing, in an effort to restart. Author's conversation with MacGill, Feb. 2009.

161 Rubinfien 1978 (see note 158).

162 The reviewer goes on to suggest that Callahan's treatment of the houses becomes a "persuasive metaphor for the New England Transcendental heritage" in their restrained sensuality. Stuart Liebman, "Callahan's Puritan Color," *SoHo Weekly News*, Apr. 13, 1978, p. 22.

163 On Sternfeld's relationship to painting, see Kerry Brougher's introduction to the new edition of *American Prospects* (New York: D.A.P., 2003).

164 Andy Grundberg, "Inhabited Terrain: Joel Sternfeld's American Landscapes," *Modern Photography* 44, no. 3 (Mar. 1980), p. 82.

165 Author's conversation with the artist, May 2009.

166 Ben Lifson, "The Wonderful World of Color," *The Village Voice*, Nov. 11–17, p. 78.

167 Ibid.

168 Rubinfien had been included in a 1980 exhibition at Castelli, curated by Marvin Heiferman, titled "Likely Stories," which treated the notion of narrative in still photography.

169 Pepe Karmel wrote perceptively, "Rubinfien is not interested in local color, or in clichéd images of Third World poverty. His color photographs seek to capture something about ordinary existence, not about life at the extremes of suffering or weirdness." Pepe Karmel, "The Anxious Moment," *SoHo Weekly News*, Nov. 10, 1981, p. 45.

170 Slavin, unpaginated.

171 On the relationship between photographic history and photography as an aspect of contemporary art, see the series of essays and responses in Charlotte Cotton and Alex Klein, eds., *Words Without Pictures* (Los Angeles: Los Angeles County Museum of Art, 2009).

RUBINFIEN (PP. 37–41)

1 Smith originally wrote these words in a letter from Saipan in 1944. They were published in the widely circulated collection *W. Eugene Smith, His Photographs and Notes: An Aperture Monograph* (New York: Aperture, 1969), n.p.

2 Robert Frank, as quoted in Edna Bennett, "Black and White Are the Colors of Robert Frank," *Aperture* 9, no. 1 (1961), pp. 20–22.

CRUMP (PP. 42–48)

1 Hilton Kramer, "The New American Photography," *New York Times Magazine*, July 23, 1978, p. SM1.

2 Gene Thornton, "Post-Modern Photography: It Doesn't Look 'Modern' at All," *Art in America* (April 1979), pp. 64–68. See also Hilton Kramer, "Art: Focus on Photo Shows," *New York Times*, May 28, 1976, p. 62.

3 John Szarkowski, wall label introducing *Photography: New Acquisitions*, April 16–July 5, 1970. Curatorial Exhibition Files, #957, Museum of Modern Art Archives, New York. "The heirs of the documentary tradition have redirected that idea in the light of their own fascination with the snapshot: the most personal, reticent, and ambiguous documents. These photographers have attempted to preserve the persuasiveness and mystery of these humble, intuitive camera records, while adding a sense of intention and visual logic."

4 See, for example, Rosalind Krauss, "Notes on the Index: Seventies Art in America," *October* 3 (Spring 1977), pp. 68–81, and the second installment, "Notes on the Index: Seventies Art in America, *October* 4 (Autumn 1977), pp. 56–67. See also Douglas Crimp, "The Photographic Activity of Postmodernism," *October* 15 (Winter 1980), pp. 91-101. For the best summary analysis of this turn in critical writing see Douglas R. Nickel, "History of Photography: The State of Research," *Art Bulletin* 83, no. 3 (Sept. 2001), pp. 548-58, esp. pp. 554-55.

5 Elizabeth Sussman, "In/Of Her Time: Nan Goldin's Photographs," *Nan Goldin: I'll Be Your Mirror*, exh. cat. Whitney Museum of American Art (New York, 1996), p. 30.

6 Ibid., p. 31. Castelli Graphics' curator of these exhibitions, Marvin Heiferman, learned of Goldin's work through New Color artist Joel Meyerowitz, who viewed her photographs in Boston around 1977.

7 Neal Benezra, "Overstated Means / Understated Meaning: Social Content in the Art of the 1980s, *Smithsonian Studies in American Art* 2, no. 1 (Winter 1988), p. 19.

8 Martin Hentschel, "The Totality of the World, Viewed in its Component Forms: Andreas Gursky's Photographs 1986 to 2008," in *Andreas Gursky: Works 80–08*, exh. cat. Kunstmuseum Krefeld (Krefeld and Ostfildern: Hatje Cantz, 2008), p. 31. Hentschel's essay quotes Gursky, stating, "I think that every picture in my work is another piece in the puzzle. In some ways this is an encyclopedic approach."

9 Andy Grundberg, *The Land through the Lens: Highlights from the Smithsonian American Art Museum*, exh. cat. Smithsonian American Art Museum (Washington, DC, 2003).

10 Nicole Krauss, "Everywhere Felt but Nowhere Seen," *Modern Painters* 17, no. 1 (Spring 2004), p. 61.

11 Samuel J. Wagstaff, Jr., transcript for symposium presentation delivered on the occasion of the exhibition *Photographs from the Sam Wagstaff Collection*, Feb. 4–March 26, 1978, Corcoran Gallery of Art, Washington. The videotaped lecture is available in its entirety on the film DVD *Black White + Gray: A Portrait of Sam Wagstaff + Robert Mapplethorpe* (Beverly Hills: Arthouse Films, 2007).

12 David Schapiro, "Interview with Jeff Wall," *Museo*, 2000. (www.museomagazine.com).

13 Lewis Baltz, "American Photography in the 1970s: Too Old to Rock, Too Young to Die," in *American Images*, ed. Peter Turner (New York and London: Viking/Barbican Art Gallery, 1985), p. 159.

14 Charlotte Cotton, *The Photograph as Contemporary Art* (London: Thames & Hudson, 2004), p. 7.

CHRONOLOGY OF COLOR PHOTOGRAPHY AND THE 1970S

Selected Chronology of 1970s Color Photography

1970
* Heinecken exhibits at Witkin Gallery, New York

1971
* Stephen Shore exhibits at The Metropolitan Museum of Art, New York

1972
* Robert Heinecken exhibits at the Pasadena Museum of Art, where *TV/Time Environment* is shown
* Stephen Shore exhibits Amarillo—"Tall in Texas," at Thomas Gibson Fine Art, London
* Stephen Shore exhibits American Surfaces at Light Gallery, New York

Selected Chronology of the 1970s

1970
* U.S. invades Cambodia
* Kent State University protests and shootings
* Trial of "Chicago 7"
* Palestinian gunmen hijack three Lufthansa planes, exchange hostages for prisoners
* Charles Manson on trial for the murder of Sharon Tate
* Apollo 13 launched
* Alvin Toffler, *Future Shock*
* Richard Bach, *Jonathan Livingston Seagull*
* Beatles, *Let it Be;* the group disbands
* Film: *Patton, Little Big Man*
* TV: Monday Night Football
* Hamburger Helper
* Sotheby's first sale of photographs
* Deaths of Janis Joplin, Jimi Hendrix

1971
* Pentagon Papers released
* Greenpeace founded
* Libertarian Party founded
* Attica prison riot
* Charles Manson and three others sentenced to death
* Completion of the World Trade Center, New York
* NASA Mariner 9
* Hunter S. Thompson, *Fear and Loathing in Las Vegas*
* Intel 4004, the first microprocessor
* "Silicon Valley" coined
* Radio: *All Things Considered,* NPR
* Film: *The French Connection, A Clockwork Orange, The Last Picture Show*
* TV: *All in the Family*
* Jell-O Pudding
* Deaths of Diane Arbus, Jim Morrison

1972
* Richard Nixon defeats George McGovern
* Nixon visits China
* Nixon and Henry Kissinger, *Time's* Men of the Year
* Bloody Sunday, Northern Ireland
* Munich Olympics, Israeli athletes killed by PLO
* Manson and The Family sentences commuted

* Pruitt-Igoe public housing demolished in St. Louis
* Bombing of Hanoi
* Watergate
* *Life* Magazine ceases publication
* Nike founded
* Film: *Deliverance, The Godfather*
* TV: *M*A*S*H*

1973

* William Christenberry exhibits photographs at the Corcoran Gallery of Art, Washington, D.C.
* Solo exhibitions of Robert Heinecken and Stephen Shore at Light Gallery, New York

1973

* U.S. withdraws troops from Vietnam
* Congress approves Alaska pipeline
* Augusto Pinochet overthrows Salvador Allende in U.S.-supported coup
* Roe *v.* Wade
* Nixon releases Watergate tapes
* Vice-President Spiro Agnew resigns
* AFLCIO endorses the Equal Rights Amendment
* Energy crisis
* Erica Jong, *Fear of Flying*
* Film: *American Graffiti, The Sting, Soylent Green, Last Tango in Paris*

1974

* Helen Levitt slide projection shown at the Museum of Modern Art, New York
* William Eggleston portfolio *14 Pictures* is published by Harry Lunn
* Jan Groover exhibits at Light Gallery, New York

1974

* Nixon resigns, Gerald Ford sworn in as president
* Abduction of Patty Hearst
* Speed limits decreased to 55 mph on U.S. highways
* Inflation is 12%
* Robert Pirsig, *Zen and the Art of Motorcycle Maintenance*
* UPC barcodes introduced
* Amana markets microwave ovens
* Film: *Chinatown, Alice Doesn't Live Here Anymore*

1975

* Max Kozloff publishes "The Coming of Age to Color" in *Artforum* (Jan.)
* *Color Photography: Inventors and Innovators* exhibition at the Yale University Art Gallery, New Haven, Connecticut
* *New Topographics: Photographs of a Man-Altered Landscape* exhibition at George Eastman House, Rochester, New York, with photographs by Stephen Shore
* Les Krims exhibits Fictocryptokrimsographs at The Visual Studies Workshop, Rochester, New York

1975

* Fall of Saigon to the Army of North Vietnam
* Death of Francisco Franco
* The Dow Jones Industrial Average drops 40%, to 600, down from 1000 in 1973
* "American Women" are *Time*'s Man of the Year
* Microsoft founded
* Muhammad Ali defeats Joe Frazier
* *Saturday Night Live*
* Film: *Jaws, One Flew over the Cuckoo's Nest, Dog Day Afternoon*
* Death of Walker Evans

1976

* William Christenberry exhibits photographs and sculpture at Zabriskie Gallery, New York
* *Photographs by William Eggleston* exhibition at the Museum of Modern Art, New York, and publication of *William Eggleston's Guide*

1976

* U.S. Bicentennial
* Jimmy Carter defeats Ford and is *Time*'s Man of the Year
* Death of Mao Tse Tung
* Palestinians hijack Air France airliner, passengers rescued by Israelis in Entebbe, Uganda
* Concorde makes first commercial flights

* Jan Groover moves from Light Gallery and exhibits at Max Protetch Gallery, New York
* Jan Groover has exhibitions at the Corcoran Gallery of Art, Washington, DC, and George Eastman House, Rochester
* Robert Heinecken exhibits at George Eastman House, Rochester, and Light Gallery, New York
* John Pfahl exhibits *Altered Landscapes* at the Visual Studies Workshop Gallery, Rochester
* Stephen Shore exhibits at the Museum of Modern Art, New York
* Eve Sonneman exhibits diptychs at Castelli Graphics, New York
* Stephen Shore portfolio of twelve prints published by the Metropolitan Museum of Art, New York
* Neal Slavin exhibits group portraits at Light Gallery, New York; The Center for Creative Photography, Tucson; and the Wadsworth Atheneum, Hartford, Connecticut

1977

* *Some Color Photographs* exhibition at Castelli Graphics, New York
* Jan Groover exhibits Kitchen Still Lifes at Sonnabend Gallery, New York
* Joel Meyerowitz exhibits *Cape Light* series at Witkin Gallery, New York
* Stephen Shore exhibits at the Kunsthalle, Düsseldorf, Germany
* Joel Sternfeld street photographs are published in *Camera* (Nov.)

1978

* *Mirrors and Windows* exhibition at the Museum of Modern Art, New York, which includes color photography
* Harry Callahan exhibits Providence series at Light Gallery, New York
* William Christenberry exhibits at the Corcoran Gallery of Art, Washington, D.C.
* John Divola exhibits *Zuma* series at the Los Angeles Institute of Contemporary Art
* Jan Groover exhibits at Sonnabend, New York
* Les Krims exhibits at Light Gallery, New York
* Joel Meyerowitz exhibits *Cape Light* series at the Museum of Fine Arts, Boston
* John Pfahl exhibits *Altered Landscapes* at Robert Freidus Gallery, New York, and the Princeton University Art Museum
* Eve Sonneman exhibits diptychs at Castelli Graphics, New York

1979

* *American Images: New Work by Twenty Contemporary Photographers* exhibition at the Corcoran Gallery of Art, Washington, D.C., which includes color photographs by Harry Callahan, William Eggleston, Jan Groover, Joel Meyerowitz, Richard Misrach, and Stephen Shore

* Viking 1 and 2 on Mars
* Tom Wolfe, "The Me Decade"
* Film: *All the President's Men, Taxi Driver*
* King Tut exhibition at the Metropolitan Museum of Art

1977

* NYC blackouts, looting
* Palestinians hijack Lufthansa airliner
* Alaska Pipeline completed
* Oklahoma first state to adopt lethal injection
* Susan Sontag, *On Photography*
* MacDonald's Happy Meal
* Death of Elvis Presley
* Film: *Star Wars, Close Encounters of the Third Kind, Annie Hall, Saturday Night Fever*
* TV: *Roots*

1978

* Camp David Peace Treaty
* Jonestown Massacre, Guyana
* Love Canal evacuation
* First "test-tube" baby
* Film: *The Deer Hunter, Days of Heaven, Midnight Express*
* TV: *Dallas*

1979

* Hostage crisis
* The Shah of Iran, Mohammad Reza Pahlavi, is overthrown and flees Iran; Ayatollah Khomeini assumes power
* Saddam Hussein becomes president of Iraq
* Margaret Thatcher becomes Prime Minister of Britain

* *American Photography in the 1970s* exhibition at the Art Institute of Chicago, which includes color photography
* *Attitudes: Photography in the 1970s* exhibition at the Santa Barbara Museum of Art, which includes color photography
* *Fabricated to be Photographed* exhibition at the San Francisco Museum of Modern Art, which includes color photography
* Solo exhibitions by Mitch Epstein and Robert Heinecken at Light Gallery, New York

1980

* *Harry Callahan: Photographs in Color / The Years 1946-1978* exhibition at the Center for Creative Photography, Tucson
* John Pfahl produces *Altered Landscapes* portfolio of ten dye transfer prints

1981

* *The New Color Photography* exhibition and catalogue by Sally Eauclaire at the International Center of Photography, New York
* Joel Sternfeld exhibits street photographs at the San Francisco Museum of Modern Art and *American Prospects* debuts at Daniel Wolf, New York
* Barbara Kasten exhibits Constructs at George Eastman House, Rochester
* Leo Rubinfien exhibits at Castelli Graphics, New York

1982

* *Color as Form: A History of Color Photography* exhibition at the Corcoran Gallery of Art, Washington, D.C.
* Stephen Shore publishes *Uncommon Places* (Aperture)

* Soviets invade Afghanistan
* Three Mile Island partial meltdown
* Jerry Falwell announces Moral Majority on *Old Time Gospel Hour*
* Skylab falls
* Inflation is 13.3%
* Gas crisis
* Sony Walkman
* Film: *Kramer vs. Kramer, Norma Rae, Apocalypse Now, Mad Max*

1980

* Ronald Reagan elected president, defeating incumbent Jimmy Carter
* Mount St. Helens erupts
* John Lennon is assassinated
* Japan surpasses U.S. as world's largest automaker
* Solidarity strikes in Poland
* Post-It Notes

1981

* Reagan is sworn into office
* Iran releases hostages
* Space Shuttle Columbia
* François Mitterand becomes French president
* John Hinkley, Jr., attempts to assassinate Reagan
* First AIDS reports
* Prince Charles and Lady Diana wed
* TV: Luke and Laura's wedding on *General Hospital, Dynasty*, MTV
* Pac-Man

1982

* Argentina invades the Falkland Islands
* Vietnam Memorial, Washington, D.C.
* Death of Leonid Brezhnev, General Secretary of the Communist Party of the Soviet Union
* Telephone monopoly ended
* Michael Jackson, *Thriller*
* Deaths of Princess Grace, John Belushi

LIST OF PLATES

The plates section is a visual essay, showing in roughly chronological order the development of the cultural patterns and aesthetic issues occurring throughout the 1970s.

ROBERT HEINECKEN

1 Robert Heinecken, *Untitled* ("This is the way love is in 1970"), c. 1970. Offset lithography on magazine page, 11 ⅛ × 7 ¹⁵/₁₆ in. Center for Creative Photography, University of Arizona: Robert Heinecken Archive / Gift of the artist

2 Robert Heinecken, *Untitled* ("Conform by Beauty Mist"), c. 1970. Offset lithography on magazine page, 11 ⅛ × 8 ⅜ in. Center for Creative Photography, University of Arizona: Robert Heinecken Archive / Gift of the artist

3 Robert Heinecken, *Untitled* ("Sequa, Elizabeth Arden"), c. 1970. Offset lithography on magazine page, 11 ⅛ × 7 ⅞ in. Center for Creative Photography, University of Arizona: Robert Heinecken Archive / Gift of the artist

4 Robert Heinecken, *Untitled* ("The freedom spray"), c. 1970. Offset lithography on magazine page, 11 ⅛ × 7 ⅞ in. Center for Creative Photography, University of Arizona: Robert Heinecken Archive / Gift of the artist

5 Robert Heinecken, *Untitled* ("The glare-killers are man-killers now"), c. 1970. Offset lithography on magazine page, 11 ⅛ × 7 ⅞ in. Center for Creative Photography, University of Arizona: Robert Heinecken Archive / Gift of the artist

6 Robert Heinecken, *Untitled* ("Be some body"), c. 1970. Offset lithography on magazine page, 11 ⅛ × 8 in. Center for Creative Photography, University of Arizona: Robert Heinecken Archive / Gift of the artist

7 Robert Heinecken, *Untitled*, c. 1970. Offset lithography on magazine page, 11 ⅛ × 8 in. Center for Creative Photography, University of Arizona: Robert Heinecken Archive / Gift of the artist

8 Robert Heinecken, *Untitled*, c. 1970. Offset lithography on magazine page, 11 ⅛ × 8 in. Center for Creative Photography, University of Arizona: Robert Heinecken Archive / Gift of the artist

9 Robert Heinecken, *Untitled* ("Moon Drops"), c. 1970. Offset lithography on magazine page, 11 ⅛ × 7 ⅞ in. Center for Creative Photography, University of Arizona: Robert Heinecken Archive / Gift of the artist

10 Robert Heinecken, *Untitled* ("What's now"), c. 1970. Offset lithography on magazine page, 11 ⅛ × 7 ⅞ in. Center for Creative Photography, University of Arizona: Robert Heinecken Archive / Gift of the artist

11 Robert Heinecken, *Untitled* ("DuBarry"), c. 1970. Offset lithography on magazine page, 11 ⅟₁₆ × 7 ¹⁵/₁₆ in. Center for Creative Photography, University of Arizona: Robert Heinecken Archive / Gift of the artist

12 Robert Heinecken, *Untitled*, c. 1970. Offset lithography on magazine page, 11 ⅛ × 7 ⅞ in. Center for Creative Photography, University of Arizona: Robert Heinecken Archive / Gift of the artist

13 Robert Heinecken, *Untitled*, c. 1970. Offset lithography on magazine page, 11 ⅛ × 8 ¼ in. Center for Creative Photography, University of Arizona: Robert Heinecken Archive / Gift of the artist

14 Robert Heinecken, *Untitled* ("Be the nurse you were meant to be"), c. 1970. Offset lithography on magazine page, 11 ⅛ × 7 ¹⁵/₁₆ in. Center for Creative Photography, University of Arizona: Robert Heinecken Archive / Gift of the artist

15 Robert Heinecken, *Untitled* ("Introducing a new country"), c. 1970. Offset lithography on magazine page, 11 ³/₁₆ × 7 ⅞ in. Center for Creative Photography, University of Arizona: Robert Heinecken Archive / Gift of the artist

16 Robert Heinecken, *Untitled* ("B&L lights up the fashion eye in golden shades of autumn"), c. 1970. Offset lithography on magazine page, 11 ⅛ × 8 ⅜ in. Center for Creative Photography, University of Arizona: Robert Heinecken Archive / Gift of the artist

17 Robert Heinecken, *Untitled* ("Almay"), c. 1970. Offset lithography on magazine page, 11 ⅛ × 8 ¼ in. Center for Creative Photography, University of Arizona: Robert Heinecken Archive / Gift of the artist

18 Robert Heinecken, *Untitled*, c. 1970. Offset lithography on magazine page, 11 ³/₁₆ × 8 ¼ in. Center for Creative Photography, University of Arizona: Robert Heinecken Archive / Gift of the artist

19 Robert Heinecken, *Untitled* ("Woman's Day"), cover of *Periodical #6, 12 of 16*, 1971. Reconfigured magazine, 8 × 11 in. Courtesy The Robert Heinecken Trust and Pace/MacGill, New York

20 Robert Heinecken, *Untitled* ("Revlon says"), spread from *Periodical #6 (3rd Group)*, 1971. Offset lithography on magazine, 11 × 16 in. Courtesy The Robert Heinecken Trust and Pace/MacGill, New York

21 Robert Heinecken, *Untitled* ("How a woman can protect herself on city streets"), spread from *Periodical #1*, 1969. Offset lithography on magazine, 11 × 16 in. Courtesy The Robert Heinecken Trust and Pace/MacGill, New York

22 Robert Heinecken, *Untitled* ("Reed & Barton"), spread from *Periodical #1*, 1969. Offset lithography on magazine, 11 × 16 in. Courtesy The Robert Heinecken Trust and Pace/MacGill, New York

23 Robert Heinecken, *TV/Time Environment*, 1970. Photolithographic transfer on polyester film, 11 ⁵/₁₆ × 14 ¹¹/₁₆ in. Center for Creative Photography, University of Arizona: Robert Heinecken Archive / Gift of the artist

24 Robert Heinecken, *Daytime Color TV Fantasy* ("Xercise boo"), c. 1975, Produced after the installation *TV/Time Environment*. Four-color photolithograph, 13 ⅜ × 17 ³/₁₀ in. Courtesy The Robert Heinecken Trust and Pace/MacGill, New York

STEPHEN SHORE

25 Stephen Shore, *Civic Center, 3rd and Buchanan*, from the series Amarillo—"Tall in Texas," 1971. Postcard, 6 × 8 in. © Stephen Shore, Courtesy 303 Gallery, New York

26 Stephen Shore, *American National Bank Building, 7th & Tyler*, from the series Amarillo—"Tall in Texas," 1971. Postcard, 6 × 8 in. © Stephen Shore, Courtesy 303 Gallery, New York

27 Stephen Shore, *Capitol Hotel, 401 S. Pierce*, from the series Amarillo—"Tall in Texas," 1971. Postcard, 6 × 8 in. © Stephen Shore, Courtesy 303 Gallery, New York

28 Stephen Shore, *Polk Street*, from the series Amarillo—"Tall in Texas," 1971. Postcard, 6 × 8 in. © Stephen Shore, Courtesy 303 Gallery, New York

29 Stephen Shore, *Potter County Courthouse, Betw. 5th & 6th on Taylor*, from the series Amarillo—"Tall in Texas," 1971. Postcard, 6 × 8 in. © Stephen Shore, Courtesy 303 Gallery, New York

30 Stephen Shore, *Feferman's Army Navy Store, 201 E. 4th*, from the series Amarillo—"Tall in Texas," 1971. Postcard, 6 × 8 in. © Stephen Shore, Courtesy 303 Gallery, New York

31 Stephen Shore, *Doug's Bar B Q No. 1, 3313 S. Georgia*, from the series Amarillo—"Tall in Texas," 1971. Postcard, 6 × 8 in. © Stephen Shore, Courtesy 303 Gallery, New York

32 Stephen Shore, *Fenley's Café, 322 W. 3rd*, from the series Amarillo—"Tall in Texas," 1971. Postcard, 6 × 8 in. © Stephen Shore, Courtesy 303 Gallery, New York

33 Stephen Shore, *St. Anthony's Hospital, 735 N. Polk*, from the series Amarillo—"Tall in Texas," 1971. Postcard, 6 × 8 in. © Stephen Shore, Courtesy 303 Gallery, New York

34 Stephen Shore, *Double Dip, 1323 S. Polk*, from the series Amarillo—"Tall in Texas," 1971. Postcard, 6 × 8 in. © Stephen Shore, Courtesy 303 Gallery, New York

35 Stephen Shore, *Albuquerque, New Mexico, June 1972*, from the series American Surfaces, 1972. Inkjet print after commercially processed chromogenic print, 3 ½ × 5 in. © Stephen Shore, Courtesy 303 Gallery, New York

36 Stephen Shore, *New York City, April 1972*, from the series American Surfaces, 1972. Inkjet print after commercially processed chromogenic print, 3 ½ × 5 in. © Stephen Shore, Courtesy 303 Gallery, New York

37 Stephen Shore, *Santa Fe, New Mexico, June 1972*, from the series American Surfaces, 1972. Inkjet print after commercially processed chromogenic print, 3 ½ × 5 in. © Stephen Shore, Courtesy 303 Gallery, New York

38 Stephen Shore, *Oklahoma City, July 1972*, from the series American Surfaces, 1972. Inkjet print after commercially processed chromogenic print, 3 ½ × 5 in. © Stephen Shore, Courtesy 303 Gallery, New York

39 Stephen Shore, *Toledo, Ohio, July 1972*, from the series American Surfaces, 1972. Inkjet print after commercially processed chromogenic print, 3 ½ × 5 in. © Stephen Shore, Courtesy 303 Gallery, New York

40 Stephen Shore, *Normal, Illinois, July 1972*, from the series American Surfaces, 1972. Inkjet print after commercially processed chromogenic print, 3 ½ × 5 in. © Stephen Shore, Courtesy 303 Gallery, New York

41 Stephen Shore, *N. M. 44, New Mexico, June 1972*, from the series American Surfaces, 1972. Inkjet print after commercially processed chromogenic print, 3 ½ × 5 in. © Stephen Shore, Courtesy 303 Gallery, New York

42 Stephen Shore, *Chicago, Illinois, July 1972*, from the series American Surfaces, 1972. Inkjet print after commercially

processed chromogenic print, 3 ½ × 5 in. © Stephen Shore, Courtesy 303 Gallery, New York

MITCH EPSTEIN

43 Mitch Epstein, *West Side Highway, New York City*, 1977. Chromogenic print, 20 × 24 in. © Black River Productions, Ltd. / Mitch Epstein. Courtesy of Sikkema Jenkins & Co., New York. Used with permission. All rights reserved

44 Mitch Epstein, *Central Park IV, New York City*, 1977. Chromogenic print, 20 × 24 in. © Black River Productions, Ltd. / Mitch Epstein. Courtesy of Sikkema Jenkins & Co., New York. Used with permission. All rights reserved

45 Mitch Epstein, *French Quarter II, New Orleans, Louisiana*, 1975. Chromogenic print, 20 × 24 in. © Black River Productions, Ltd. / Mitch Epstein. Courtesy of Sikkema Jenkins & Co., New York. Used with permission. All rights reserved

46 Mitch Epstein, *Houston, Texas*, 1974. Dye transfer print, 16 × 20 in. © Black River Productions, Ltd. / Mitch Epstein. Courtesy of Sikkema Jenkins & Co., New York. Used with permission. All rights reserved

47 Mitch Epstein, *Madison Avenue, New York City*, 1973. Dye transfer print, 16 × 20 in. © Black River Productions, Ltd. / Mitch Epstein. Courtesy of Sikkema Jenkins & Co., New York. Used with permission. All rights reserved

48 Mitch Epstein, *Mardi Gras I, New Orleans, Louisiana*, 1975. Dye transfer print, 16 × 20 in. © Black River Productions, Ltd. / Mitch Epstein. Courtesy of Sikkema Jenkins & Co., New York. Used with permission. All rights reserved

49 Mitch Epstein, *Miami Beach II, Florida*, 1976. Chromogenic print, 20 × 24 in. © Black River Productions, Ltd. / Mitch Epstein. Courtesy of Sikkema Jenkins & Co., New York. Used with permission. All rights reserved

50 Mitch Epstein, *Springfield, Massachusetts*, 1973. Dye transfer print, 16 × 20 in. © Black River Productions, Ltd. / Mitch Epstein. Courtesy of Sikkema Jenkins & Co., New York. Used with permission. All rights reserved

51 Mitch Epstein, *Topanga Canyon, California*, 1974. Dye transfer print, 16 × 20 in. © Black River Productions, Ltd. / Mitch Epstein. Courtesy of Sikkema Jenkins & Co., New York. Used with permission. All rights reserved

52 Mitch Epstein, *Massachusetts Turnpike*, 1973. Dye transfer print, 16 × 20 in. © Black River Productions, Ltd. / Mitch Epstein. Courtesy of Sikkema Jenkins & Co., New York. Used with permission. All rights reserved

53 Mitch Epstein, *Vietnam Veteran's Parade, New York City*, 1973. Dye transfer print, 16 × 20 in. © Black River Productions, Ltd. / Mitch Epstein. Courtesy of Sikkema Jenkins & Co., New York. Used with permission. All rights reserved

HELEN LEVITT

54-62 Helen Levitt, Untitled still from *Projects: Helen Levitt in Color, 1971–74*, The Museum of Modern Art, New York, 1974. Forty color photographs shown in continuous projection. Courtesy of the Estate of Helen Levitt, New York, and the Museum of Modern Art, New York

JOEL MEYEROWITZ

63 Joel Meyerowitz, *From the Car, New York Thruway*, 1975. Chromogenic print, 11 × 14 in. © Joel Meyerowitz, Courtesy Edwynn Houk Gallery, New York

64 Joel Meyerowitz, *From the Car, New York Thruway*, 1973. Chromogenic print, 11 × 14 in. © Joel Meyerowitz, Courtesy Edwynn Houk Gallery, New York

65 Joel Meyerowitz, *From the Car, Stonehenge, England*, 1966. Chromogenic print, 11 × 14 in. © Joel Meyerowitz, Courtesy Edwynn Houk Gallery, New York

66 Joel Meyerowitz, *From the Car, New York Thruway*, 1975. Chromogenic print, 11 × 14 in. © Joel Meyerowitz, Courtesy Edwynn Houk Gallery, New York

67 Joel Meyerowitz, *From the Car, Taos, New Mexico*, 1971. Chromogenic print, 11 × 14 in. © Joel Meyerowitz, Courtesy Edwynn Houk Gallery, New York

68 Joel Meyerowitz, *From the Car, New York Thruway*, 1974. Chromogenic print, 11 × 14 in. © Joel Meyerowitz, Courtesy Edwynn Houk Gallery, New York

EVE SONNEMAN

69 Eve Sonneman, *Landscape/Cloud, New Mexico*, 1978. Two Cibachrome prints, each 8 × 10 in. © Eve Sonneman

70 Eve Sonneman, *Sight/Sound: For Mike Goldberg, Samos, Greece*, 1977. Two Cibachrome prints, each 8 × 10 in. © Eve Sonneman

71 Eve Sonneman, *Photo Novellas, Bordeaux*, 1980. Two Cibachrome prints, each 8 × 10 in. © Eve Sonneman. Collection of Nion McEvoy, San Francisco

72 Eve Sonneman, *Newspaper, New York*, 1980. Two Cibachrome prints, each 8 × 10 in. © Eve Sonneman

73 Eve Sonneman, *Cropduster, Clovis, New Mexico*, 1980. Two Cibachrome prints, each 8 × 10 in. © Eve Sonneman

74 Eve Sonneman, *Goldfish, Athens*, 1979. Two Cibachrome prints, each 8 × 10 in. © Eve Sonneman

75 Eve Sonneman, *The Instant and the Moment, Greece*, 1977. Two Cibachrome prints, each 8 × 10 in. © Eve Sonneman

76 Eve Sonneman, *Oranges, Manhattan*, 1978. Two Cibachrome prints, each 8 × 10 in. © Eve Sonneman

NEAL SLAVIN

77 Neal Slavin, *International Twins Association, Muncie, Indiana*, c. 1976. Chromogenic print, 16 × 20 in. © Neal Slavin

78 Neal Slavin, *Salt Lake Mormon Tabernacle Choir*, c. 1976. Chromogenic print, 16 × 20 in. © Neal Slavin

79 Neal Slavin, *Lithuanian Scouts Association, Inc., Rancho Palos Verdes, California*, c. 1976. Chromogenic print, 16 × 20 in. © Neal Slavin

80 Neal Slavin, *Continental Baths, New York, New York*, c. 1976. Chromogenic print, 16 × 20 in. © Neal Slavin

81 Neal Slavin, *Lloyd Rod and Gun Club, Highland, New York*, c. 1976. Chromogenic print, 16 × 20 in. © Neal Slavin

82 Neal Slavin, *Wilhelmina Models, Inc., New York, New York*, c. 1976. Chromogenic print, 16 × 20 in. © Neal Slavin

83 Neal Slavin, *The Star Trek Convention, Star Trek Associates, A Division of Tellurian Enterprises, Inc., Brooklyn, New York*, c. 1976. Chromogenic print, 16 × 20 in. © Neal Slavin

84 Neal Slavin, *Camp Tahoe, Loch Sheldrake, New York*, c. 1976. Chromogenic print, 16 × 20 in. © Neal Slavin

85 Neal Slavin, *Miss U.S.A. Pageant, Miss Universe, Inc., New York, New York*, c. 1976. Chromogenic print, 16 × 20 in. © Neal Slavin

LES KRIMS

86 Les Krims, *Nude with Balanced Severed Ear and Pasted Peanuts*, 1974. Inkjet print after unique Polaroid, 5 × 3 ¾ in. © Les Krims

87 Les Krims, *Goldfish Bowl Press and Plug*, 1974. Inkjet print after unique Polaroid, 5 × 3 ¾ in. © Les Krims

88 Les Krims, *Attacking Banana Marauders*, 1974. Inkjet print after unique Polaroid, 5 × 3 ¾ in. © Les Krims

89 Les Krims, *Kosher Pickles, Gentile Woman*, 1974. Inkjet print after unique Polaroid, 5 × 3 ¾ in. © Les Krims

90 Les Krims, *Man with Tattoo of a Satyr Displaying the "Up Yours" Sign*, 1975. Inkjet print after unique Polaroid, 5 × 3 ¾ in. © Les Krims

91 Les Krims, *Optical Illusion*, 1974. Inkjet print after unique Polaroid, 5 × 3 ¾ in. © Les Krims

92 Les Krims, *High-Speed, Red Shape Impact Image*, 1974. Inkjet print after unique Polaroid, 5 × 3 ¾ in. © Les Krims

93 Les Krims, *Pencil Test #7*, 1975. Inkjet print after unique Polaroid, 5 × 3 ¾ in. © Les Krims

94 Les Krims, *Magnified Heat Sources*, 1974. Inkjet print after unique Polaroid, 5 × 3 ¾ in. © Les Krims

JOEL STERNFELD

95 Joel Sternfeld, *Summer 1976, Chicago?*, 1976. Chromogenic print, 16 × 20 in. © Joel Sternfeld, Courtesy the artist and Luhring Augustine, New York

96 Joel Sternfeld, *Chicago, August 1976 (On the L)*, 1976. Chromogenic print, 16 × 20 in. © Joel Sternfeld, Courtesy the artist and Luhring Augustine, New York

97 Joel Sternfeld, *New York City, June 1976 (Chelsea)*, 1976. Chromogenic print, 16 × 20 in. © Joel Sternfeld, Courtesy the artist and Luhring Augustine, New York

98 Joel Sternfeld, *Summer 1976, probably Chicago*, 1976. Chromogenic print, 16 × 20 in. © Joel Sternfeld, Courtesy the artist and Luhring Augustine, New York

99 Joel Sternfeld, *Chicago, August 1976*, 1976. Chromogenic print, 16 × 20 in. © Joel Sternfeld, Courtesy the artist and Luhring Augustine, New York

100 Joel Sternfeld, *New York City, 1976 (Eight Avenue?)*, 1976. Chromogenic print, 16 × 20 in. © Joel Sternfeld, Courtesy the artist and Luhring Augustine, New York

101 Joel Sternfeld, *New York City, 1976 (Park Avenue?)*, 1976. Chromogenic print, 16 × 20 in. © Joel Sternfeld, Courtesy the artist and Luhring Augustine, New York

102　Joel Sternfeld, *July 1976, Chicago*, 1976. Chromogenic print, 16 × 20 in. © Joel Sternfeld, Courtesy the artist and Luhring Augustine, New York

103　Joel Sternfeld, *New York City, May 1976 (Soho)*, 1976. Chromogenic print, 16 × 20 in. © Joel Sternfeld, Courtesy the artist and Luhring Augustine, New York

WILLIAM CHRISTENBERRY

104　William Christenberry, *Coleman's Café, Greensboro, Alabama*, 1971. Dye transfer print, 4½ × 3½ in. © William Christenberry; Courtesy Pace/MacGill Gallery, New York

105　William Christenberry, *Green Warehouse, Newbern, Alabama*, 1973. Pigment print, 4½ × 3½ in. © William Christenberry; Courtesy Pace/MacGill Gallery, New York

106　William Christenberry, *South End of Palmist Building, Havana Junction, Alabama (Walker Evans to right)*, 1973. Ektacolor print, 4½ × 3½ in. © William Christenberry; Courtesy Pace/MacGill Gallery, New York

107　William Christenberry, *Building with False Brick Siding, Warsaw, Alabama*, 1974. Dye transfer print, 4½ × 3½ in. © William Christenberry; Courtesy Pace/MacGill Gallery, New York

108　William Christenberry, *Grave with Egg Carton Cross, Hale County, Alabama*, 1975. Ektacolor print, 4½ × 3½ in. © William Christenberry; Courtesy Pace/MacGill Gallery, New York

109　William Christenberry, *Green Warehouse, Newbern, Alabama*, 1976. Evercolor print, 4½ × 3½ in. © William Christenberry; Courtesy Pace/MacGill Gallery, New York

110　William Christenberry, *Coleman's Café, Greensboro, Alabama*, 1976. Pigment print, 4½ × 3½ in. © William Christenberry; Courtesy Pace/MacGill Gallery, New York

111　William Christenberry, *Corn Sign with Storm Cloud, near Greensboro, Alabama*, 1977. Dye transfer print, 4½ × 3½ in. © William Christenberry; Courtesy Pace/MacGill Gallery, New York

112　William Christenberry, *Coleman's Café, Greensboro, Alabama*, 1977. Pigment print, 4½ × 3½ in. © William Christenberry; Courtesy Pace/MacGill Gallery, New York

113　William Christenberry, *House and Car, near Akron, Alabama*, 1978. Dye transfer print, 4½ × 3½ in. © William Christenberry; Courtesy Pace/MacGill Gallery, New York

114　William Christenberry, *Green Warehouse, Newbern, Alabama*, 1978. Pigment print, 4½ × 3½ in. © William Christenberry; Courtesy Pace/MacGill Gallery, New York

115　William Christenberry, *Kudzu with Sky (Summer), near Akron, Alabama*, 1978. Ektacolor print, 4½ × 3½ in. © William Christenberry; Courtesy Pace/MacGill Gallery, New York

116　William Christenberry, *Black House, Red Roses, and Rooster (for William Eggleston), Hinds County, Mississippi*, 1979. Ektacolor print, 4½ × 3½ in. © William Christenberry; Courtesy Pace/MacGill Gallery, New York

117　William Christenberry, *Coleman's Café, Greensboro, Alabama*, 1979. Pigment print, 4½ × 3½ in. © William Christenberry; Courtesy Pace/MacGill Gallery, New York

118　William Christenberry, *Coleman's Café, Greensboro, Alabama*, 1979. Pigment print, 4½ × 3½ in. © William Christenberry; Courtesy Pace/MacGill Gallery, New York

WILLIAM EGGLESTON

119　William Eggleston, *Memphis*, c. 1972. Dye transfer print, 23½ × 18 in. © Eggleston Artistic Trust, Courtesy Cheim & Read, New York

120　William Eggleston, *Sumner, Mississippi, Cassidy Bayou in Background*, c. 1970. Dye transfer print, 16 × 20 in. © Eggleston Artistic Trust, Courtesy Cheim & Read, New York. Collection of Joseph and Stephanie Kraeutler, New York

121　William Eggleston, *Jackson, Mississippi*, c. 1969–70. Dye transfer print, 16 × 20 in. © Eggleston Artistic Trust, Courtesy Cheim & Read, New York

122　William Eggleston, *Southern Environs of Memphis*, c. 1969–70. Dye transfer print, 11 × 17 in. © Eggleston Artistic Trust, Courtesy Cheim & Read, New York. Collection of Trevor Traina, San Francisco

123　William Eggleston, *Memphis*, c. 1969–71. Dye transfer print, 19 × 22¾ in. © Eggleston Artistic Trust, Courtesy Cheim & Read, New York

124　William Eggleston, *Greenwood, Mississippi*, 1973. Dye transfer print, 16 × 20 in. © Eggleston Artistic Trust, Courtesy Cheim & Read, New York. Collection of Joseph and Stephanie Kraeutler, New York

125　William Eggleston, *Memphis, Tennessee*, 1971. Dye transfer print, 15 × 20 in. © Eggleston Artistic Trust, Courtesy Cheim & Read, New York. Collection of Penny Pritzker and Bryan Traubert, Chicago

126　William Eggleston, *Tallahatchie County, Mississippi*, c. 1972. Dye transfer print, 22½ × 18 in. © Eggleston Artistic Trust, Courtesy Cheim & Read, New York

127　William Eggleston, *Greenwood, Mississippi*, c. 1972. Dye transfer print, 24 × 20 in. © Eggleston Artistic Trust, Courtesy Cheim & Read, New York

128　William Eggleston, *Morton, Mississippi*, c. 1969–70. Dye transfer print, 25 × 18¾ in. © Eggleston Artistic Trust, Courtesy Cheim & Read, New York

129　William Eggleston, *Memphis*, c. 1969–70. Dye transfer print, 14 × 11 in. © Eggleston Artistic Trust, Courtesy Cheim & Read, New York. Collection of Vicki Harris, New York

130　William Eggleston, *Memphis*, c. 1969–70. Dye transfer print, 16 × 20 in. © Eggleston Artistic Trust, Courtesy Cheim & Read, New York

131　William Eggleston, *Highway 78, Northern Mississippi*, 1972. Dye transfer print, 15¼ × 19½ in. © Eggleston Artistic Trust, Courtesy Cheim & Read, New York

132　William Eggleston, *Huntsville, Alabama*, c. 1972. Dye transfer print, 14 × 17 in. © Eggleston Artistic Trust, Courtesy Cheim & Read, New York

133　William Eggleston, *Tallahatchie County, Mississippi*, c. 1969–71. Dye transfer print, 16 × 20 in. © Eggleston Artistic Trust, Courtesy Cheim & Read, New York. Collection of Joseph and Stephanie Kraeutler, New York

134　William Eggleston, *Morton, Mississippi*, c. 1972. Dye transfer print, 18 × 23 in. © Eggleston Artistic Trust, Courtesy Cheim & Read, New York

135　William Eggleston, *Near Greenwood, Mississippi*, c. 1971. Dye transfer print, 20 × 24 in. © Eggleston Artistic Trust, Courtesy Cheim & Read, New York

136　William Eggleston, *Near Minter City and Glendora, Mississippi*, c. 1969–70. Dye transfer print, 20 × 24 in. © Eggleston Artistic Trust, Courtesy Cheim & Read, New York. Bequest of Carl Jacobs to the Cincinnati Art Museum

137　William Eggleston, *Huntsville, Alabama*, c. 1969–70. Dye transfer print, 14 × 17 in. © Eggleston Artistic Trust, Courtesy Cheim & Read, New York

138　William Eggleston, *Memphis*, c. 1969–70. Dye transfer print, 16 × 20 in. © Eggleston Artistic Trust, Courtesy Cheim & Read, New York. Collection of Joseph and Stephanie Kraeutler, New York

139　William Eggleston, *Memphis*, c. 1969–70. Dye transfer print, 18½ × 24¾ in. © Eggleston Artistic Trust, Courtesy Cheim & Read, New York

140　William Eggleston, *Nashville, Tennessee*, 1971. Dye transfer print, 15¼ × 19½ in. © Eggleston Artistic Trust, Courtesy Cheim & Read, New York

141　William Eggleston, *Peaches, Near Greenville, Mississippi*, c. 1973. Dye transfer print, 14½ × 20¼ in. © Eggleston Artistic Trust, Courtesy Cheim & Read, New York

142　William Eggleston, *Downtown Morton, Mississippi*, c. 1969–70. Dye transfer print, 16 × 20 in. © Eggleston Artistic Trust, Courtesy Cheim & Read, New York

JAN GROOVER

143　Jan Groover, *Untitled*, 1979. Chromogenic print, 20 × 16 in. © Jan Groover, Courtesy of the artist and Janet Borden, Inc., New York

144　Jan Groover, *Untitled*, 1978. Chromogenic print, 16 × 20 in. © Jan Groover, Courtesy of the artist and Janet Borden, Inc., New York

145　Jan Groover, *Untitled*, 1978. Chromogenic print, 20 × 16 in. © Jan Groover, Courtesy of the artist and Janet Borden, Inc., New York

146　Jan Groover, *Untitled*, 1978. Chromogenic print, 20 × 16 in. © Jan Groover, Courtesy of the artist and Janet Borden, Inc., New York

147　Jan Groover, *Untitled*, 1978. Chromogenic print, 16 × 20 in. © Jan Groover, Courtesy of the artist and Janet Borden, Inc., New York

148　Jan Groover, *Untitled*, 1979. Chromogenic print, 20 × 16 in. © Jan Groover, Courtesy of the artist and Janet Borden, Inc., New York

149　Jan Groover, *Untitled*, 1980. Chromogenic print, 20 × 16 in. © Jan Groover, Courtesy of the artist and Janet Borden, Inc., New York

BARBARA KASTEN

150　Barbara Kasten, *Untitled 11*, c. 1975. Cyanotype, 30 × 40 in. © Barbara Kasten

151　Barbara Kasten, *Untitled 9*, c. 1975. Cyanotype, 30 × 40 in. © Barbara Kasten

152　Barbara Kasten, *Untitled 28*, c. 1975. Cyanotype, 30 × 40 in. © Barbara Kasten

153　Barbara Kasten, *Construct II-B*, 1979. Polaroid photograph, 9½ × 7½ in. © Barbara Kasten

154　Barbara Kasten, *Construct II-D*, 1980. Polaroid photograph, 9½ × 7½ in. © Barbara Kasten

155　Barbara Kasten, *Construct I-A*, 1979. Polaroid photograph, 7½ × 9½ in. © Barbara Kasten

156　Barbara Kasten, *Construct II-A*, 1980. Polaroid photograph, 7½ × 9½ in. © Barbara Kasten

157　Barbara Kasten, *Construct IV-C*, 1980. Polaroid photograph, 7½ × 9½ in. © Barbara Kasten

158　Barbara Kasten, *Construct III-D*, 1980. Polaroid photograph, 9½ × 7½ in. © Barbara Kasten

159　Barbara Kasten, *Construct III-C*, 1980. Polaroid photograph, 9½ × 7½ in. © Barbara Kasten

160　Barbara Kasten, *Construct III-F*, 1980. Polaroid photograph, 9½ × 7½ in. © Barbara Kasten

161 Barbara Kasten, *Construct IV-B*, 1979. Polaroid photograph, 9½ × 7½ in. © Barbara Kasten

JOHN DIVOLA

162 John Divola, *Zuma #3*, 1977. Dye transfer print, 14 × 18 in. © John Divola, Courtesy Gallery Luisotti, Santa Monica. Collection of Gregory Gooding, New York

163 John Divola, *Zuma #7*, 1977. Dye transfer print, 14 × 18 in. © John Divola, Courtesy Gallery Luisotti, Santa Monica. Collection of Gregory Gooding, New York

164 John Divola, *Zuma #5*, 1977. Dye transfer print, 14 × 18 in. © John Divola, Courtesy Gallery Luisotti, Santa Monica. Collection of Gregory Gooding, New York

165 John Divola, *Zuma #38*, 1978. Dye transfer print, 14 × 18 in. © John Divola, Courtesy Gallery Luisotti, Santa Monica. Collection of Gregory Gooding, New York

166 John Divola, *Zuma #12*, 1977. Dye transfer print, 14 × 18 in. © John Divola, Courtesy Gallery Luisotti, Santa Monica. Collection of Gregory Gooding, New York

167 John Divola, *Zuma #19*, 1978. Dye transfer print, 14 × 18 in. © John Divola, Courtesy Gallery Luisotti, Santa Monica. Collection of Gregory Gooding, New York

168 John Divola, *Zuma #21*, 1977. Dye transfer print, 14 × 18 in. © John Divola, Courtesy Gallery Luisotti, Santa Monica. Collection of Gregory Gooding, New York

169 John Divola, *Zuma #25*, 1978. Dye transfer print, 14 × 18 in. © John Divola, Courtesy Gallery Luisotti, Santa Monica. Collection of Gregory Gooding, New York

170 John Divola, *Zuma #14*, 1978. Dye transfer print, 14 × 18 in. © John Divola, Courtesy Gallery Luisotti, Santa Monica. Collection of Gregory Gooding, New York

171 John Divola, *Zuma #29*, 1978. Dye transfer print, 14 × 18 in. © John Divola, Courtesy Gallery Luisotti, Santa Monica. Collection of Gregory Gooding, New York

JOHN PFAHL

172 John Pfahl, *Wave, Lave, Lace, Pescadero Beach, CA*, 1978. Dye transfer print, 8 × 10 in. © John Pfahl, Courtesy Janet Borden, Inc., New York

173 John Pfahl, *Canyon Point, Zion National Park, UT*, 1977. Dye transfer print, 8 × 10 in. © John Pfahl, Courtesy Janet Borden, Inc., New York

174 John Pfahl, *Haystack Cone, Freeport, ME*, 1976. Dye transfer print, 8 × 10 in. © John Pfahl, Courtesy Janet Borden, Inc., New York

175 John Pfahl, *Live Oak Lightening, Lompoc, CA*, 1978. Dye transfer print, 8 × 10 in. © John Pfahl, Courtesy Janet Borden, Inc., New York

176 John Pfahl, *Australian Pines, Fort Desoto, FL*, 1977. Dye transfer print, 8 × 10 in. © John Pfahl, Courtesy Janet Borden, Inc., New York

177 John Pfahl, *Slanting Forest, Artpark, Lewiston, NY*, 1975. Dye transfer print, 8 × 10 in. © John Pfahl, Courtesy Janet Borden, Inc., New York

178 John Pfahl, *Shed with Blue Dotted Lines, Penland, NC*, 1975. Dye transfer print, 8 × 10 in. © John Pfahl, Courtesy Janet Borden, Inc., New York

179 John Pfahl, *Six Oranges, Delaware Park, Buffalo, NY*, 1975. Dye transfer print, 8 × 10 in. © John Pfahl, Courtesy Janet Borden, Inc., New York

180 John Pfahl, *Red Setters in Red Field, Charlotte, NC*, 1976. Dye transfer print, 8 × 10 in. © John Pfahl, Courtesy Janet Borden, Inc., New York

181 John Pfahl, *Pink Rock Rectangle, Artpark, Lewiston, NY*, 1975. Dye transfer print, 8 × 10 in. © John Pfahl, Courtesy Janet Borden, Inc., New York

RICHARD MISRACH

182 Richard Misrach, *Hawaii XVII*, 1978. Dye transfer print, 16 × 20 in. © Richard Misrach. Courtesy Fraenkel Gallery, San Francisco, Marc Selwyn Fine Art, Los Angeles, and Pace/MacGill Gallery, New York

183 Richard Misrach, *Hawaii*, 1978. Dye transfer print, 16 × 20 in. © Richard Misrach. Courtesy Fraenkel Gallery, San Francisco, Marc Selwyn Fine Art, Los Angeles, and Pace/MacGill Gallery, New York

184 Richard Misrach, *Hawaii XV*, 1978. Dye transfer print, 16 × 20 in. © Richard Misrach. Courtesy Fraenkel Gallery, San Francisco, Marc Selwyn Fine Art, Los Angeles, and Pace/MacGill Gallery, New York

185 Richard Misrach, *Hawaii VIII*, 1978. Dye transfer print, 16 × 20 in. © Richard Misrach. Courtesy Fraenkel Gallery, San Francisco, Marc Selwyn Fine Art, Los Angeles, and Pace/MacGill Gallery, New York

186 Richard Misrach, *Hawaii XIV*, 1978. Dye transfer print, 16 × 20 in. © Richard Misrach. Courtesy Fraenkel Gallery, San Francisco, Marc Selwyn Fine Art, Los Angeles, and Pace/MacGill Gallery, New York

187 Richard Misrach, *Hawaii VI*, 1978. Dye transfer print, 16 × 20 in. © Richard Misrach. Courtesy Fraenkel Gallery, San Francisco, Marc Selwyn Fine Art, Los Angeles, and Pace/MacGill Gallery, New York

188 Richard Misrach, *Hawaii VII*, 1978. Dye transfer print, 16 × 20 in. © Richard Misrach. Courtesy Fraenkel Gallery, San Francisco, Marc Selwyn Fine Art, Los Angeles, and Pace/MacGill Gallery, New York

189 Richard Misrach, *Hawaii IV*, 1978. Dye transfer print, 16 × 20 in. © Richard Misrach. Courtesy Fraenkel Gallery, San Francisco, Marc Selwyn Fine Art, Los Angeles, and Pace/MacGill Gallery, New York

190 Richard Misrach, *Hawaii XII*, 1978. Dye transfer print, 16 × 20 in. © Richard Misrach. Courtesy Fraenkel Gallery, San Francisco, Marc Selwyn Fine Art, Los Angeles, and Pace/MacGill Gallery, New York

191 Richard Misrach, *Hawaii V*, 1978. Dye transfer print, 16 × 20 in. © Richard Misrach. Courtesy Fraenkel Gallery, San Francisco, Marc Selwyn Fine Art, Los Angeles, and Pace/MacGill Gallery, New York

192 Richard Misrach, *Hawaii IX*, 1978. Dye transfer print, 16 × 20 in. © Richard Misrach. Courtesy Fraenkel Gallery, San Francisco, Marc Selwyn Fine Art, Los Angeles, and Pace/MacGill Gallery, New York

193 Richard Misrach, *Hawaii XIII*, 1978. Dye transfer print, 16 × 20 in. © Richard Misrach. Courtesy Fraenkel Gallery, San Francisco, Marc Selwyn Fine Art, Los Angeles, and Pace/MacGill Gallery, New York

STEPHEN SHORE

194 Stephen Shore, *Church Street and Second Street, Easton, Pennsylvania, June 20, 1974*, 1974. Chromogenic print, 20 × 24 in. © Stephen Shore, Courtesy 303 Gallery, New York

195 Stephen Shore, *Holden Street, North Adams, Massachusetts, July 13, 1974*, 1974. Chromogenic print, 20 × 24 in. © Stephen Shore, Courtesy 303 Gallery, New York

196 Stephen Shore, *Meeting Street, Charlestown, South Carolina, August 3, 1975*, 1975. Chromogenic print, 20 × 24 in. © Stephen Shore, Courtesy 303 Gallery, New York

197 Stephen Shore, *U.S. 10, Post Falls, Idaho, August 25, 1974*, 1974. Chromogenic print, 20 × 24 in. © Stephen Shore, Courtesy 303 Gallery, New York

198 Stephen Shore, *Proton Avenue, Gull Lake, Saskatchewan, August 18, 1974*, 1974. Chromogenic print, 20 × 24 in. © Stephen Shore, Courtesy 303 Gallery, New York

199 Stephen Shore, *Presidio, Texas, February 21, 1975*, 1975. Chromogenic print, 20 × 24 in. © Stephen Shore, Courtesy 303 Gallery, New York

200 Stephen Shore, *Beverly Boulevard and La Brea Avenue, Los Angeles, California, June 21, 1975*, 1975. Chromogenic print, 20 × 24 in. © Stephen Shore, Courtesy 303 Gallery, New York

201 Stephen Shore, *Sault Ste. Marie, Ontario, August 13, 1974*, 1974. Chromogenic print, 20 × 24 in. © Stephen Shore, Courtesy 303 Gallery, New York

202 Stephen Shore, *Fifth Street and Broadway, Eureka, California, September 2, 1974*, 1974. Chromogenic print, 20 × 24 in. © Stephen Shore, Courtesy 303 Gallery, New York

203 Stephen Shore, *Mount Blue Shopping Center, Farmington, Maine, July 30, 1974*, 1974. Chromogenic print, 20 × 24 in. © Stephen Shore, Courtesy 303 Gallery, New York

204 Stephen Shore, *U.S. 22, Union, New Jersey, April 24, 1974*, 1974. Chromogenic print, 20 × 24 in. © Stephen Shore, Courtesy 303 Gallery, New York

205 Stephen Shore, *West Fifteenth Street and Vine Street, Cincinnati, Ohio, May 15, 1974*, 1974. Chromogenic print, 20 × 24 in. © Stephen Shore, Courtesy 303 Gallery, New York

JOEL MEYEROWITZ

206 Joel Meyerowitz, *Red Interior, Provincetown*, 1976. Chromogenic print, 20 × 24 in. © Joel Meyerowitz, Courtesy Edwynn Houk Gallery, New York

207 Joel Meyerowitz, *Cumberland Farms, Provincetown*, 1976. Chromogenic print, 20 × 24 in. © Joel Meyerowitz, Courtesy Edwynn Houk Gallery, New York

208 Joel Meyerowitz, *Dairy Land, Provincetown*, 1976. Chromogenic print, 20 × 24 in. © Joel Meyerowitz, Courtesy Edwynn Houk Gallery, New York

209 Joel Meyerowitz, *Roseville Cottages, Truro*, 1976. Chromogenic print, 20 × 24 in. © Joel Meyerowitz, Courtesy Edwynn Houk Gallery, New York

210 Joel Meyerowitz, *Cold Storage Beach, Truro*, 1976. Chromogenic print, 20 × 24 in. © Joel Meyerowitz, Courtesy Edwynn Houk Gallery, New York

211 Joel Meyerowitz, *Diane, Cape Cod*, 1982. Chromogenic print, 24 × 20 in. © Joel Meyerowitz, Courtesy Edwynn Houk Gallery, New York

212 Joel Meyerowitz, *Caroline, Cape Cod*, 1983. Chromogenic print, 24 × 20 in. © Joel Meyerowitz, Courtesy Edwynn Houk Gallery, New York

213 Joel Meyerowitz, *Eliza, Cape Cod*, 1982. Chromogenic print, 24 × 20 in. © Joel Meyerowitz, Courtesy Edwynn Houk Gallery, New York

214 Joel Meyerowitz, *Darrell, Cape Cod*, 1983. Chromogenic print, 24 × 20 in. © Joel Meyerowitz, Courtesy Edwynn Houk Gallery, New York

215 Joel Meyerowitz, *Bay/Sky, Provincetown*, 1977. Chromogenic print, 20 × 24 in. © Joel Meyerowitz, Courtesy Edwynn Houk Gallery, New York

216 Joel Meyerowitz, *Bay/Sky, Provincetown*, 1977. Chromogenic print, 20 × 24 in. © Joel Meyerowitz, Courtesy Edwynn Houk Gallery, New York

217 Joel Meyerowitz, *Bay/Sky*, 1977. Chromogenic print, 24 × 20 in. © Joel Meyerowitz, Courtesy Edwynn Houk Gallery, New York

HARRY CALLAHAN

218– Harry Callahan, *Untitled*, c. 1977. Chromogenic print,
228 11 × 14 in. © The Estate of Harry Callahan, Courtesy Center for Creative Photography, University of Arizona, Harry Callahan Archive

JOEL STERNFELD

229 Joel Sternfeld, *Near Lake Powell, Arizona, August 1979*, 1979. Chromogenic print, 16 × 20 in. © Joel Sternfeld, Courtesy of the artist and Luhring Augustine, New York

230 Joel Sternfeld, *Pendleton, Oregon, June 1980*, 1980. Chromogenic print, 20 × 24 in. © Joel Sternfeld, Courtesy of the artist and Luhring Augustine, New York

231 Joel Sternfeld, *Near Tucson, Arizona, April 1979*, 1979. Chromogenic print, 16 × 20 in. © Joel Sternfeld, Courtesy of the artist and Luhring Augustine, New York

232 Joel Sternfeld, *Rustic Canyon, Santa Monica, California, May 1979*, 1979. Chromogenic print, 16 × 20 in. © Joel Sternfeld, Courtesy of the artist and Luhring Augustine, New York

233 Joel Sternfeld, *Approximately 17 of 41 Sperm Whales That Beached and Subsequently Died, Florence, Oregon, June 1979*, 1979. Chromogenic print, 20 × 24 in. © Joel Sternfeld, Courtesy of the artist and Luhring Augustine, New York

234 Joel Sternfeld, *Wet'n Wild Aquatic Theme Park, Orlando, Florida, September 1980*, 1980. Chromogenic print, 20 × 24 in. © Joel Sternfeld, Courtesy of the artist and Luhring Augustine, New York

LEO RUBINFIEN

235 Leo Rubinfien, *At Los Angeles International Airport*, 1981. Chromogenic print, 19 ¾ × 23 ¾ in. © Leo Rubinfien. Courtesy Robert Mann Gallery, New York

236 Leo Rubinfien, *In Hamburg Harbor*, 1981. Chromogenic print, 19 ⅜ × 23 ¾ in. © Leo Rubinfien. Courtesy Robert Mann Gallery, New York

237 Leo Rubinfien, *On a Train to Brighton, England*, 1980. Chromogenic print, 19 ⅜ × 23 ¾ in. © Leo Rubinfien. Courtesy Robert Mann Gallery, New York

238 Leo Rubinfien, *Americans in the Breakfast Room of the Chateau d'Artigny, Montbazon, France*, 1981. Chromogenic print, 19 ⅜ x 23 ¾ in. Leo Rubinfien. Courtesy Robert Mann Gallery, New York

239 Leo Rubinfien, *Leaving Bangkok at Sunrise*, 1979. Chromogenic print, 19 ⅜ × 23 ¾ in. © Leo Rubinfien. Courtesy Robert Mann Gallery, New York

240 Leo Rubinfien, *On the West Side Highway, New York*, 1980. Chromogenic print, 19 ⅜ × 23 ¾ in. © Leo Rubinfien. Courtesy Robert Mann Gallery, New York

241 Leo Rubinfien, *On a Flight to Pagan, Burma*, 1980. Chromogenic print, 19 ⅜ × 23 ¾ in. © Leo Rubinfien. Courtesy Robert Mann Gallery, New York

242 Leo Rubinfien, *On Repulse Bay Beach, Hong Kong, Christmas Day*, 1980. Chromogenic print, 19 ⅜ × 23 ¾ in. © Leo Rubinfien. Courtesy Robert Mann Gallery, New York

243 Leo Rubinfien, *On a Slow Train to Surabaya*, 1980. Chromogenic print, 19 ⅜ × 23 ¾ in. © Leo Rubinfien. Courtesy Robert Mann Gallery, New York

244 Leo Rubinfien, *On the Staten Island Ferry, New York*, 1980. Chromogenic print, 19 ⅜ × 23 ¾ in. © Leo Rubinfien. Courtesy Robert Mann Gallery, New York

245 Leo Rubinfien, *At Yaumati Typhoon Shelter, Kowloon, Hong Kong*, 1980. Chromogenic print, 19 ⅜ × 23 ¾ in. © Leo Rubinfien. Courtesy Robert Mann Gallery, New York

ACKNOWLEDGMENTS

Thanks to the many people who contributed to this project, most importantly the artists, their estates, and their gallery representatives. In addition to providing work for the exhibition and catalogue, these individuals offered a wealth of commentary and personal anecdote unobtainable through written sources. I would thus like to thank: The Estate of Harry Callahan as well as Peter MacGill and Lauren Panzo of Pace/MacGill Gallery, New York; William Christenberry; John Divola along with Theresa Luisotti and James Bae of Gallery Luisotti, Santa Monica; William Eggleston in addition to Howard Read and Chris Burnside of Cheim & Read, New York, as well as Caldecot Chubb of the Eggleston Artistic Trust; Mitch Epstein and Meg Malloy of Sikemma Jenkins Inc., New York; Jan Groover as well as Janet Borden and Matthew Whitworth of Janet Borden, Inc., New York; Luke Batten of The Robert Heinecken Trust; Barbara Kasten along with Michael Welch of Stephen Daiter Gallery, Chicago, and Yancey Richardson in New York; Les Krims; Marvin Hoshino of The Helen Levitt Estate as well as Laurence Miller and Vicki Harris of Laurence Miller Gallery, New York; Joel Meyerowitz and his assistant Ember Rilleau as well as Edwynn Houk and Julie Castellano of Edwynn Houk Gallery, New York; Richard Misrach along with Jeffrey Fraenkel and Dawn Troy of Fraenkel Gallery, San Francisco; John Pfahl; Leo Rubinfien along with Robert Mann, New York; Stephen Shore as well as Mari Spirito and Mariko Mori of 303 Gallery, New York; Neal Slavin; Eve Sonneman; Joel Sternfeld and Natalia Sacasa of Luhring Augustine, New York. Thanks as well to providers of additional images for the catalogue: Hans P. Kraus, Jr., New York; Leslie Nolan of Marian Goodman Gallery, New York; Jessica Witkin of David Zwirner Gallery, New York; the Princeton University Art Museum; Andra Russek of Scheinbaum & Russek, Santa Fe; Victoria Haas and Bob Fagan of the Ernst Haas Estate; and Deborah Bell, New York.

In addition to the artists and galleries who lent works to the exhibition, thanks to numerous lenders, both private and institutional: The Center for Creative Photography, Tucson; Gregory Gooding, New York; Vicki Harris, New York; Joseph and Stephanie Kraeutler, New York; Nion McEvoy, San Francisco; The Museum of Modern Art, New York; Penny Pritzker and Bryan Traubert, Chicago; The Cincinnati Art Museum; and Trevor Traina, San Francisco. Thanks as well to Joshua Holdeman of Christie's, New York; Vanessa Kramer of Phillips de Pury & Company, New York; and Lauren Ryan of Allan Schwartzman Inc. for their help in locating additional works for the exhibition.

I would also like to thank various curators and specialists for their intellectual and practical help along the way: Peter Bunnell, who offered his thoughts and personal files on the subject during the project's early stages; Peter Galassi and Susan Kismaric of The Museum of Modern Art, New York; Britt Salvesen, formerly of the Center for Creative Photography, Tucson; Joel Smith of the Princeton University Art Museum; and Marvin Heiferman, onetime director of Castelli Graphics, New York.

Thanks as well for the support of staff at the Center for Creative Photography, Tucson: Leslie Calmes, Tim Mosman, Sarah Newby, and Amy Rule. Very special thanks to the staff of the Cincinnati Art Museum: Jay Pattison, Susan Hudson, Matt Leininger, and Cassandra Taylor.

For the book's production, I would like to thank my friend Andrew Scott, who created an early mockup for the book; Mary Christian for her editorial expertise; and the staff at Hatje Cantz: Markus Hartmann, Tas Skorupa, Angelika Hartmann, and Martina Reitz.

Finally, I wish to express my special gratitude to several individuals without whose support this book and exhibition could not have happened: Aaron Betsky, director of the Cincinnati Art Museum, who believed in the project and got behind it early on; Ross Finocchio, the best of research assistants; Leo Rubinfien, my philosophical guide to the seventies; Jason Siebenmorgen, whose taste and judgment are always right on; and James Crump, curator of photography at the Cincinnati Art Museum, who not only offered great intellectual insight but also moved mountains to make this whole thing happen. Thank you everyone for your interest, intelligence, hard work, and friendship.

Kevin Moore

This catalogue is published in conjunction with the exhibition
Starburst: Color Photography in America 1970–1980

cincinnati ✻ art museum

Cincinnati Art Museum
February 13–May 9, 2010

Copyediting: Mary Christian
Graphic design and typesetting: hackenschuh com. design
Typeface: Avenir
Production: Angelika Hartmann, Hatje Cantz
Reproductions and printing: Dr. Cantz'sche Druckerei, Ostfildern
Paper: Mega Gloss, 170 g/m²; Munken Polar, 150 g/m²
Binding: Conzella Verlagsbuchbinderei, Urban Meister GmbH,
Aschheim-Dornach

Published by

Hatje Cantz Verlag
Zeppelinstrasse 32
73760 Ostfildern
Germany

Tel. +49 711 4405-200
Fax +49 711 4405-220
www.hatjecantz.com

Hatje Cantz books are available internationally at selected bookstores.
For more information about our distribution partners, please visit our
homepage at www.hatjecantz.com.

ISBN 978-3-7757-2490-6

A paperback edition is available in the museum only.

Printed in Germany

Cover illustration: Mitch Epstein, *Madison Avenue, New York City*, 1973
(detail of plate 47)